RUSSIAN
FOLK ARTS

Other Books by Alexander Pronin

Russian Vocabulary Builder by Subjects: Ten Words a Day
Russian Vocabulary Builder: Seven Verbs a Day
History of Old Russian Literature: Bilingual Lectures
Byliny: Heroic Tales of Old Russia

RUSSIAN FOLK ARTS

Alexander and Barbara Pronin

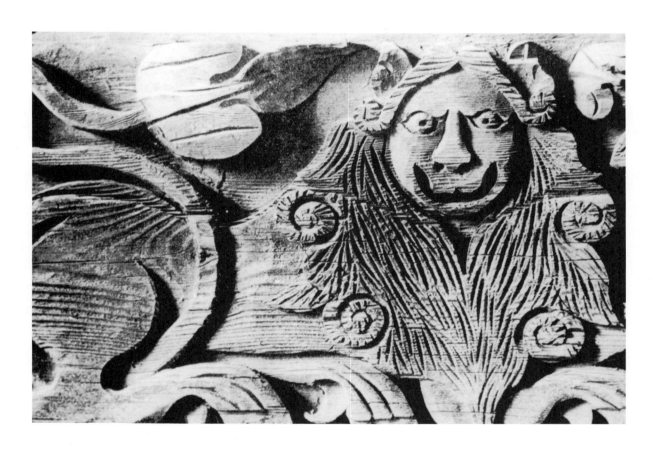

South Brunswick and New York: A. S. Barnes and Company
London: Thomas Yoseloff Ltd

A. S. Barnes and Co., Inc.
Cranbury, New Jersey 08512

Thomas Yoseloff Ltd
108 New Bond Street
London W1Y OQX, England

Library of Congress Cataloging in Publication Data

Pronin, Alexander.
 Russian folk arts.

 Bibliography: p.
 1. Folk art—Russia—History. I. Pronin, Barbara,
joint author. II. Title.
NK975.P76 745'.0947 73-117
ISBN 0-498-01276-X

PRINTED IN THE UNITED STATES OF AMERICA

To
Elisabeth and Ivan Ivanovich Stenbock-Fermor

CONTENTS

INTRODUCTION

Russia, with its immense spaces and multinational population, could not sensibly be regarded as a single unified whole until relatively recent days. The larger towns alone were linked by railways, roads were few and far between, and village life was isolated and communal. For both the necessities and adornments of life, villagers relied upon themselves, building their own houses and furniture, making their own clothing, implements, utensils, and decorative objects. The presence of certain raw materials determined which districts would be prominent in which types of production. Surplus products were distributed by *kustari,* itinerant craftsmen who traveled about the country practicing their crafts and selling their wares.

Until the eighteenth century, Russian folk art remained relatively simple and traditional, serving the peasant's own needs and tastes. It was largely unrelated to the changing period tastes of urban Russia, had little to do with current styles in architecture, sculpture, or painting, and, as the artists depended on talent rather than on academic training, was little concerned with technical finesse. The motifs used repeatedly over the ages were not invented by individual artists but belonged to a common stock handed down the generations and used by all who practiced the handicrafts. Although individual decoration might vary from one area to another, it was this common expression above all that produced the quintessential character of Russian folk art.

While Russian folk art continued to reflect the traditional tastes of peasant craftsmen, during the eighteenth and nineteenth centuries folk artists were increasingly influenced by the tastes of educated landowners and townspeople who often trained and employed them in building, decorating, and small factory-type work. Both subject matter and approach began substantially to change, and although the peasant artist became more versatile, handicraft work became increasingly stylized and idealized to accommodate the tastes of its customers. During the nineteenth century, especially, the Russian intelligentsia, which had hitherto exhibited a patronizing attitude toward peasant art, suddenly adopted the reverse attitude and endowed it with an almost comically high-flown sanctity having something vague to do with the nature of the cloudy "collective soul" of Russia.

The nineteenth-century Russian peasant, struggling to make a living and far less impressed by the sanctity of the past than were members of the classes above him, responded, naturally enough, to sales. The effort by a few dedicated Russian revivalists to keep the folk arts "pure" came too late to prevent peasant art from splitting into two largely self-contained styles: that which served the peasant himself and that which served his masters.

Both styles underwent foreign influence and were affected by foreign innovations, but nineteenth-century industrialization in Russia had the effect of hampering the further natural development of the genuine folk article. The peasant arts declined rapidly after the abolition of serfdom in Russia in 1861 and declined still further as urban drift increased toward the end of the century. Handicraft articles could not compete in price with the mass-produced factory product, and few buyers were willing to pay their price.

Shortly before World War I, local authorities and a number of Russian philanthropists attempted to revive the old peasant crafts.

> The great beauty of the handicraft arts is that preserved in them is the imprint of the hand, of individuality, and of that lively, intimate feeling that is often present in roughly made objects. These are considerably more precious than the perfect objects produced by soulless machinery. By this criterion, the handicrafts of a nation will be boldly expressive of national individuality, and thus it is that a demand for these works inevitably arises. This is not a theory. Experience at a number of international exhibitions has shown that Russian art objects have been in great demand by foreigners when imitations of foreign art were ignored.

So spoke A. V. Krivoshein, a government representative, at the opening of the Second Russian National Handicrafts Exhibition on 17 March 1913 in Petrograd (now Leningrad). A first exhibition held in 1902 had reawakened the Russian public to the appeal of the various native crafts, but no record of that show exists. The purpose of the second exhibition was to bring the handicrafts once again to the public's attention and to suggest their connection with other forms of Russian art. It was felt at the time that alien and imitative tendencies had adversely affected them, although their general artistic quality was believed to be on the rise.

Because the peasant crafts had long played an important part in the country's national economy, it was also believed in 1913 that government and local administrations should lend them economic support—arrange easy credit for craftsmen, provide them with better equipment, and help sell products by extending markets for their goods. A new government office would attempt to stimulate an interest in Russian handicrafts among the Russian public, and plans were made to bring these crafts to the attention of potential buyers outside Russia as well. Schools and workshops had already been established, but the stimulus which they gave to the ancient crafts was short-lived. Their products suffered in general from self-consciousness and artificiality, and 1917 brought such efforts to an end.

Rural handicrafts began gradually to reappear after the Revolution, the artists having preserved the historic traditions of their crafts and the old methods of working as much as possible. The economic position of the artisans changed somewhat in Soviet times. Once isolated and dependent on speculators, they were now united in specialized cooperatives belonging to a national association of craftsmen and received a general education in addition to specialized art training. The Russian handicrafts, which have long since lost their purely utilitarian value, are regarded today as a special branch of Russian national art. While relatively few examples are to be found in museums outside Russia, folk art is collected in museums throughout the USSR, and annual contests are held by the Moscow Arts and Handicrafts Museum to find the best masters in each field.

"What an excellent field for discriminating collectors is lying fallow in the rural quiet of Russia!" an English art historian, Cyril G. E. Bunt, exclaimed in 1946. It would be clearly impossible in such a selective survey as this book offers to document every individual handicraft of every area and nationality in a country as vast as Russia. The main divisions of the following text were suggested by the album that was originally published in connection with the Second Russian National Handicrafts Exhibition of 1913, graciously loaned to the authors by Elisabeth and Ivan Ivanovich Stenbock-Fermor of Palo Alto, California. Additional material has been the result of research in a considerable number of Russian writings in the field. The geographical emphasis of the text is on what is customarily regarded as European Russia, which means that certain subjects of great interest and importance—such as Caucasian rugmaking, for example—have necessarily been omitted. Omitted, too, are the many minor crafts of Russia from both old and more recent times. New genres of Russian folk art have arisen in recent times, but they, like the various traditional arts of the Asian, Caucasian, and Baltic areas of Russia, are outside the scope of this survey.

It has often been difficult in the course of the following chapters to differentiate the decorative arts from the folk arts, and the folk arts from the souvenir crafts of the present period. Suffice it to say that the handicraft souvenirs so eagerly sought by foreign tourists today—painted *matryoshki*, Vyatka clay toys, Palekh jew-

elry boxes, Khokhloma decorative bowls, Vologda carvings on birchbark, and Kholmogory bonecarvings—are all articles long familiar and dear to the Russian people.

A note on the text: From the eighteenth century, Russia was divided administratively into *guberni* (provinces). Each gubernia was subdivided into *uezdy* (districts) and later into cities, *slobody* (large settlements or city suburbs in which, before the liberation of serfs in 1861, the population was composed of both serfs and free citizens), and villages. The *oblast* (region) was another large administrative subdivision, and in some parts of the empire there were organized governor-general areas which included several *guberni*.

The transliteration of Russian words remains an insuperable problem. For the most part we have followed established systems, general usage, and common sense.

RUSSIAN FOLK ARTS

For those peasants, buffoons
and simpletons at first seeming,
are like those dolls within a doll,
secrets within secrets concealing.
 Yevgeny Yevtushenko,
 "A Russian Toy—Roly
 Poly," *Yevtushenko
 Poems,* trans. Herbert
 Marshall (New York:
 E. P. Dutton & Co.,
 1966), pp. 30–40.

.

1
THE ICON

Russia inherited the art of iconmaking from Byzantine Greece. According to the chronicle "The Tales of Bygone Years," on his conversion to Christianity in A.D. 988 Prince Vladimir of Kiev engaged Byzantine craftsmen to build churches and adorn them with paintings and mosaics of religious figures. During the eleventh and twelfth centuries, Russian art at Kiev, Vladimir, and Novgorod was chiefly Byzantine Greek, and the icon was purely Byzantine as well, governed by the rigid dogma established by the masters at Mount Athos, the site of a cluster of mostly Orthodox monasteries in northeast Greece.

The first Russian school of icon painting appeared in Suzdal at the end of the thirteenth century, flourished in the fourteenth century, and early in the fifteenth century merged with the Muscovite school. The Novgorodian school took its distinctive shape at the beginning of the fourteenth century, reached its highest development in the mid-fifteenth century, and continued to influence the art of the icon even after the city's annexation by Moscow.

Novgorod's geographic and commercial position accounts in part for the superiority of its artists during the centuries that followed. Novgorod was a stronghold of the Hanseatic League and the great market center for the overland fur trade. It was also the only substantial town in Russia to have escaped domination by Mongols during the thirteenth century. Trade brought foreign ideas as well as prosperity to Novgorod, and although there were a number of other icon schools almost as notable—among them, Tver, Pskov, Vologda, Vladimir-Suzdal, and Moscow—in quality, style, and technique, Novgorod exceeded them all.

Among the many Greek artists in Novgorod who followed the Byzantine tradition in art were native Russians who worked under them and studied their techniques. Although most of these Russians imitated the Greek manner, they began in time to modify the Byzantine heritage and to develop the rudiments of an original style. As early as the thirteenth century the Novgorodian school had produced individual painters whose work led to the emerging Russian style of the fourteenth century, a style that would eventually supplant the Byzantine tradition in the North.

Although icon painters worked in groups, certain individual names stand out from the earliest days. The works of Theofanes the Greek, sometimes called the father of the Russian icon, bear the special character-

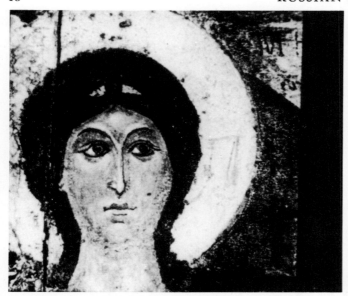

The Archangel Michael's Convocation (detail, in process
of restoration). Thirteenth century.

istics of line, color, and composition that distinguish
the Novgorodian school. In the second half of the
fourteenth century, a school began to form in and
around Moscow which came to be led by the most cel-
ebrated icon painter of all times—Andrei Rublev, a
monk and pupil of Theofanes the Greek, who lived
from approximately 1370 to 1430. The few extant works
known to be Rublev's are characterized generally by
exquisite drawing, a subordination of minor details
to coordinated design, and the use of relatively light
colors. Before the end of the fifteenth century, how-
ever, the style indentified with Rublev had lost its best
qualities and become increasingly mannered.

The individuality of another singular painter, Dion-
ysus, temporarily delayed the impending decadence.
Dionysus was active in the first decade of the sixteenth
century, and his icons are distinguished by a quality of
gracefulness, especially in the delineation of figures.
His larger reputation rests upon his frescoes, notably
those executed at the Ferapontov Monastery in 1500-
1501. The works of Rublev and Dionysus are said to
have set the high standard of icon painting not only in
Russia but generally in the Orthodox East as well.

Although the Novgorod painters continued to ex-
emplify the best in the Russian style for the first three-
quarters of the sixteenth century, during the reign of
Ivan III the center of artistic life in Russia moved from
Novgorod to Moscow, where to a certain degree the two

schools became one. In 1547, during the reign of Ivan
the Terrible, Moscow was devastated by a fire, and the
czar, with the assistance of Metropolitan Macarius, at-
tempted to repair the damage. Icons were collected
from Novgorod, Smolensk, Dmitrov, and Zvenigorod,
and painters from Novgorod and Pskov were ordered
to Moscow to help refurbish the churches. This was, in
a sense, the Novgorodian school's last contribution to
the art of the icon. Moscow absorbed the technical
expertise of the older schools, and before the century
ended Russian icon painters were following the Musco-
vite style.

The Stroganov school, supported by the great mer-
chant family of the northeast that subsidized Ermak's
conquest of Siberia in 1581, was active from roughly
1580 to 1630. Art and craft workshops were estab-
lished at Solvychegodsk, Usole, and other centers of
the Stroganov salt monopoly. The influence of this
school spread throughout Russia and was later evi-
dent in Moscow as well as in the Yaroslavl and northern
schools. The Stroganov icons—most of them small,
almost miniatures, in fact—were highly colored, elab-
orately meticulous, and brightly gilt, full of charm and
detail. It was, however, the last spark of an art declin-
ing into mere prettiness.

In the second half of the seventeenth century, Rus-
sian icon painting was dominated by the school of the
czar's icon painters in the Oruzheinaia Palata, headed
by the boyar Bogdan Khitrovo. Begun early in the six-
teenth century as an arsenal, the Oruzheinaia Palata
had continued to manufacture arms at the same time
that it had gradually become a technical, scientific,
pedagogical, and art institute containing shops and
studios of icon and portrait painting and gold and sil-
versmith work. Working in the monumental style, the
czar's icon painters reflected the influence of Western
studies in anatomy and perspective. The school's cel-
ebrated master was Semyon Ushakov (1626-86), who
was praised for his ability to combine Byzantine and
Western elements in his work.

Although notable works continued to be produced
during the Muscovite period, the school of the czar's
icon painters marked the end of another period. Before
long, the West would influence the art of Russia, and
after Peter the Great's massive reforms, the Russian
fine arts would join those of the Western world. With
the seventeenth century, therefore, the icon can no
longer be strictly included among the Russian prim-
itives, although to meet the religious needs of the nation

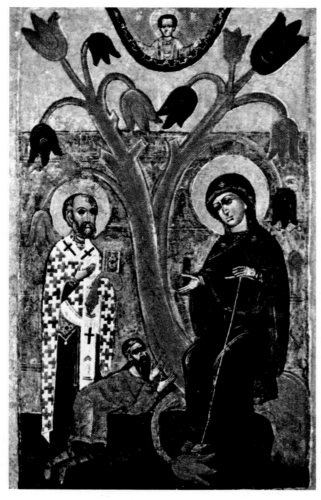

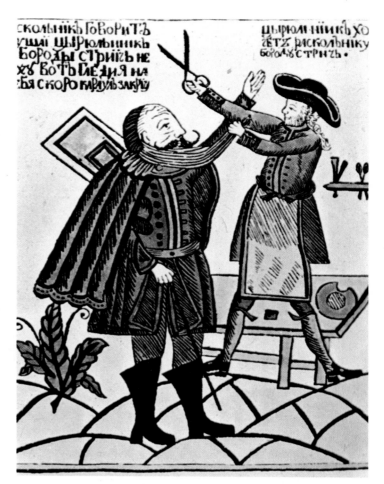

The Appearance of the Holy Virgin and St. Nicholas to the Sexton Yurysh. Northern Russia, eighteenth century.

Barber Cutting the Beard of Old Believer. Woodcut, first quarter of the eighteenth century.

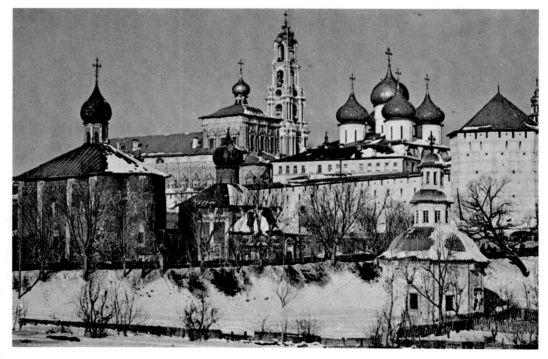

Holy Trinity-St. Sergius Monastery, Zagorsk.

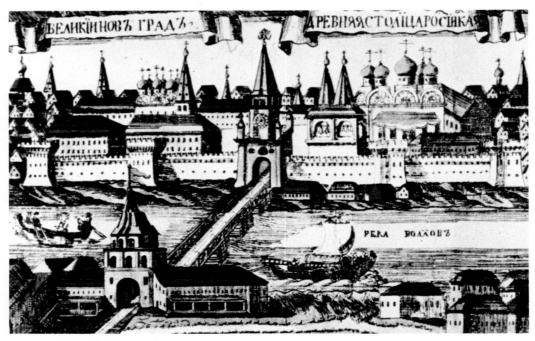

Novgorod the Great (fragment). Copper engraving, eighteenth century.

The Savior Enthroned (detail). From the Deisis Tier, Rostov-Suzdal school, sixteenth century.

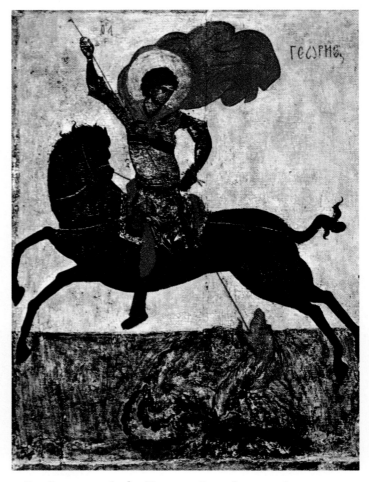

St. George and the Dragon. Late fourteenth century.

iconmaking continued to number among the more important Russian crafts. Even after the opening of the Imperial Academy of Arts in 1757 and the establishment of other art schools in Russia, icons continued to be made by rural craftsmen.

Specialists have restored enough icons found in expeditions in the Karelian Autonomous Republic to prove that there were major art centers in ancient Karelia as well. The forests of Karelia have always been its principal natural resource. Most of its churches were made of wood, which is why frescoes were rare and icons so common in the North. An interesting local school of painting flourished in Karelia at the turn of the eighteenth century as a result of church construction. Scores of little chapels as well as complex architectural ensembles were embellished with a multitude of icons. The local artists almost certainly learned their

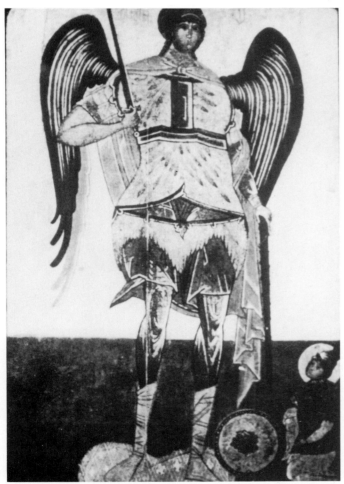

The Archangel Michael. **Moscow school, mid-sixteenth century.**

craft from village elder craftsmen. The work is characteristically understated, austere, and free of superfluous embellishment. Religious themes and the lives of saints are treated in terms of everyday life, and the Karelian artist used only homemade colors.

Palekh, Mstera, and Kholui

By the mid-eighteenth century there were only three icon painting centers left in Russia: the villages of Palekh, Mstera, and Kholui. Here, iconmaking provided the main source of income; from here, icons were sent out by distributors (known as *ofeni*) throughout Russia, Siberia, and the Caucasus and were later shipped by rail to the most distant outposts of the empire. The association of these old Suzdal villages with the art of the icon is believed to have originated at the Holy Trinity-St. Sergius Monastery, which in the seventeenth century owned lands that included the icon painting settlement of Kholui. Old documents indicate that iconmaking was an established craft in the Suzdal area by the seventeenth century.

The icon painters of Palekh are first mentioned in sixteenth-century chronicles; although the exact date of the village's founding is not known, a letter addressed in the mid-seventeenth century to Semyon Ushakov speaks of Palekh villagers who bartered icons they had painted in exchange for eggs and onions. In Palekh, where the secrets of the craft were handed down from father to son, the art of iconmaking reached its peak during the eighteenth century with, for the most part, costly icons that were extremely popular among aristocrats and wealthy businessmen.

Goethe was the first to express a scholarly interest in the icons of this area. In a letter to the Russian government in 1813, he inquired how long the industry had existed in Suzdal and in neighboring Vladimir Province, whether Greek icons served as prototypes, whether there were any eminent artists among the Suzdal icon painters, and whether all the work conformed to the traditional icon style, or whether other, more modern art objects were made there as well. The governor of Vladimir Province replied that Suzdal painters did not engage in modern work, and in detailing all the icon painting villages, he singled out Palekh.

For iconmaking, the nineteenth century was a period of decline, commercialism, and essentially mechanical production. The number of rural iconmakers decreased somewhat during the second half of the centu-

ry. Many craftsmen moved to Moscow, St. Petersburg, and other cities, where they established icon handicraft shops, while many others abandoned the craft altogether because of the competition offered by printed icons. Suzdal iconmakers objected to printed icons for the same reason that scribes had protested the invention of the printing press. Printed icons, however, threatened only the painters of cheap popular icons and had no effect upon the artisans producing better works, appealing, as they did, to different markets. After prolonged demands by the artists that icon printing be stopped, the Suzdal artisans (mainly those of Mstera) began to buy printed icons themselves and to make icon cases for them.

Several types of iconmakers eventually surfaced. The *zavodchiki* maintained special icon shops housing and employing from fifteen to twenty painters and apprentices. A second group, composed of worker-owners, produced icons at their own homes with the help

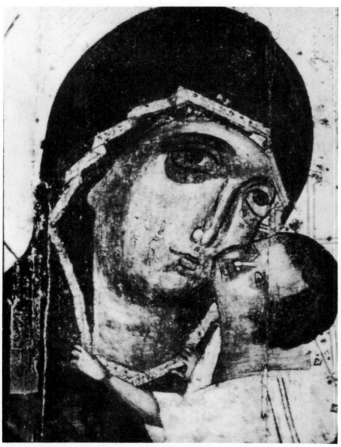

The Virgin of Tenderness of Kuben (detail, in process of restoration). Thirteenth century.

of their families and a few hired workers; these icons were either sold directly to icon shops or distributed through dealers. A third group, the *promyshlenniki* (roughly, "contractors"), took orders which they filled either on the spot or at home. The large majority was made up of the workers and apprentices who worked for the *zavodchiki* and worker-owners, either on a monthly salary or on the basis of piecework. A worker engaged by the month was expected to put in twenty-three to twenty-five days per month. On the other days he was allowed to produce icons for himself, sell them, and keep the profits. Those who worked by the piece were paid either per icon or per hundred icons.

The work of these craftsmen was essentially mechanical, each man executing only one specific job. The result of such specialization was that a shop employing five to six craftsmen could produce 100 to 300 of the more popular icons a day. These pieces were priced low, but metal icons were produced even more cheaply and rapidly because only the face and hands showed, the rest of the surface being covered with metal. In other shops, more expensive icons were made by better artists imitating Greek, Novgorodian, and Stroganov techniques. But these artists, too, specialized in details—some in faces, others in background. The icons in imitation of the old styles differed from the more popular, inexpensive icons in their use of the best materials and in the quality of the work. This is especially evident in the wonderful accuracy and precision of the work in the small icons. Craftsmen capable of producing these small icons were in great demand and were better paid than the makers of popular icons.

In the normal procedure for training icon painters, a boy would join a shop at the age of eight or nine for a period of five to seven years, during which time he would live with the owner without pay. He would begin by mixing paints, cleaning boards, and doing various kinds of ancillary work. He would then be given an icon of St. John the Evangelist, the patron saint of the trade, which he would repeatedly copy until he had mastered the technique of following the outlines. After five or six months of such exercises, he would be ready to paint inexpensive icons, although their quality would not be of special concern at this point; his main task was to acquire speed. When he was ready to start producing icons, he was generally paid at first on the basis of piecework.

Icon craftsmen were for the most part poorly quartered in small wooden houses with cramped, uncom-

fortable rooms redolent of varnish and full of woodpiles and unfinished work. The family would seat itself round a table in the middle of the room, working on various details; in the evening they would gather round a kerosine lamp. Glass globes filled with water hung from the ceiling, the light reflected by the globes directed toward those sections of the icon being painted. The table would be littered with tools—paints, brushes, small vessels of water for washing the brushes, eggshells containing egg yolks for binding, wooden compasses, and other paraphernalia of the craft.

Drawing was not taught at icon shops until 1901, when a special government office was established in connection with iconmaking in Palekh, Mstera, and Kholui. At special training shops, drawing was taught and the old techniques were preserved. A graduate of an art academy was assigned to such schools to instruct trainees in drawing, painting, anatomy, perspective, and other disciplines. In addition, two of the best local craftsmen would be assigned to each shop to teach secrets of the craft and to instruct apprentices in iconography.

In Mstera, icon craftsmen concentrated on the production and reproduction of traditional pieces—meticulously copying old masters, imitating all the schools of old icon painting in Russia, restoring old icons which itinerant peddlers brought them from remote backwoods villages throughout the country, and faking antique icons as well. Because they were traditional in style and execution, Mstera icons were in great demand by the Old Believers, a religious sect that had separated itself from the Orthodox church during the seventeenth century, refusing to accept the church reforms of Patriarch Nikon (1605-81).

The restored icons were resold at a great profit to antique collectors in Moscow and St. Petersburg. The bogus antique icons, accompanied by a sham authenticity guarantee, were palmed off on collectors, museums, and even on the imperial court. Cataloguing the art collection of the Leningrad Winter Palace after 1917, Soviet art scholars found in the czar's personal collection a considerable number of early twentieth-century Mstera fakes previously believed to have been the work of Russian icon painters of the twelfth to fifteenth centuries.

Perhaps because the Old Believers remained strong there, the Suzdal region remained the last stronghold of traditional iconmaking in Russia, even though the works produced there gradually acquired a local char-

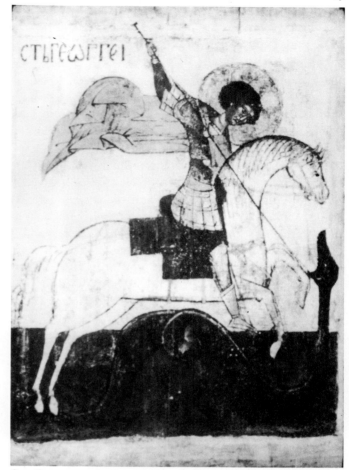

St. George and the Dragon. **Northern Russia, sixteenth century.**

acter in place of the national character they had once had. The artisans of Kholui abandoned the traditional tempera techniques still employed at Mstera and Palekh, painted in oil with wide brushes in imitation of academic artists, and were not concerned with fine finishing effects. From Kholui, too, came the muralists who went out in groups during the summer to decorate church interiors. The art of Kholui was improved by the establishment of a school there in 1883 by Archbishop Feognost of Vladimir and headed by the artist N. N. Kharlomov. At the time of the Second Russian National Handicrafts Exhibition of 1913, the school was under the government office for the preservation of icon art.

At the juncture of the nineteenth and twentieth centuries, Palekh work fell somewhere between the old and the new, with some parts of icons painted in oil and other parts in tempera, often set against a gold back-

ground. Palekh also preserved its knowledge of the old techniques of fresco decoration, although its frescoes were only student copies of originals and not durable. By the beginning of the twentieth century, however, Palekh painting had virtually died out. Anton Chekhov, himself descended from icon painters on his mother's side, lamented in 1901 that the art of icon painting was dying and that Palekh would never get back on its feet again.

With the Bolshevik Revolution, the demand for icons fell off, and the Palekh painters took any job that came their way, including the decoration of wooden toys, although not long afterward the craft of the Suzdal artisans would find new application in the making of lacquered miniatures. After 1917 countless icons that had been secluded in churches and private collections were brought into public museums, and since World War II Soviet art scholars have been engaged in an enormous labor of icon restoration.

Techniques

Although the secrets of the *iconopisets* were traditionally handed down the centuries, it is possible to describe the steps in the creation of the old Russian icon. Although variations of this technique existed, the methods described here represent those generally used throughout the history of the craft.

Iconmaking commenced with the preparation of a panel. One or several pieces of native woods, including pine, lime, alder, fir, and cypress, were shaped with an ax, glued together, and strengthened by slats of wood at the back to prevent warping. The smoothened panel was treated with a paste, then primed with a layer or more of thin glue made from hides or fish or another admixture, and smoothed again with a kind of palette knife (*klepik*). When the priming had dried the surface was wiped with a wet cloth and polished with the palm of the hand. Sixteenth-century icons were occasionally primed, though with less care, on the back as well, to preserve the wood. The design was then applied to this ground, the artist drawing directly on the gesso in the earliest and better method.

Copying an icon involved a different method. With his brush, the artist outlined the details of the icon to be copied in a pale green color obtained from a variety of natural substances, including garlic, onion juice, or a mixture of kvass, sugar, and soot, covered the icon with a sheet of paper, and took an impression of the orginal.

The Descent into Hell with Chosen Saints (detail). Northern Russia, sixteenth century.

From six to twelve additional sheets were placed beneath the transfer, and the transfer (and simultaneously the undersheets) was pricked. Removing the undersheets for future use, the artist dusted the transfer with charcoal or other dry color so that the dust sifted through the pricked holes onto the white ground below. The outline so obtained was "fixed" with a fine needlelike instrument to guide the artist when colors were applied later. Finer works, however, were always done with the brush directly; such engraving was rare on ancient icons. It was more common in the fifteenth century, less so in the sixteenth century, but by the seventeenth century had become commonplace in iconmaking.

Next the background gold or silver and colors would be applied. For nonlinear gold details, gold leaf was applied over a coat of dull yellow and red, the gold cov-

ered with a mixture of reddish yellow earth, egg yolk, and a touch of vegetable or animal fat. This work was usually performed by apprentices; any chasing was done by an expert.

The icon painters of Old Russia made their own mineral pigments and mixed them with egg yolk (with thin glue as a base and a preservative such as kvass or wine) to bind the paint to the ground. Over the years, the egg emulsion hardened so that the layer of paint remained firm. The mixture, thinned with water if required, was kept at hand in small pots or eggshells. Especially in the early icons, colors were limited and mixed not on a palette but on the painting itself. There were generally two methods of applying colors: wet and dry. "Wet" meant applying thin washes of color with a saturated brush and removing excess paint when the color was dry. "Dry" meant a thick application of color with barely-moistened brushes, producing a compact surface to which varnishing would later lend a certain transparency.

Attention to details followed the completion of these basics, and details were executed by a number of individual specialists. An icon was not the work of one man but of several artisans expert in only one area each; many specializing in the face, for example, were unable to draw the body. First everything was painted in except the face—that is, the clothing, then various natural and architectural details—the painter applying the colors in a strict sequence. The icon then went to the *lichnik,* or face expert, who also followed a strict sequence in the application of paint layers. After spaces were painted in for the face, hands, and other parts of the body, more details were added and the shadows lightened with white paint, the *lichnik* completing the head and, last, the hair. Shading and gold highlighting were normally attended to after everything else was completed, by a process of overworking. Gold was not used before the sixteenth century. Later, it was brushed on carefully with a feather or featherlike brush over a ground of gum and red pigment, any surplus being removed with a feather or hare's foot when it was dry.

Another artisan would paint the borders of the icon with reddish brown colors or black and white lines. Still another would execute any lettering with a blunt pen and soot or ink. Finally, the icon was covered with a varnish composed for ages of boiled linseed oil and amber (copal replaced amber in later times), which heightened the colors for a while, then slowly and inevitably dulled them. The icon was placed horizontally until the varnish began to thicken. Then any surplus was removed with the palm of the hand, and the icon was placed face to the wall to allow slow, dust-free drying.

The damp, dark churches in which such icons were placed were ultimately unfavorable to their preservation. The drying varnish filmed over their surfaces to throw colors into relief darkened quickly. Smoke and soot from candles hastened the destruction, and in sixty or seventy years the original painting was scarcely discernible. In the old days, restoration in the modern sense of the word did not exist. An artist commissioned to renovate an icon would sometimes scrape off the old painting, destroying the original, or, at best, paint a new image over the darkened oil. This painting also darkened with time and was again repainted, so that on some icons one finds several paintings made at different times, the later ones much different from the originals in technique and artistry.

The study of early Russian icon painting has been greatly assisted by the development and refinement of modern restoration techniques, including the use of X rays, infrared photography, and organic solvents. Museums depend on X-ray photographs to tell them whether an icon needs restoring. With X-ray prints, the restorer can estimate the condition of the paint layer he needs to strip off. The use of solvents enables restorers to transfer a segment of a painting, or the whole painting, to a new ground by stripping off layers of colors from the film of darkened dry oil. Even microscopic layers done in tempera and bound firmly to one another are separated by the softening solvents.

Thus, restoring an icon is today a kind of archaeology. Every painting freed of its dark layers of dried oil and overpainting yields valuable information about the work of the masters of Novgorod, Moscow, Pskov, Vladimir, and Suzdal. Restorers are still uncovering masterpieces of northern folk art which until fairly recently appeared irretrievably beyond restoration, so that today the principal museums in the USSR possess some of the greatest icon treasures in world art history.

2
THE LUBOK

Russia, like other countries, had its "street literature" —its broadsides, chapbooks, prints, and advertisements of the type collectively classified as popular art. This graphic literature appeared later in Russia and persisted longer than it did elsewhere, gaining in its lengthy development a unique and fascinating variety. But the Russian *lubok,* or broadside, remains outside Russia, a little investigated aspect of Russian folk art.

In the second half of the nineteenth century, D. A. Rovinski, a Russian lawyer, art authority, and collector of broadsides, produced nine volumes of scholarship on the lubok which is to this day the authoritative work in the field. A number of other investigations (by I. Snigirev, I. Golyshev, and others) appeared in mid-century, and still others have been made in the twentieth century. But still very little is known about the specific social origins of these pictures, their development, their place among the other graphic arts, or the origins of the name itself: *lubochnye kartinki—* more familiarly, *lubki.*

The word *lubok* may derive from *lub,* denoting the carvable inner bark of a tree; or it may derive from the name of the limewood block from which lubki were originally printed or the bast baskets from which they were hawked from village to village by itinerant ped-

dlers. Another explanation associates the word with Lubianka Street in old Moscow where such prints were once sold, although Lubianka Street may, on the other hand, owe its name to the lubki that were sold in the vicinity.

Early Lubki

Introduced in the sixteenth century by Hanseatic merchants from Germany, the lubok first took root in the Ukraine, where it was produced at the Monastery of the Caves near Kiev. The oldest lubok, of anonymous workmanship and dated between 1619 and 1624, was a woodcut of the popular *Dormition of the Holy Virgin* icon; the second oldest, *A Dungeon Dark, Pleasing in the Sight of God.*

Ukrainian engravers of this period often modeled lubki on easily accessible German and Dutch editions—in particular, the Piscator Bible, the 1541 Wittenberg Bible, and the engravings of Dürer—upon which they superimposed Orthodox iconographic style. It was this combination of Orthodox iconographic mannerisms together with the unsophisticated copying of West European engravings that produced the "lubok style," which ultimately shed both parents, retaining

Picture Bible. Woodcut by Ilia the Monk, 1645–49.

Picture Bible. Woodcut by Ilia the Monk, 1645–49.

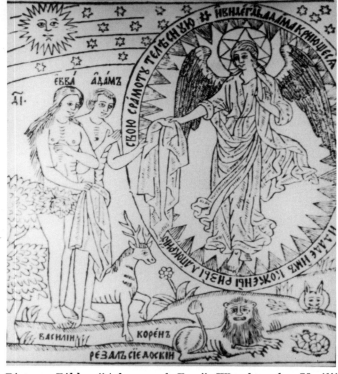

Picture Bible: "Adam and Eve." Woodcut by Vasilii
Koren, 1696.

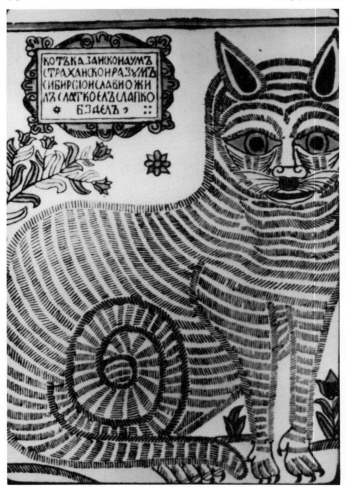

The Cat of Kazan. Woodcut, possibly by Vasilii Koren, late seventeenth century.

other Kiev master was one Prokopii, who produced twenty-four *Apocalypse* plates between 1646 and 1661.

In Russia, the introduction of engraving on wood coincided roughly with the establishment by Ivan the Terrible of the first printing press in Moscow in 1564. All of the Russian woodcuts of this period were of a religious character, depicting popular icons, biblical scenes taken from illuminated manuscripts, and legends of sacred history taken from church murals, and all illustrated books of devotion. In the mid-seventeenth century, individual prints much like these but designed for greater popular appeal considerably increased in number. Many inexpensive broadside icons were used in place of the more expensive icons painted on wood, and these were sold in large numbers outside the Redeemer Gate tower of the Moscow Kremlin.

Unfortunately, few copies of late seventeenth-cen-

only the crude stroke, laconic drawing, and clear-cut composition that characterized the Russian broadside throughout most of its history.

The Orthodox clergy of Kiev and Lvov made its own use of the lubok. Preserved at the Bodleian Library is the only extant copy of a chapbook composed of twelve hand-painted woodcuts, one for each month of the year, executed in 1628-29 by the Kiev engraver Pamva Berynda. More than just a church calendar, this chapbook served to remind its owner of the holy saints in the Orthodox religion and was thus employed as a weapon against Polish Catholicism. Second in artistry to Berynda was Ilia the Monk, who, between 1645 and 1649, cut 132 of a planned 150 blocks for a broadside bible similar to the 1475 German *Biblia pauperum.* Adapted from the illustrated Piscator Bible, these woodcuts are simple and concise but very expressive. An-

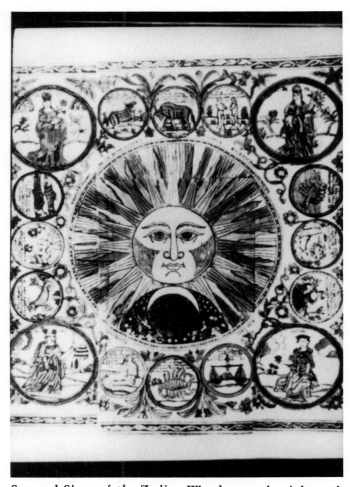

Sun and Signs of the Zodiac. Woodcut, early eighteenth century.

The Usefulness of Smallpox Vaccination. Woodcut, second half of the eighteenth century.

tury woodcut broadsides are extant, so that it is difficult now to gain a complete picture of the thematic variety and tastes of the period. Among those extant, however, are thirty-six woodcut broadsides on biblical and apocalyptic subjects by Vasilii Koren, who adapted Dürer engravings for his purpose. Koren's woodcuts seem crude compared to the copper engravings done by the silversmiths and icon painters of the Oruzheinaia Palata, but they greatly influenced the work of later craftsmen.

The art of engraving on metal did not begin to develop in Russia until engraving on copper had been introduced from Western Europe. In 1647 the Moskovskaia Tipografia published its first copper-plate print based on a drawing by Grigorii Blagoushin, but the plate was engraved in Holland. The first Russian metal engravers worked at the Serebrianaia Palata in Moscow, an establishment connected with the Oruzheinaia Palata, which was then the center of imperial-sponsored arts and crafts. Among the well-known artists working here were Semyon Ushakov, the icon painter; the engraver Afanasii Trumenski; his pupil, Vasilii Andreev; and Leontii Bunin, the director of the establishment, who is best known for his copies of Dutch prints. Thereafter, even the foremost Russian engravers employed themselves in this popular art.

Until the death of Peter the Great in 1725 most lubki were woodcuts, primarily because copper was scarce

but also because metal engravers had been largely employed in Peter's attempts to tout his reforms. Typical of this period is a print depicting a barber cutting off the beard of an Old Believer. The print was evidently printed with the permission of the emperor, who, in an effort to introduce Western manners and costume in Russia, had decreed that chins be shaved, although the church viewed a shaved chin as denoting a heretic.

This was but one of countless broadsides made by the craftsmen of the "Printers' Quarter" in Moscow. Some of the printers living here may have installed simple presses for the printing of broadsides, the plates for which were cut by hand. Ink—a mixture of soot and burnt sienna dissolved in boiled linseed oil—was spread over the block; a sheet of damp paper was laid upon it, and the whole was pressed together. The prints thus obtained were sent out to women to be colored by hand in three or four colors, usually reds, purples, yellows, and greens.

Subject Groups

Over the roughly two-and-a-half centuries of its existence, the lubok accommodated a great variety of subject matter. Omitting the earliest woodcuts of Kiev and Moscow, the popular prints may be divided into several groups, beginning with the group on biblical and

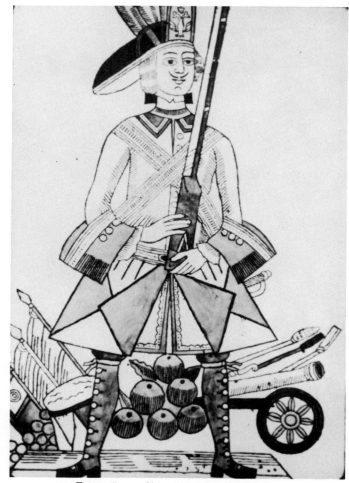

Foot Grenadier. Woodcut, 1760s.

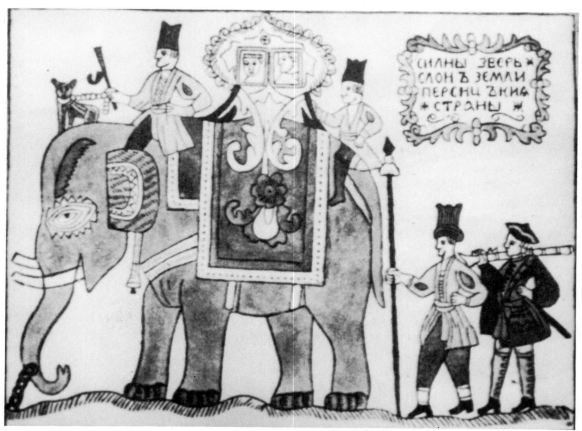

The Elephant from Persia. Woodcut, first half of the eighteenth century.

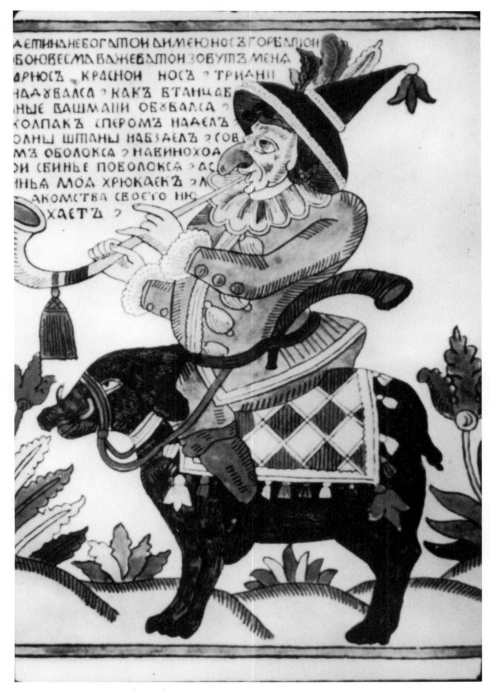

Farnos the Clown Riding a Pig. Woodcut, mid-eighteenth century.

apocalyptic subjects, of which the Koren biblical pictures are the best known.

The broadsides of the Petrine period exhibit a pre-occupation with the Russian emperor and take sides both for and against him. In *Alexander the Great Fight-ing a Battle with King Porus*, Peter's face is recognizable in the heroic Macedonian. The emperor is also represented in a broadside depicting the legendary Russian *bogaty*r Ilia Muromets battling with an ogre, the Nightingale Robber. Ilia is bewigged and wear-

Novgorodian Monasteries. Copper engraving, eighteenth century.

ing contemporary European dress, and the ogre resembles Charles XII of Sweden, whom Peter defeated at Poltava.

A number of broadsides caricaturing the emperor as a cat or crocodile and his wife, Catherine I, as a Witch-Baby were in all likelihood produced by the Old Believers, who bitterly opposed Peter's reforms. In one such lubok, Peter is caricatured as *The Cat of Kazan.* In *The Witch-Baby Going Off to Fight the Crocodile*, the Witch-Baby is wearing Estonian national costume (Catherine I was born in Estonia), and a representation of a small sailboat alludes to Peter's founding of the Russian navy. A series of Witch-Baby prints show the Witch-Baby compelling a bald-headed man to dance to her piping, fighting a bearded crocodile, and riding a bearded ancient.

Rovinski has established beyond all doubt that the lubok entitled *How the Mice Buried the Cat*, so popular that it ran through six reprints in one century, was directed against Peter the Great. The dead cat represents Peter, at whose funeral eight horses and a band had appeared. Some of the mice in the funeral train represent territories that Peter had won from the Swedes. Both the pipe and the cabriolet in the picture had been introduced in Russia by Peter. Possibly the work of Vasilii Koren or one of his pupils, this broadside may have been subsidized by the church, which

in 1700 Peter had deprived of many of its former privileges. Satan himself is given Peter's face in a copper engraving depicting the fall of Antichrist, also produced in this period.

Almanacs and calendars form another group of broadsides sold at the juncture of the seventeenth and eighteenth centuries. A famous example was a large nine-sheet woodcut of the sun and the zodiac that exactly reproduced the ceiling of a room in the Kolomenskoe Palace, an astonishing palace of wood built in 1671 on a high bank of the Moscow River near Moscow and dismantled thirty years later. This first printed secular calendar was immensely popular and was soon reissued as a small copper engraving. Another extremely popular woodcut broadside that ran through several reprints was entitled *Husband Plaiting Bast Shoes While His Wife Spins*, which was later reproduced in wood by Bogorodskoe peasant carvers and in china at the Popov potteries.

After Peter the Great died, official printing establishments temporarily declined in Russia and many professional engravers, out of work, turned to the making of broadsides, a considerable number of which copied prints of Germany and France. An early seventeenth-century French print of Gargantua at dinner, for example, reappeared a century later in Moscow as *The Eat-all and Drink-all.* In the mid-nineteenth century the figure became a drunken artisan; during the Boer War he became a huge Boer devouring British soldiers; in 1904, shortly after the outbreak of the Russo-Japanese War, he became a Russian rifleman devouring Japanese.

A series of lubki depicting mountebanks and clowns based on French and Italian models appeared in the second quarter of the eighteenth century. In *Dancing to Hornpipe*, among the first in this series, the piper resembles the Punch in a Callot Punch-and-Judy engraving, but he is gradually Russianized to become the beak-nosed Farnos in a foolscap, with a beak-nosed wife, Pigasia, and a companion, Gonos (also derived from a Callot engraving). With the passage of time, the fool family increased, adopting other names and costumes. Karp and Laria continued faintly to resemble their Italian originals, but Foma, Paramoshka, Savoska, and Erema were characteristically Russian. On the whole, foreign adaptations did not dominate Russian lubki. There were many adaptations, but various alterations (not always for the better) and the inevitable addition of Russian features made them into

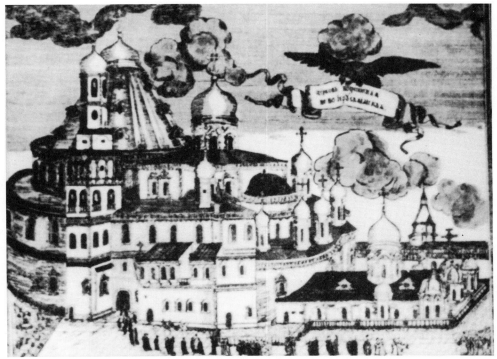

Church of the Resurrection in New Jerusalem. Copper
engraving, first half of the eighteenth century.

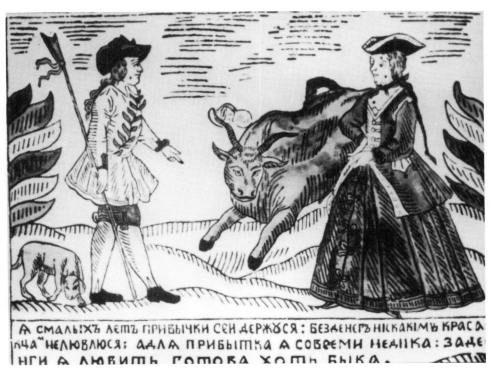

А СМАЛЫХЪ ЛЕТЪ ПРИБЫЧКИ СЕН ДЕРЖУСЯ : БЕЗДЕНЕГЪ НІСКАКІМЪ КРАС А
ПЦА НЕЛЮВЛЮСЯ : АДЛА ПРИБЫТКА А СОВРЕМИ НЕДПКА : ЗАДЕ
НГИ А ЛЮВИТЬ ГОТОВА ХОТЪ БЫКА.

For Money I Will Love a Bull. Woodcut, eighteenth
century.

Hops Are Head Above All Other Fruit. **Copper engraving, second half of the eighteenth century.**

all strata of the Russian population, including the czarist palace. As early as 1635, printed amusing sheets— German imports as well as Russian prints—had been purchased at the Moscow market for the seven-year-old czarevich, Alexei Mikhailovich. In the early eighteenth century, the provincial nobility especially had even used such sheets for the instruction of their children. But the Petrine reforms had accelerated the process of cultural stratification in Russia, and by the mid-eighteenth century the lubok began to lose its aristocratic clientele to professional engravings.

In the eighteenth century the lubok was made primarily for the urban middle classes, and, except for biblical lubki, the overwhelming majority reflected city life. Cheap as it was, only townspeople could afford to pay the price of a lubok, and they alone were literate enough to read the accompanying texts. The engravers were themselves usually of the urban middle-class, while the texts, which abound in spelling and grammatical errors, were mostly written by minor office clerks. Not until the nineteenth century did the lubok become financially accessible to a rural audience and the urban poor.

Lubki were often used in the eighteenth century as advertisements, to serve propaganda purposes, and

Russian pictures in effect, if not precisely in fact.

A series of comic and amusing lubki published in the 1740s include prints of various popular diversions. Pictures of wrestling matches and fistfights, which were usually arranged for Shrovetide and the first day of summer, commanded a ready sale. *The Bear and Nanny Goat,* possibly engraved by a student of Vasilii Koren, depicts an entertainment popular until the early twentieth century.

Lubki also reflected their creators' reactions to those vagaries of fashion among the aristocracy that were quickly imitated by the merchant and urban middle classes. These were concerned with hair styles and fashions in clothing, ribbons, false beauty spots, and so forth, by means of which amorous silent conversations were carried on at soirees and balls. A beauty spot between eyebrows meant a lovers' meeting; on the left cheek, it meant happiness. A light green ribbon meant hope; an orange one, kisses. Details of this sort were recorded in such lubki as *Register of Beauty Spots and What They Mean.*

In its early period the lubok had appealed to

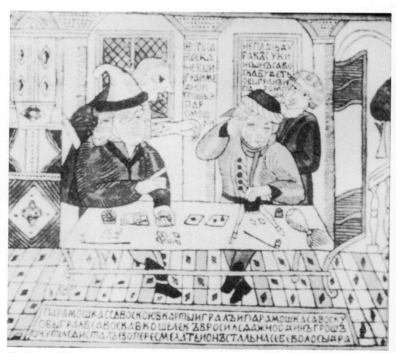

Paramoshka Playing Cards with Savoska. **Woodcut, second half of the eighteenth century.**

to commemorate newsworthy events. An extant lubok-type advertisement announcing the arrival in Moscow of a company of English traveling players is composed like a hagiographic icon, with the text in a central panel framed by twelve scenes from the performance. Such advertisements were pasted on the wall of the Church of the Holy Virgin of Kazan, a sort of news display which the powers-that-were also used in behalf of their own interests. In July 1759, after the Russians defeated King Frederick of Prussia, a copper engraving pasted here depicted the military might of a Russian cossack. In the same week nine woodcuts appeared, one portraying a Russian dragoon and the others brave Russian grenadiers. Catherine the Great is known to have used the lubok to further her smallpox prevention projects.

In the late 1750s, Ilia Akhmetiev's twenty-press printing establishment in Moscow initiated an illustrated supplement to the *Moskovskie vedomosti* ("Moscow News"), a newspaper begun in 1756 and printed by the university printing shop. One of his sheets, dated 11 July 1760, depicted a bizarre monster with the description: "The head, brow, eyes, and eyebrows are those of a man, the ears of a tiger, the whiskers of a cat, the beard of a goat, the mouth of a lion, and a hoop of bone in place of teeth." One lubok dealt with a whale caught in the White Sea on 21 July 1760, another with a comet that appeared on 16 August 1769. When Moscow saw its first elephant from Persia, Akhmetiev commemorated the event with two broadsides—one, a woodcut; the other, printed a few years later, a copper engraving accompanied by an elephant biography and a moral poem.

On the outbreak of war with Turkey in 1768, Moscow printers published lubki depicting celestial omens auguring a Turkish defeat and a religious procession in Constantinople with a mob of fanatics following the tomb of Muhammad. The first lubok to relate the hostilities, issued two years later, commemorated the Russian naval victory at Chesme. Three more lubki depicted the taking of the Turk-held fortresses of Bendery, Zhurzha, and Perekopskaia. The peace treaty of 1774 brought forth a profusion of broadsides—one depicting the Turkish ambassador's arrival in Moscow; another eulogizing the military prowess of Count Rumiantsev, commander in chief of the Russian armies; still another devoted to the anniversary gala held in Moscow on 21 July 1775 to celebrate the final Russian victory with pageants, fireworks, and flowing fountains of wine.

Producers of woodcut prints could not meet the com-

Begone! Woodcut, second half of the eighteenth century.

petition offered by these copper engravings by Akhmetiev. In addition, with the general expansion of the publishing business—a reflection of Russian cultural advancement that was especially rapid toward the end of the eighteenth century—the need for more engravers in metal became permanent. Increasingly fewer printers worked in xylography, and the decline of this trade was reflected in the broadside, which grew steadily more complex and refined. As the applied arts now required more sophisticated study and training than heretofore, a similar demand was eventually put on the metal engraving, by now inevitably to be found in any Russian bourgeois home. The future lithographic lubok of the 1820s would reflect largely middle-class tastes, with satirical political broadsides intended for the *raznochintsy* intellectual—the intellectual from all social classes except the nobility—appearing only in the 1850s.

Meanwhile, popular literature influenced the development of the lubok. In the mid-eighteenth century, one woodcut after another was devoted to the heroes of chivalric romances, stories, legends, and tales introduced into Russia in the late seventeenth and eighteenth centuries. Prince Bova, Peter of the Golden Keys,

and Uruslan Lazarevich—all of foreign origin—were particular favorites and quickly Russianized. Although lubki portraying such native Russian folk heroes as Ilia Muromets, Alyosha Popovich, and Buslai Buslaevich were also published, these did not compete in quantity with the other woodcuts, possibly because the Russian *byliny*—the heroic folk tales of Old Russia—had come down only by word of mouth in the countryside.

In the late 1760s, Akhmetiev and his engraver P. Chuvaev drew extensively from the works of A. P. Sumarokov, a celebrated contemporary poet, playwright, and fabulist, whose blend of the literary language and the vernacular was well suited to lubok clientele. Sumarokov dominated the lubok for sixty years; engravers did not address themselves to the works of Krylov, Nekrasov, Pushkin, and Lermontov until the 1830s. Notable among thirteen prints of literary inspiration, dealing for the most part with unfaithful wives and cuckolded husbands, are *The Fox and the Sour Grapes* and *The Court Clerk and Death*.

The dubious law courts of Old Russia were satirized in a literary-inspired lubok entitled *Ruff, Son of Ruff*, which, though popular for its story, was replaced in the early nineteenth century by the far more acrid *Unfair Trial*, concerning a clever peasant who outwits his rich brother, a greedy priest, and a corrupt judge. Banned by a censor in the 1820s, this copper engraving was composed of twelve scenes, each with an explanatory text, which were separated to form a chapbook. Such editions were essentially popular publications produced for a mass audience. Oldest among them were the extremely popular *Life of Aesop*, which was banned for its "seditious" character in the 1830s, and the *History of Joseph and the Coat of Many Colors*, a chapbook composed entirely of a series of woodcuts.

Chapbooks—collections of tales, parables, calendars, primers, fortune-telling almanacs, and hagiographies—flourished, were exceedingly inexpensive (costing from but three to six kopecks), and were read by thousands, mostly burghers, artisans, small merchants, village clergy, and so forth. The year or place of publication of these editions was never given to allow for further printings whenever necessary, and they were preserved as family heirlooms, with memorable personal events often lovingly recorded on the flyleaf. *Bruce's Calendar,* a wholly engraved edition similar to a chapbook, was especially popular among the poorer country squires.

Despite the fact that the 1760s and 1770s was a time of pronounced social ferment in Russia, Moscow engravers published primarily amorous broadsides from both woodcuts and copper plates in which all the social strata were represented. Some, influenced by French engravings, were obscene, and these sold readily into the nineteenth century. Many broadsides published in Moscow at this time retain the flavor and humor of earlier prints. These include a picture of a strange crowned bird that was supposed to have appeared in Paris at four o'clock in the afternoon on 6 April 1776. Another satirized the dowry register kept by merchant families, calling the bride "as pretty and pink as a monkey." One print reprinted repeatedly was a picture of a magic circle for telling fortunes. Of the many prints devoted to drunkards and taverns, one is composed like a hagiographic icon, with fanlike hops in the center framed by nine scenes illustrating the various miseries that befall the besotted.

During this period, the range of broadside subjects was extremely wide, including peasant scenes and festivals, portraits of historic personages, and views of Russia, many of the latter serving as souvenirs of shrines and other places visited. Engravings of monasteries, biblical broadsides, and broadside icons appeared at roughly the same time and were purchased by devout pilgrims by the thousands.

The first such scenic lubok, cut by Ilia the Monk in 1661, depicts Russia's oldest cloister, the Monastery of the Caves near Kiev, in great detail, with several projections on one plane. The same method is to be found in an engraving of the Holy Trinity–St. Sergius Monastery near Moscow, with the upper section presenting the Holy Virgin, Archangel Gabriel, and the first abbots of the monastery; the lower, the monastery itself. An eighteenth-century copper engraving presents a panoramic view of the Solovetskie Islands in the White Sea, including the Solovetskii Monastery, the cottages along the shore, fishing sloops, frigates, and exotic fish.

Such prints enable modern historians to clarify facts. Panoramic lubok views of Moscow, Yaroslavl, Novgorod, Torzhok, and other cities often depict monuments and buildings no longer in existence. The first picture print of the Moscow Kremlin, which appeared in the 1740s, shows in the foreground an image of the Savior that was mounted in the mid-seventeenth century above the Redeemer Gate tower. The background provides a view of the Kremlin walls from Red Square, with domes, bell towers, and the tent-shaped roofs of ancient palaces visible. A comparison of early and late nineteenth-cen-

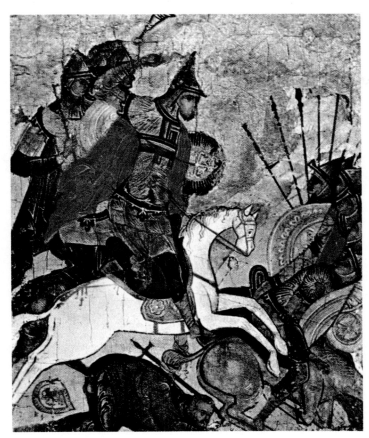

St. Nikita the Warrior, with Scenes from His Life: "The Battle" (border scene). Moscow school, sixteenth century.

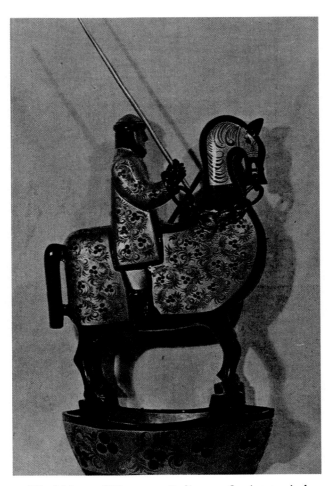

Khokhloma "Horseman" dipper, Soviet period.

Distaff (detail). Northern Dvina, early twentieth century.

Distaff (detail). Northern Dvina, first half of the nineteenth century.

Grandmother's Fairy Tales. Snuffbox miniature, P. and A. Lukutin factory, 1840s–1860s.

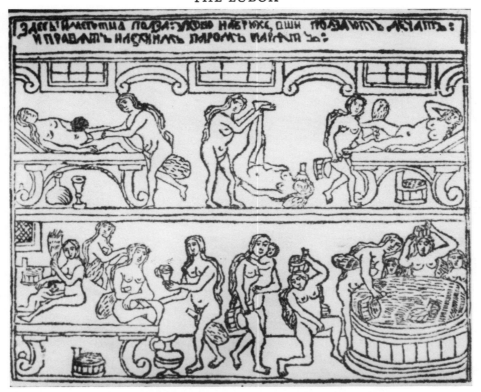

Russian Bathhouse. Woodcut, eighteenth century.

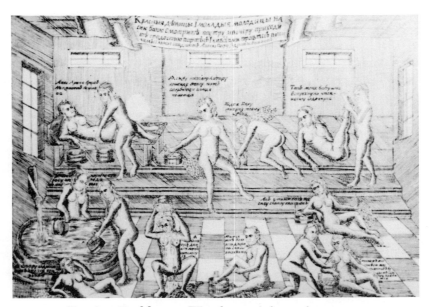

Russian Bathhouse. Woodcut, eighteenth century.

tury prints of the fourteenth-century Peshnoshskii Monastery about forty-five miles north of Moscow reveals the changes in the structures over some eighty years. An early eighteenth-century lubok engraving helped Soviet architects restore the Nazi-destroyed Church of the Resurrection in New Jerusalem which Patriarch Nikon had built in the seventeenth century on the plan of the church in Jerusalem where, according to legend, the body of Jesus was buried.

The prints produced by the Old Believers were in style and character like seventeenth-century illuminated manuscripts. Composition and drawing are austere, and the influence of the Moscow baroque fashionable during the reign of Alexei Mikhailovich is evident. Among the Old Believer broadsides in the collecton of the V. I. Lenin Library in Moscow is one presenting the genealogical tree of all the venerated masterminds of the Schism, with two cloisters—a monastery on the Vyg River and a convent on the Leksa River—depicted below.

Old Believer prints are of special interest because they were made entirely by hand. The original was transferred to a sheet of thick paper by placing the heavily pin-pricked original on top of a clean sheet. Coal dust was pounced on top and the original removed. The contour lines produced by the dust that had sifted through the holes were gone over, the dust blown off, and the result colored by hand. The number of copies was never large, seldom exceeding 150.

Censorship

The broadsides of the nineteenth and early twentieth centuries that were not intended primarily for a peasant clientele lack the merits of eighteenth-century lubki, which, despite the rigid censorship introduced in 1721, reveal, better than official engravings and in greater detail than many written sources, much about the urban life of the period. The nineteenth-century lubok was little more than a poor copy of a professionally executed original, and the still harsher censorship enforced under Nicholas I had the effect of killing off what remained of the folk tradition in drawing and text.

The more popular and widespread the lubok became, the more attention it elicited in various official circles. Censorship concerned itself primarily with religious prints and secondarily with czarist portraiture. As early as 1674, Patriarch Joachim complained in an epistle of the distortion of icon subjects in the lubok. In 1721,

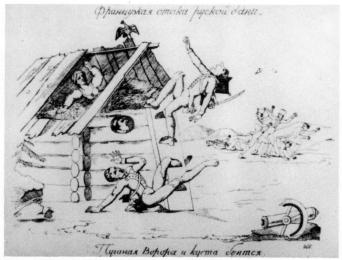

French Attack on a Russian Bathhouse. Woodcut, eighteenth century.

Peter the Great ordered that lubok representations of the czars be supervised. A special *ukas*, or regulation, of the Holy Synod in 1744 provided that all lubki dealing with religious matter would be subject to censorship.

The history of lubok censorship coincides with the history of book censorship in Russia. A law published in 1763 dealing with book printing and the establishment of new printing houses stipulated that printed matter should not contain licentious material or "that which is contrary to civil laws and the law of God." In 1828, the Shishkov Order provided for the compulsory examination of all books, drawings, and sketches. In 1838, official censorship ordered the reexamination of all popular material dealing with fairy tales and portraits of czars and heroes. By means of government censorship introduced in 1850, all lubok plates were reexamined and many were destroyed. Henceforth, the lubok would meet the regulations set for all printed matter. It could not be heretical from the point of view of the Orthodox church, and it could not depict Russian rulers as ugly.

Style

The earliest lubki were woodcuts. A simple picture was drawn on a wooden block, the dark portions were chiseled out, the outline was inked, and an impression was taken. From 1727, copper plates largely replaced wood blocks. The picture was etched in metal, and the depressions were inked. Factories organized in the second half of the eighteenth century for the production of

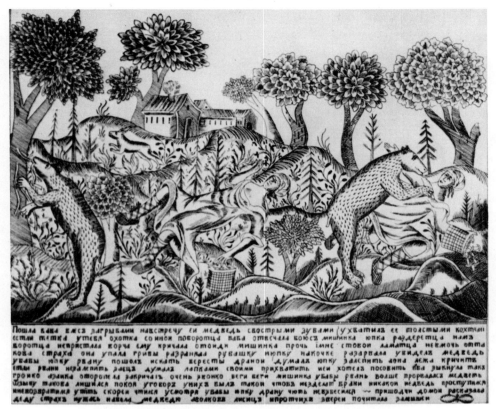

A Bear and a Woman. Woodcut, eighteenth century.

lubki possessed a number of earlier plates. When these were too worn for further use, new plates, either copied precisely or only slightly modified, were made from them, which is why it is often possible to see the style of older originals in certain eighteenth- and nineteenth-century prints. A didactic lubok called *The Seven Deadly Sins,* which duplicated a print made in 1665 by Semyon Ushakov, was still being sold in the nineteenth century.

Lubki rarely have background; perspective and scale are generally absent. The drawing is starkly simple, and the main thought is expressed with total straightforwardness. Rarely printed in black and white, the early lubok often employed four or five colors, the colors being applied by hand or with the help of a stencil in villages to which they were sent for that purpose. The village of Mstera, for example, was a well-known center for the painting of icons and coloring of lubki in the eighteenth century.

Drawing and lettering are often combined in the composition, the latter employed sometimes as background, sometimes as frame. Frequently the subject is presented in separate sequences, as in *The Tale about Shemiaka,* in which the peasant protagonist tears out a horse's tail, falls into a baby's crib, unintentionally kills a sick man, shows the judge a stone, and so on. Often, too, the main feature will be centered and surrounded by various events of the story, as in *Ruff, Son of Ruff,* in which the fish occupy the foreground, with verses and figures arranged about them in smaller forms.

N. Teleshov's *Recollections of a Writer* indicates that lubki were still being sold in marketplaces as late as the end of the last century.

While *ofeni* wander through the crowd with lubok pictures on various subjects—*Fallen Adam, Life after Death in Paradise, Life in Hell, Among Green and Red Devils with Long Pitchforks, Horns on Their Heads, and Tufts at the End of Their Tails*—here also, in a hut of moderately-priced goods, there sits a man with an ascetic face selling bibles, saints' lives, and other books, very inexpensively and well-printed by a society for the distribution of soul-saving reading. But despite the strict days of Lent, this commodity is not in demand. "Who wants the *Seven Deadly Sins?* Who wants the *Future in Another World?*" gaily shouts a strolling *ofenia,* holding at head's level his lubok pictures of green and red devils, which are in demand by

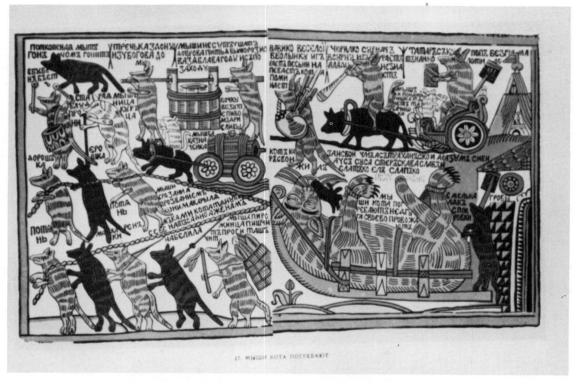

How the Mice Buried the Cat. Woodcut, eighteenth century.

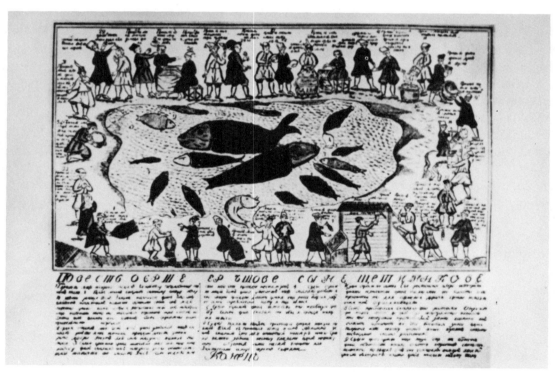

Ruff, Son of Ruff. Copper engraving, end of the eighteenth century.

The Tale about Shemiaka (detail). Copper engraving,
eighteenth century.

the vegetable growers who come to this market, and espe-
cially by their wives.

To all intents and purposes, however, the history of the
Russian popular print may be said to have closed in the
nineteenth century, when it was gradually replaced by
the illustrations in popular journals. Although lubki con-
tinued to be produced in the early twentieth century,
copper engraving was generally preferred over wood-
cuts, and both techniques were replaced by lithography
in most of the later examples.

The Russian lubki of the seventeenth and eighteenth
century are not rare, and they display outstanding tech-
nical or artistic excellence in none of their phases. Never-
theless, they remain of interest for their charm and be-
cause they provide an index to the popular taste of an
earlier Russia.

3
LACQUERS

Exotic lacquered articles of wood or metal coated with an unusual, sometimes tinted resin were first brought to Europe from China by traders in the sixteenth century. But the Asian tree, whose sap provided the basic material for Oriental lacquers, was not available in Europe, so that early attempts by Europeans to reproduce these pieces were largely unsuccessful. Persian lacquers, also introduced in Europe in the sixteenth century and soon mastered, were made of several layers of glued paper that was subsequently coated with a mixture of glue and chalk, then painted and covered with transparent varnish. The colors were mixed with egg tempera, and the painting followed the same methods employed by Byzantine and early Russian icon painters.

Fedoskino

In Russia, the lacquered miniature originated approximately two centuries ago in Fedoskino, a village near Moscow, when the custom of taking snuff came to Russia from Western Europe in the eighteenth century and was immediately adopted by virtually the entire male population. Inspired by a visit to the Stobwasser snuff-box factory in Brunswick, Germany, in 1795 a merchant named Pavel Korobov purchased Danilkovo, which was

part of the village of Fedoskino, and there established the first Russian factory to make lacquered articles of papier-mâché. At first Korobov's serf artisans produced lacquered visors for the Russian army; later they began to make caskets and boxes on foreign patterns and snuff-boxes with engravings of historic scenes or portraits painted on the lids. The painted papier-mâché articles of Fedoskino were extremely popular. Of the 13,000 articles produced in 1804, 9,094 were sold in Russia, the remainder being marketed abroad.

Fedoskino artisans soon introduced technical innovations that tended to improve upon the Brunswick product. In a seventy-day process, Korobov's serfs glued together compressed sheets of cardboard, which were boiled in linseed oil and oven dried to produce a material that was both water-resistant and strong enough to be machined. The object was then polished, given a grounding, and varnished in the same manner as icons. After a design or picture had been painted on the lid, the object was given several coats of lacquer, oven dried again, and polished.

The assortment of products was greatly expanded when Korobov's son-in-law, Pyotr Lukutin, inherited the factory in 1818. Cigarette boxes, matchboxes, boxes for needlework, trays, caskets, and pencil holders with

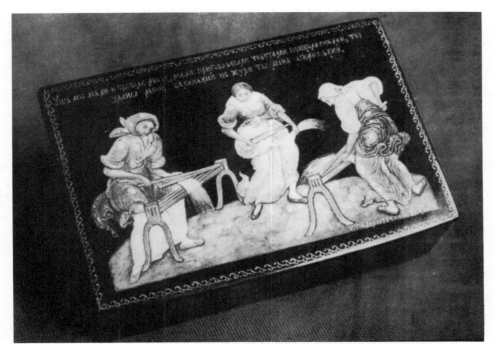

Threshing Flax. Small lacquered box by I. Bakanov, 1924.

Troika and Wolves. Jewelry box by I. Golikov.

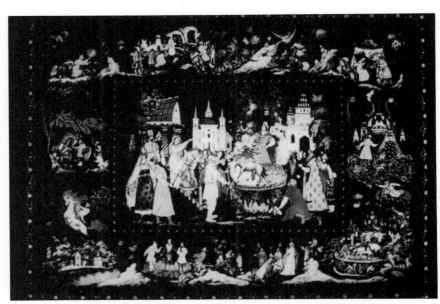

The Humpbacked Horse. Casket by Alexander Borunov. 1955.

painted genre scenes or landscapes on the lids were made for the rich. For the less well-to-do—merchants, minor officials, and townsfolk—there were reproductions of famous paintings or, in later days, copies of pictures from illustrated magazines.

The scenes of a rustic or middle-class character increasingly introduced by peasant craftsmen have great historic and ethnographic value today. These include scenes of haymaking, tavern carousals, card playing, troika rides, market affairs, and various architectural representations, favorites among the latter being views of Red Square, the Moscow Kremlin, and the Church of St. Basil the Blessed in Moscow. Lukutin miniaturists often copied and simplified a well-known painting of a peasant dance scene by Paul Maurice Roussel, a French painter, ceramist, and lithographer (1804–77). A scene on the lid of a small casket depicting two artisans sipping tea from saucers (a Russian custom) shows a typical Tula samovar of the 1870s as well as the characteristic boots, clothing, and hair style of the period.

Some of these pieces were inlaid with mother-of-pearl, others painted to resemble tortoiseshell, birch, or mahogany or embellished with thin strips of silver and gold. Paint was applied in two manners: opaque for vigor, and transparent for muted effects obtained by preserving the visibility of the ground below. Considering that the painter's job was to paint as many boxes as possible, the high quality of these miniatures is remarkable. The ten men—four painters, three turners, two lacquer men, and one polisher—employed by Lukutin in 1821 made 48,000 boxes a year.

Lukutin put out of business most of the small enterprises competing with him. Only the Vishniakov factory managed to survive, staffed for the most part by ex-serf craftsmen of Count Sheremetev, who bought their freedom before 1861 when all Russian serfs were emancipated by Alexander II. Vishniakov and Lukutin produced almost identical objects, but the Vishniakov product was weaker in workmanship. In 1828 Lukutin was granted the right to place the czar's seal (the imperial double-headed eagle in gold) on his boxes and sell them at court, which undoubtedly had the effect of overshadowing what remained of his competition. The last Lukutin snuffbox carried four seals, one for each of the reigning czars of his time.

Contemporaries rated Lukutin's work very highly, and by the 1830s it was known throughout Europe. In 1844 a book entitled *Moscow and Its People* by M. N. Zagoskin related that a friend of the book's hero, wishing to bring an unusual souvenir from Paris, bought a "good paper snuffbox," meanwhile deploring that "we, in Russia, could not do such things." Home again, he examined the box more closely and found on the inner side of the lid the seal of the Russian czar and the Lukutin trademark.

In the same book, Zagoskin wrote: "The snuffboxes manufactured at the Lukutin factory were decidedly superior to the famous Brunswick product in finish, elegance of shape, and particularly the durability of the lacquer itself. These Moscow snuffboxes are sold in large quantities abroad as well." Again: "Some of our artistic workshops can now without shame be compared with the best foreign European ones. . . . I need hardly mention the factory of Lukutin, because relatively it stands higher than all the others. It is far superior to the celebrated Brunswick lacquer." Unfortunately, the boxes bore only the name of the factory owner, not of the painters, most of whom are unknown today.

Until the second half of the nineteenth century, when Russia began to be flooded with cheap factory-made objects, Lukutin's son managed to keep the business intact. By the 1880s, however, he was no longer able to compete financially with mass production. The quality of Lukutin objects began to decline; Lukutin went bankrupt, and in 1904 the factory was closed, some of its artisans finding work elsewhere in the painting of metal trays, which had a market abroad.

At the turn of the twentieth century, Fedoskino (located twenty-two miles from Moscow) was the only center of art lacquers in Europe. In 1910, with the help of the Morozov Fund and the local *zemstvo*, a number of artisans who had worked at the Lukutin factory formed their own guild, and lacquered boxes were revived. In 1910 the Fedoskino guild won a silver medal at an arts and crafts exhibition in Kazan; in 1913 it took a gold medal at a larger exhibition in Kiev.

In the early days, the master craftsmen of Fedoskino served an apprenticeship of a decade or more and were even then confined for the most part to auxiliary work. At the Lukutin factory, the last group of apprentices was taken on in 1898, and no new craftsmen were trained for more than a quarter of a century. Today apprentices come mostly from Fedoskino village; the master craftsmen are in their twenties and are graduates of the Fedoskino School of Art, opened in 1931. The 300 young people employed at Fedoskino shops in 1967 produced 4,000 boxes a month exhibiting 350 different scenes. About 150 of these artisans were painters, the remaining 150

Card Faces. Box by P. Bazhenov.

after each coating. When the last coat has dried, the box goes to the painter. The entire process takes seventy-five days.

Palekh, Mstera, and Kholui

Although the Fedoskino guild was greatly supported during the Soviet period as the most important surviving center of Russian art lacquers, the villages of Palekh, Mstera, and Kholui, also supported by Soviet authorities, were perhaps even more instrumental in reviving this Russian craft.

During World War II, Nazi forces in Leningrad captured Peterhof (Peter the Great's country palace) and destroyed, among other things, its famous "lacquer room," whose walls, inset with black lacquered panels decorated with drawings in silver and gold, had been made —it was assumed—by Chinese craftsmen. Searching through the charred ruins, E. Tikhomirova, a Leningrad scholar, accidentally found in a Nazi pillbox four of the ninety-two lacquered panels that had once adorned the room. When the Soviet government decided after the war to rebuild Peterhof and other destroyed historic monuments, restoration artists wondered whether the lost lacquered panels could be reproduced.

Tikhomirova engaged as a consultant A. V. Kotukhin, an old Palekh-born artist, who, after careful scrutiny, declared that the four recovered panels were painted on limewood boards like icons and made not by Chinese but by Russian craftsmen. Thereafter, historians discovered several documents of great importance, including a letter which Peter the Great had written to an architect named Brownstein, commissioning him to build a room to contain his collection of old Chinese and Japanese porcelain tableware, and the contract which Brownstein had signed with craftsmen Ivan Tikhanov and Ivan Poliakov to do Chinese lacquer work for the palace. The contract was signed on 26 June 1720; the painters and their apprentices signed the final payroll almost two years later to the day. When the decision was made to reproduce these panels, craftsmen from Palekh (300 miles northeast of Moscow) were given the job.

During a visit to the Moscow Arts and Handicrafts Museum in the early twenties, the Palekh icon craftsman Ivan Golikov saw some painted lacquered pieces and wondered whether the painters of Palekh could not make such ware themselves. Several months later, in 1924, the Palekh Cooperative of Ancient Painting was founded and, in 1925, won a gold medal at the World

making the pressed cardboard boxes in 100 different shapes. In 1958, Fedoskino boxes won a gold medal at the Brussels World's Fair.

Fedoskino boxes are made not of hard wood but of ordinary cardboard cut into strips of the desired length, glued together, and wrapped around a form. The form is placed in a press, and the cardboard layers adhere under pressure to form the sides of a box, whose lid and bottom are pressed separately. The parts are dried naturally, then soaked in heated vegetable oil, and dried again in special ovens for several days, during the course of which the temperature is gradually raised to 201° F., which makes the cardboard as hard as wood and even stronger. A joiner and turner glue on the bottom and attach the lid, whence the entire surface is given a black grounding, is polished and lacquered—inside with red, outside with black—and is dried in an oven

Palekh artists use magnifying glasses in their work.

Exhibition of Decorative Art in Paris. In 1930 a school, which subsequently developed into the State Institute of Art, was established in Palekh.

Maxim Gorky, who at the age of fourteen had been apprenticed to the icon-painting shop of the merchant Salabanov, himself from Palekh, had much to do with the Palekh revival. Gorky promoted Palekh art work in any way that he could and was instrumental in raising money to outfit a new workshop, as well as in establishing a library on the history of the visual arts. In appreciation, on 25 September 1932 a deputation from the village presented Gorky with a Palekh cooperative certificate of honorary membership and a large lacquered casket bearing scenes from his short story "Old Woman Izergil," painted by D. Butorin.

Palekh craftsmen cut the desired shape out of cardboard, glue the parts together, press and dry the box for fifteen days, soak it in linseed oil for twenty-four hours, and dry it again. The box is then polished and primed three times and dried for thirty hours after each priming. To obtain the black background, they dilute soot with oil lacquer and coat the box four times. The artists use paint mixed with egg yolk and gold dust dissolved in gum arabic, and they paint with fine squirrel's hair brushes which they make themselves. The basic colors are applied first, then the undertints, after which form, detail, and ornamentation are elaborated. Finally, the gold is polished with the tooth of a dog or wolf, and the box is coated again with lacquer. The final polishing is done with the palm of the hand.

Ivan Golikov, and many of his contemporaries who participated in the Palekh revival, died long ago. The artists of the second generation have retired and been replaced by a third and fourth generation. In addition to lacquered minatures, Palekh artists also do book illustrations, paint stage sets, and decorate the interiors of new boarding schools and palaces of culture. Their black lacquered papier-mâché boxes with filigree miniature painting, however, have become collectors' items.

When the demand for icons fell off after the Revolution, Mstera craftsmen turned from icon painting to the making of painted wooden toys and the painting of oilcloth, kerchiefs, tea caddies, and sugar bowls. Among the icon painters of Mstera to put an end to that were Nikolai Klykov, who would become an instructor at the Stroganov School of Arts, Alexander Briagin, and Alexander Kotiagin, both of whom excelled in restoration work at St. Petersburg museums and the churches of Pskov and Novgorod.

Klykov, Briagin, and Kotiagin had heard of the Fedoskino painters; indeed, Briagin had once owned a Lukutin snuffbox. Their earliest lacquered miniatures were unsuccessful, however. The houses and landscapes had been copied from old miniatures; the human figures had the stiff appearance of saints in lay dress; and an icon-like coat of gold totally obscured the black lacquer. But two art scholars, Professor A. V. Bakushinski and V. M. Vasilenko, came to Mstera to assist the craftsmen, and in 1932 the Proletarian Art Cooperative of Mstera started quantity production of papier-mâché lacquered objects.

The work of Fedoskino is easily distinguished from that of Palekh, Mstera, and Kholui. Fedoskino artists paint three or four layers of oil onto the lid and frequently lay transparent paints on a lining of gold leaf, mother-of-pearl, or a background powdered in gold or silver. Palekh, Mstera, and Kholui artists paint in tempera and make their own colors.

The earliest Lukutin miniatures were copies of famous paintings, and the Fedoskino style remains largely realistic today. Originally icon painters, the craftsmen of Palekh, Mstera, and Kholui learned to paint miniatures from the Fedoskino masters without, however, discarding their own characteristic style. For this reason, the Palekh box often appears older than the Fedoskino box, although it is in fact only one-fourth as old.

The Palekh landscape is conventional, with trees and bushes in the background and the black lacquer serving as sky. Mstera craftsmen favor a realistic depiction of

genre scenes, perhaps because of the influence of the *lubok*, and a lush pattern of natural imagery unknown in either Palekh or Fedoskino—the golden thread of a fabulous herb intricately mingling with and radiating away from the long stalks of exotic, brilliantly colored flowers.

Russian lacquers today combine traditional techniques with both traditional and modern subject matter. Lacquer artists still copy nineteenth-century Russian paintings, but they have also introduced picturesque themes from Russian folklore, fairy tales, and literature, especially Pushkin's narrative poems. These coexist with stereotyped Soviet subjects executed in the style of socialist realism. In 1967, Alexei Kruglikov, a veteran Fedoskino master, remarked to an interviewer from *Soviet Life*:

> I heard tell that one of our artists intended to paint a miniature entitled *Life Kills off the Fairy Tale,* showing sprites, mermaids, and the little hunchbacked horse and Vasilisa the Beautiful fleeing in terror from sputniks and rockets soaring into outer space. I think he has the wrong idea. Our time can't frighten fairy tales. It's a beautiful fairy tale itself.

4
BONECARVING

The art of bonecarving, which peaked in eighteenth-century Russia and declined during the second half of the nineteenth century, had existed, mostly in the North, from time immemorial. A bone dagger with a handle made in the shape of an elk's head was found in Karelia; a bone box, in old Novgorod. Archaeological excavations have revealed that bonecarving was well under way in Russia before the Mongol invasion in the thirteenth century. Excavations at a Bronze Age settlement in Kazakhstan have revealed that the prehistoric residents used ice skates made from the bones of large domestic animals.

Carving materials included walrus and mammoth tusks, deer horn, and the bones of various domestic and wild animals. The *Hypatian Chronicle* mentions as early as 1160 that princes exchanged gifts made from "fish teeth"—i.e., walrus tusks. The oldest objects, however, were mainly intended for household use; prominent among these from the tenth to the thirteenth century were bone combs of various shapes, often exhibiting geometric ornamentation. Two such combs by unknown craftsmen were found during the 1928 excavation of Sarsk Settlement and the 1945–48 excavation of the

Pskov Kremlin, both combs well proportioned and expressive of a genuine feeling for the art.

Bonecarving in Novgorod from the eleventh to the fourteenth century encompassed a great variety of subjects and motifs and frequently revealed a close relation with other Russian art forms. Among the early bone objects having much in common with woodcarving are two miniature sculptures: one from the eleventh century representing the head of an eagle; another, from the twelfth century, in the shape of an owl's head. From time to time a jobber would come to collect some such finished article, which he would sell elsewhere at a profit of about a thousand percent to rich foreign merchants. At one time, Russian bonework ranked in the West on a par with Oriental silks and gems. The twelfth-century Byzantine writer Johann Tzetzes composed odes to the carved bone of the Slavs—or "Russian ivory," as Europeans called it, for in twelfth-century Europe bone-carving was considered to be a uniquely Russian art.

The ornamentation used in Russian church books from the twelfth to the fifteenth century was also to be seen in early Russian bonecarving; which came first remains conjectural. In Novgorod, a thirteenth-century spoon was found with a wattled design such as was common

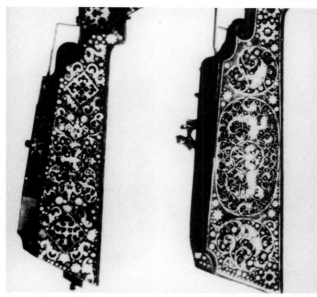

Harquebus buttstocks, seventeenth century.

in the decoration of contemporary church books. But the same design had been used earlier on the handle of a wooden cup carved in the shape of a dragon, suggesting that the design had originated in wood and bone and was only later borrowed by the illuminators of ancient church books.

Rus was overrun by Mongol Tatars during the first half of the thirteenth century, and the Mongol Yoke continued for 250 years. Beyond dense forests and impassable swamps, however, inhabitants of the distant North retained their freedom and preserved their own customs. In the fifteenth and sixteenth centuries, fugitives who had fled the harsh bondage of the Russian nobles of the period settled the free territories along the Northern Dvina and the White Sea coast. Novgorod trappers and hunters seeking fur and walrus tusk passed on to them the bonecarving skills of the craftsmen of their own towns, and the local people passed the long polar nights carving by the light of primitive oil wicks or wooden torches. This craft they handed down from generation to generation.

Bonecarving was also an ancient Yakutian craft passed down from father to son. Mammoth tusks from all over Siberia were sold in abundance at fairs in the remote Siberian town of Tobolsk, once among the empire's biggest economic, administrative, and cultural centers. Generations of the Khanty and Mansi tribes of northern Siberia had carved miniature sculptures of animals—it

being traditional before a hunt to utter incantations for luck before the carved image of a bear, deer, or walrus —and the Russians settled in these areas learned sculptural carving from them. Carved miniatures of hunters in national costumes and of animals sold briskly at fairs in Ekaterinburg, Kazan, Kursk, and Nizhni Novgorod.

In the seventeenth century a brisk trade in walrus tusks developed in the North Sea areas of Mezen, Vaigach, and Novaia Zemlia and from the mouth of the River Kolyma in Siberia. The tusks were sold in Moscow and also exported to the Near East and Central Asia. So profitable was this trade that in 1649, by *ukas* of Czar Alexei Mikhailovich, it was turned into a state monopoly. The art of the bonecarvers of Kholmogory village in the North became famous in 1650 when Alexei Mikhailovich commanded that its master carvers be brought to Moscow to work in the Oruzheinaia Palata, then the center of Russian decorative and applied art. Walrus tusks from the White Sea were the chief material employed, and the craftwork of the Kholmogory artists not only won the admiration of European travelers but was often presented by embassies of the czar as gifts to neighboring rulers.

Fifteenth–Seventeenth Centuries

Bonecarving continued to develop during the fifteenth and sixteenth centuries, but from the fifteenth century the bone objects of everyday life began to be replaced by religious pieces and articles in demand by the rich. In the sixteenth century especially, one finds bonecarved icons, crosses, and imperial scepters, and bone is used with mother-of-pearl in the decoration of arms.

The bonework icons of the period were characteristically executed in low relief, were distinguished by clarity of composition, and were often placed in silver frames and decorated with precious stones. Such is the example of a small fifteenth-century icon of the Virgin now in the Zagorsk historical art museum. Another fifteenth-century icon in the same museum, closely resembling the former in technique, is an octagonal piece depicting the Archangel Michael on one side and the Virgin on the other.

Among the outstanding monuments of fifteenth- and sixteenth-century bonework icons is one depicting the life of Metropolitan Peter. Russian art experts believe the latter to have been worked on at different times: the first part in the fifteenth century, the second part in the first half of the sixteenth century, the last part in the sev-

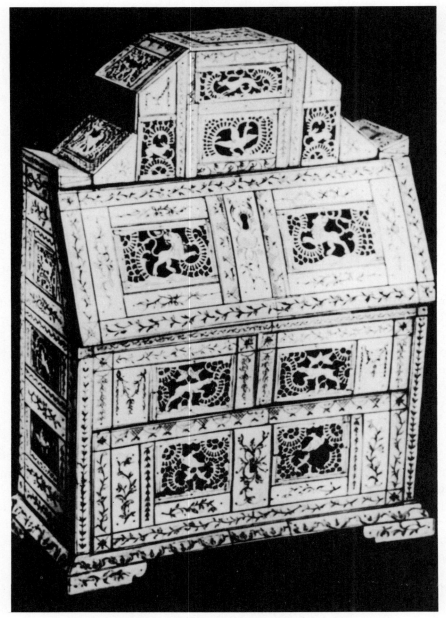

Bureau, second half of the eighteenth century.

enteenth century. This bonework icon of Peter's life is interesting because there is in Moscow's Cathedral of the Dormition a wooden icon of the school of Dionysus (1462–83) which it greatly resembles.

The most remarkable secular achievement in the bone-carving art of this period is the imperial crosier made by an unknown Novgorodian craftsman in the fifteenth century, consisting of a long metallic rod bearing eleven tubes covered with relief carving and openwork. The real and mythical birds which make up the main motif

are woven into the wattled ornamentation. Along with the ox, bull, horse, eagle, and other animals and birds, one encounters the unicorn and centaur of myth, all skill-fully executed. This outstanding example of Russian bonework displays a combination of Novgorodian and Vladimir-Suzdalian ornamentation such as had previ-ously been used in the decoration of church books.

The master bonecarvers of Kholmogory who had been brought to the Oruzheinaia Palata by Alexei Mikhail-ovich devoted themselves to the production of highly

ornamented art objects for the czar and the nobility. In addition to the Russians connected with the Oruzheinaia Palata at this time, however, there were also employed Byelorussians, Poles, and even some Hamburg Germans. Although too few bonework articles have survived from this period to give anything like a complete contemporary picture of the art, archival material suggests that bonecarving was highly developed in seventeenth-century Russia.

Preserved in the Oruzheinaia Palata are weapons decorated with bonecarving and mother-of-pearl. Very complex compositions are to be found on the buttstocks of harquebuses, one of which exhibits a fairy tale scene in carved bone. Ornamental decorations include heraldic motifs, especially the double-headed eagle of the Moscow coat of arms. At the same time, ornamental bonework was rich in such folk motifs as the stylized diamond, the eight-pointed star, and the floral designs widely used by the common folk in their textile arts.

Contemporary craftsmen knew how to combine such disparate elements with proportion, taste, and style. Indeed, artisans decorating weapons in the second half of the seventeenth century succeeded in creating a "Moscow style" that corresponded in many ways to the richness of contemporary Russian clothing. By no means ignorant of history, artisans working in the Oruzheinaia Palata knew of such bonework masterpieces as the carved throne brought to Rus from Byzantium on the marriage of Ivan III to Sofia Paleologue. In short, the art of bonecarving preserved its centuries-old traditions into the seventeenth century and thus set the stage for the eighteenth century, when the art would flourish in Russia.

In the eighteenth century Russian bonecarving followed a complicated route of development. It took on a mostly secular character and was much in demand by the aristocracy, whose tastes had changed under the influence of Peter the Great. From the seventeenth and eighteenth centuries there survive a number of bonework chests made of carved plates joined by metal. Designs are composed of interwoven branches, birds, and architectural motifs, all united in the single work and all strongly connected aesthetically with the seventeenth century. Chests are heavy and massive in shape, their

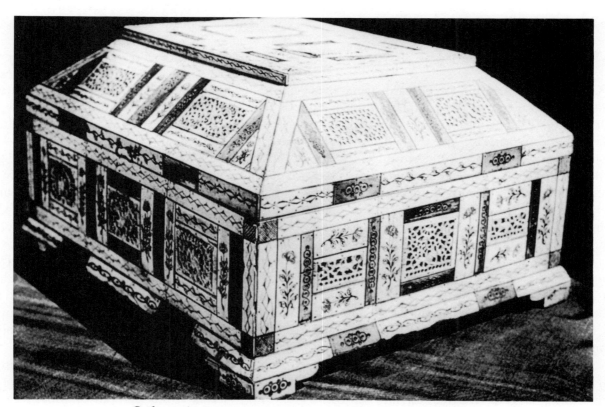

Casket of tinted carved bone. Kholmogory, mid-eighteenth century.

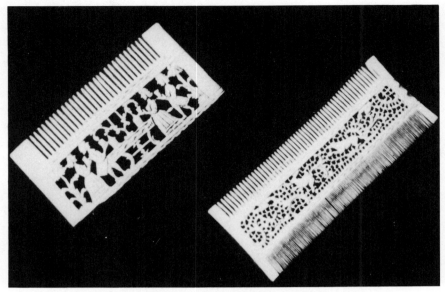

Carved bone combs, eighteenth century.

ornamentation almost carpetlike. The carvings on some chests suggest the influence of renaissance and baroque elements. These are now believed to have been produced at the Oruzheinaia Palata at the juncture of the seventeenth and eighteenth centuries.

The Eighteenth Century: Kholmogory Work

The Oruzheinaia Palata lost its primary significance when Peter the Great moved the capital from Moscow to St. Petersburg. The main suppliers of bonework became the city of Archangelsk and the villages of the Kholmogory region—Rovdin, Ukhtostrov, Kurostrov, and Verkhnie-Matigory—where bonecarving was practiced until the nineteenth century. Most of the bone objects surviving from the eighteenth century were produced by the Archangelsk masters, but since the Kholmogory carvers had been famous since the previous century, all the northern bonecarving was commonly referred to as Kholmogory work. Bonecarving was also done in Novgorod, Vologda, Velikii-Ustiug, and Solvychegodsk, where the art had been highly developed during the fifteenth and seventeenth centuries but would lose its significance during the first half of the eighteenth century.

The great Russian scientist Mikhail Lomonosov was from the North. He had received his first schooling from the master carver Ivan Shubin, one of whose sons —the sculptor Fedot Shubin—later carved Lomonosov's

portrait in bone. Another son, Ia. Shubin, also an outstanding Kholmogory carver, left a "genealogical" carving bearing 61 portrait medallions in low relief, starting with the grand princes of Rus and ending in 1774 with Catherine the Great. Lomonosov's brother-in-law, the master carver Evsei Golovin, was the first to attempt to establish a professional school for the training of carvers. Exquisite objects carved by other Lomonosov relatives, including another brother-in-law and his son, are to be seen in Soviet museums today. Lomonosov is himself credited with the carving of a chess set now in a historical museum.

During the second quarter of the eighteenth century, Russian bonework became increasingly diversified, richer in design, lighter, and less clumsily monumental. The Kholmogory artists began to decorate wooden objects with carved bonework plates. Color engraving was widely practiced, and different techniques were often combined. Bone was dyed malachite green and various shades of brown; engraving was touched with black and brown and shades of green and red. From the second quarter of the century, the combination of warm browns and cool greens gave the Kholmogory object its special decorative quality.

The abundance of walrus tusk and mammoth bone, the persistence of local tradition, and the opportunity to study Western art objects—all contributed to the development of superior bonecarving in Kholmogory. Kholmogory artisans were well acquainted with examples

of German, French, and Dutch work because they had dealings with Archangelsk, through which trade was conducted with the West. Peter the Great, who was personally interested in bonecarving, had examples of foreign work sent to Kholmogory. Bonework was one of his hobbies. He quite frequently carved in bone while discussing matters of state and always called on the craftsmen of Kholmogory whenever he went to Archangelsk.

On occasion, the Kholmogory artisans would employ biblical and allegorical subjects on objects in which bone plates were glued to a wooden base. These subjects are of interest to art historians because they are believed to have been influenced by the Piscator Bible, published in Russia in 1650 and 1674, and by *Symbols and Emblems*, an illustrated book which served folk craftsmen as a source of ornamental motifs (published by Peter the Great in Amsterdam in 1705; republished in Russia in 1778 and 1809). For many years bonecarvers borrowed subjects from these works, as well as from the church books used by icon painters. Simple plates were carved on such subjects as *Adam and Eve, The Judgment of Solomon,* and *The Miracle of St. Paul,* but

the Kholmogory craftsmen failed to produce anything outstanding in this line.

In the decoration of utilitarian objects, subject matter was drawn from secular life—wine or tea drinking in a pleasant summerhouse, a promenade, scenes of the hunt and other amusements, various birds and animals, or such images as an eagle perched on a firing cannon, a dog chasing a hare, and burning hearts transfixed by an arrow. These generally appeared without perspective on small inlaid plates.

During the first half of the eighteenth century, circle motifs were popular—large and small circles in groups of two, four, or five. The numerous coffers and boxes of eighteenth-century bonework often exhibit geometrical and floral designs engraved on plates having either a plain or colored base. Carved plates bearing very simple imagery, often a floral motif, were inlaid. A wooden object covered with bonework might take dozens, or, in the case of very large objects, even hundreds of plates, some carved, others engraved. The color of the bone would have to be taken into account in the engraving, and the finishing of plates was strictly ordered, step by step, in accordance with the general design.

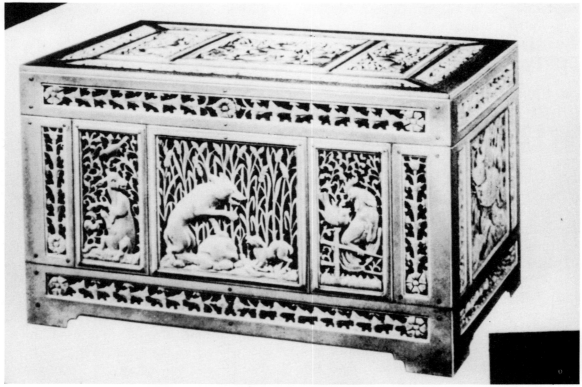

Casket, mid-eighteenth century.

Openwork was characteristic of Russian carving from remote antiquity. Outstanding examples of the technique are to be found in the work of Novgorod and Moscow from the thirteenth to the fifteenth century, but it was not until the mid-eighteenth century that it became predominant. During the second half of the century, when unity of style came to characterize bonework, Kholmogory carvers seldom employed the circle motif but turned instead to openwork and untinted bone. The openwork was as delicate as lace—in the North, in fact, it was referred to as lace until the nineteenth century—and the thin, finely carved plates were used as inlays, sometimes against a background of red foil. Mother-of-pearl became popular during the second half of the century, when it was frequently inlaid among the bonework plates. Especially in the making of goblets and tankards, openwork carving was often used with tortoiseshell, which was placed under the lacework.

In the second half of the eighteenth century, bonework plates were often glued onto such furniture pieces as a highboy bureau, a work typical of Kholmogory, whose carvers were particularly skilled in the technique. Its form is not unusual, such bureaus being common at the time. The circle motif of the first half of the century is absent here. A lace motif is combined with a foliated design; the number of birds and animals is fewer; and they are not enclosed in medallions but are silhouetted against an openwork background. Some plates are garlanded, others exhibit casually flung branches; but all the decorations are distinguished by their motion, grace, and form.

Kholmogory craftsmen also did high-quality work in relief miniatures and engraved portraiture. Portraits were done on special bone plates or on the surface of such everyday objects as cups and vases, which reached a high degree of proficiency at this time. Most of the artists remain unknown, although from the second half of the century there are a number of works by Osip Dudin. N. Vereshchagin, who worked at the juncture of the eighteenth and nineteenth centuries, was another outstanding craftsman. A Vereshchagin vase bearing an allegorical treatment of the seasons is preserved at the Hermitage.

The second half of the eighteenth century also saw the development of groups of carved figurines, such as the *Camp of Northern People*, consisting of approximately forty carved figures. Kholmogory artists produced carvings on historical themes as well. *Peter the Great's Battle with the Swedes,* a small multifigure sculp-

ture made in the eighteenth century, has a certain naïve charm because of the artist's unfamiliarity with the subject and the artificial position of the figures.

Toward the end of the century the character of the work with glued-on plates underwent a change. Design became increasingly subdued, and tinting was minimized. Among the new decorative elements were flower receptacles in the shape of ancient craters and amphoras. Reflecting changes in architectural design, finely netted geometric background patterns appeared in lozenge, hexagonal, and oval forms. A typical end-of-century plate, which suggests the direction in which bonework was developing at the time, is a toilet chest with mirror stand. Composition is stricter, the emphasis is on symmetry, and plant ornamentation is replaced by geometrical design on the mirror stand and sloping cover of the highboy. Color plates are used but with modest decoration; they are to be viewed not as decorations themselves but rather as decorative frames for the inlays.

The inventory of the czarist treasury for the second half of the eighteenth century includes among its bone objects combs, goblets, tankards, hunting horns, powder horns, and chessmen. The State Historical Museum has preserved the handle of a sixteenth or seventeenth-century crosier representing a crouching dragon with open jaws. Bone icons, crosses, and other religious objects remained on a high level throughout the century. Colored bone and color engravings were introduced in golds, red, and dark browns which agreed beautifully with the general harmony of the icon.

Nineteenth Century

In 1868 the Archangelsk *Provincial News* published a brief note on the past of the bonecarving industry, commenting that the craft was by now virtually extinct. Articles of exquisite elegance were still being produced, but in insignificant quantity, because peasants considered bonework difficult to market. By the close of the nineteenth century, the fashion for carved bonework had died out. General Bibikov's voluminous report for 1912, "Archangelsk Province, Its Riches and Needs," noted: "The village of Lomonosovo once possessed a developed carving handicraft, which has waned, though, due to the absence of a demand." By World War I, the craft was in complete oblivion.

The bonecarving industry of Tobolsk experienced a similar decline. Of his visit to the Nizhni Novgorod fair

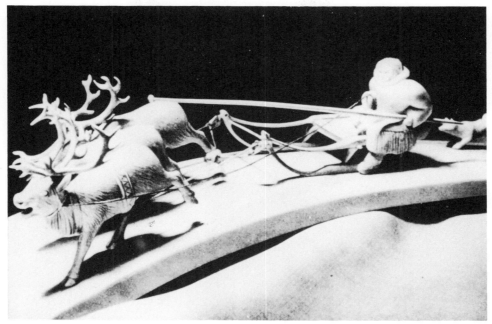

Deer team. Tobolsk bonework.

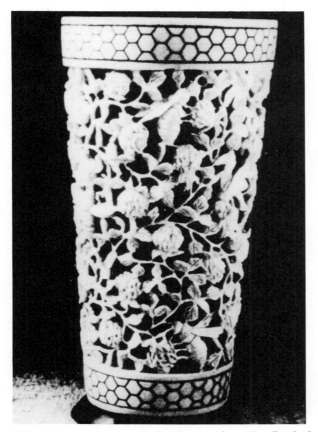

Carved picture frame of walrus tusk, by U. Sharypina-Tryapitsina. Kholmogory, 1947.

Pencil holder of carved beefbone, by K. Dmitriev. Khotkovo, postwar craftsmanship.

in 1896, Maxim Gorky wrote in the *Odessa News*: "The handiwork of Russian master carvers is to be seen in the show windows of Melgunova's workshop in Tobolsk. There are some nice things there, but the price is prohibitive." Eager to stimulate the dying handicraft, scholars on the staff of the Tobolsk Provincial Museum importuned the ministry of agriculture to allocate a small sum for cash prizes to be awarded to craftsmen for the best handiwork. But czarist officials refused the request on the grounds that the industry had no serious future.

Khotkovo

Khotkovo is a small town some forty miles north of Moscow near Zagorsk, whose inhabitants, like those of the neighboring villages, have engaged in woodcarving for countless generations. At the end of 1946, the Council of Ministers of the Russian Federation resolved to establish a new bonecarving center here as part of an effort at postwar recovery. Carvers working in boxwood were chosen as the principals, and as mammoth and walrus tusks were very expensive, it was suggested that ordinary beefbone be used, the material to be supplied by the nearest meat-packing plant. Khotkovo was proposed because it was near Zagorsk, where the carvers lived, because it had a vocational school for woodcarving which could be enlarged to train bonecarvers, and because it was near Moscow, where it could obtain the beefbone and sell its products.

A two-story brick building was given to house the new craft and endowed with an ordinary range of dental drilling machines. It was thought that these machines could be used to work beefbone as well as to drill teeth and that they would make the painstaking work of carving simpler and quicker. The earliest articles produced here included bone buttons shaped as snowflakes and baby spruces, and earrings and brooches with branches, berries, and flowers in relief.

Beefbone, at best, yielded a plate roughly one-quarter of an inch thick, which gave very little scope for initiative. One carver spent months producing wafer-thin plates and throwing away the knuckle as waste, until one day the knuckle suddenly reminded him of a tree stump. Finding a suggestive subject in Krylov's fables,

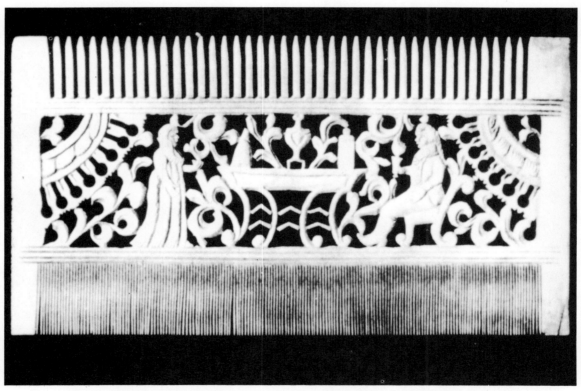

Bone comb. Kholmogory, second half of the eighteenth century.

Casket of carved bone, by A. Gureev. Kholmogory, twentieth century.

he added a young spruce over the stump and placed a crow in the tree and a fox at the foot of the stump. The fox was an inch-and-a-quarter long and the crow still smaller—making this the first dimensional work in common beefbone. Another craftsman, a skilled worker in hardwoods, had the idea of combining bone and wood. His experiments led to a wooden casket with an openwork bone plate inset on the lid. Other innovations included a papier-mâché box inset with carved bone silhouettes of girl skaters.

For a long time the openwork plate remained flat and devoid of dimensional effect. Ultimately, however, it was seen that the effect of receding space could be achieved by using several plates at once. This suggested the "Michurin" casket, in which the top plate served to frame the scene, the middle plate was used to depict the scene, and the back plate was employed to give a background of fruit-laden trees. The plates were glued together, the resulting inset producing a scene with perspective and depth.

Meanwhile, the amount of available mammoth and walrus tusk was diminishing, and beefbone was not suit-able for every object. The news of more beefbone carving centers in the Far Eastern Maritime Territory, Buryat-Mongolia, and the Altai stimulated Khotkovo craftsmen to experiment with miniature sculptures in hardwoods. Soon the factory had produced dozens of carved miniatures of animals as well as an extensive assortment of tea caddies, powder compacts, sugar bowls, and small boxes in polished hardwood.

Hornware

Soviet handicraft shops and various Soviet exhibitions of applied art often display stylized miniatures of birds and animals made of a silvery brown or pitch-black material. In execution, these pieces resemble Siberian bonecarvings, but they possess characteristic traits of their own which derive from the unique features of the medium. This is sculptured hornware. In the second half of the eighteenth century, Russian folk craftsmen had been partial to horn, but changes in fashion had consigned the medium to oblivion for two centuries. Today Soviet hornware is produced at the arts and handicrafts

shop of the Mikoyan meat-packing plant in Moscow.

In 1952 the manager of one of the plant's subsidiaries had the idea of transforming ordinary horn into decorative objects by scrubbing out the inside, polishing the horn, and, if the subject required it, attaching additional ornaments, themselves carved from horn plates. To this end, he ordered all the horn from the plant to be collected and stored away. Two sausage makers with a gift for drawing were transferred to the shop that produced consumer commodities, and, in spite of the difficulty of the viscous, yielding medium, the number of carvers grew steadily. These include former lathe operators, electricians, secondary-school dropouts, and graduates of vocational and trade schools, most of whom had been attracted to drawing or carving from childhood, but none of whom had had any special art training. Here they were trained by a number of self-taught carvers and two graduates of the Moscow Institute of Industrial Arts.

The horn goes from the slaughterhouse directly to the art workshop, where it is cleaned and graded. After studying its form and unevenly distributed coloring—ranging from a silvery white to a thick brownish black—the artist cuts off pieces of the needed size with an ordinary circular saw. The tools on his bench are an ordinary dental drilling machine run by a small electric motor, and a small wooden block on which the drill bits are mounted in holes. In front of his seat is a suction ventilation hood to draw away the microscopic particles of horn dust.

Because the medium requires special treatment, the carving is difficult. As soon as the chisel follows the grain, the horn laminates. If the almost-ready but unpolished piece is not properly greased, it cracks and peels. The carving completed, the article is polished by a special machine tool, and the piece is then either accepted or rejected by a quality inspector.

This is the state of handicraft bonecarving in Russia today. Kholmogory artists continue to make graceful toilet articles, mirror frames, and goblets with delicate filigree work, usually involving images of northern animals—the marten, sable, reindeer, and squirrel. The figurines and household articles carved by the folk artisans of ancient Yakutia from the tusks of prehistoric mammoths found in the region are still greatly prized by collectors.

Although the carvers of Khotkovo and the Mikoyan meat-packing plant work in new mediums and use new methods based on a mechanization not common to the older carving arts, the old and new continue to learn from one another. Victor Kuznetsov, a master carver in horn, studied for four years at the carving school in Kholmogory before coming to Moscow to try something new. Kholmogory carvers have inspected the machinery at Khotkovo with interest, and Khotkovo carvers continue to find ornamental motifs in books and museums, from nature, and from Kholmogory craftsmen as well.

5
WOODCARVING

Of all the folk arts of Russia, woodcarving easily occupies the first place in importance. In Old Russia there was scarcely a village to be found that did not offer some striking example of this peasant craft—perhaps a fancifully carved wagon or a richly ornamented sledge, its shafts, yoke, and backboard covered with fine carving; perhaps the lacelike tracery of the cornice of an *izba* roof or some clever scrollwork on the lintel of a window. In some cases the entire pediment of a house would be ornamented with carving. A broad carved frieze would conceal the joint between the pediment and the log wall of the house, and this frieze would often be the most elaborately carved component, its sides adorned with symmetrical mermaids and water sprites with tridents. Carved lions or fabulous monsters would be found on the *nalichniki* (carved window and door frames), and gates would be ornamented with nature motifs.

Within the home there would be carved wooden plates and bowls, cups, spoons, ladles, and gingerbread molds of many different shapes, as well as a variety of carved frames, candlesticks, saltcellars, trinket boxes, and musical instruments. There were carved pails, carved spindles and distaffs in abundance, and carved laundry beetles—short-handled wooden bats—which, like the mangles of Scandinavia, display a compendium of national folk art motifs. These wooden objects for everyday use were fashioned by the same carpenters who built houses, bridges, and boats. The same woods—pine, spruce, birch, maple, and oak—were used for all kinds of construction, as were the same tools: ax, knife, adze, chisel, awl, saw, and lathe. Archaeological excavation has been the main source of information about ancient Russian woodcarving, supplemented by information extracted from the chronicles, legends, *byliny*, various iconographical materials, and contemporary accounts.

Household Objects and Furniture

Novgorod especially is known for its domestic wooden objects dating from the tenth to the thirteenth century. Huge wooden pillars decorated from top to bottom with carpetlike carving supported the central beam of the larger log houses of Novgorod and were placed directly in the center of the room. Examination of bark scrolls which archaeologists discovered in Novgorod and estimated to be some seven or eight hundred years old indicate that these were the remains of eleventh–twelfth

Liudogoshchskii Cross, 1359.

were sometimes ornamented with wooden sculpture depicting a human hand. Whether this motif was Christian or pagan is difficult to determine, but it persisted in Russia until the twentieth century.

From the boxwood tree Novgorodian craftsmen made finely contoured combs ornamented with circular or hatched designs. A miniature lion is carved on one such comb, and lions are also to be found on distaffs and gingerbread molds. (Russian folk craftsmen have handed the image of the lion down through the ages. The lion is found on twelfth-century copper buckles from Novgorod, on the Cathedral of St. Dmitrii in Vladimir, on carved fifteenth-century wooden icons, on eighteenth-century *izby,* and even on the handle of a nineteenth-century jackplane.

In ancient times, the head of a sacrificed bird or animal was hung on the roof to protect a house from evil spirits; even in mid-fourteenth-century Novgorod it was customary to place the head of a sacrificed animal at the foundation of a house. But sacrificial heads were eventually replaced by carved ones, their symbolic meaning gradually yielding to a purely decorative function, and this is the origin of the traditional horse or rooster heads that once decorated Russian rooftops. The carved mermaid often found on peasant homes was

century "wallpapers". Ancient Novgorodians covered the walls of their dwellings with strips of birchbark having either brightly painted or openwork ornamentation.

The remains of massive chairs, stools, and benches discovered by archaeologists also display a carved interlace design. Wide chairs with semirounded backs were found in merchant and boyar homes; less prosperous homes used chairs called *duplianki,* made from a single block of wood. Trestles supported the boards that served as a table; and although it is known that Prince Igor had a bed made of yew in the twelfth century, people generally slept on *polaty*—planking fixed between ceiling and stove. Beds as we know them were not popular in Russia until the 1670s.

In Old Novgorod, children played with toys made from tree roots lightly carved to suggest an animal likeness. Wooden spoons, carved goblets, cups, and wine dippers made from maple or elm were used even at princely feasts. The weaver's shuttle, distaffs, the staves of tubs and barrels were all carved. Spindles and, in some cases, furniture bore narrative carving. Distaffs

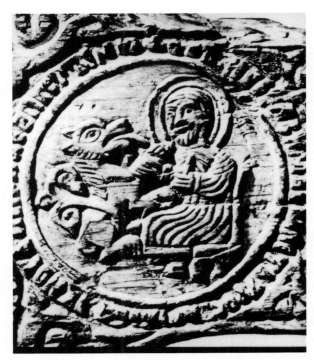

Gerasim with Lion (detail of the Liudogoshchskii Cross).

Dmitrii Solanskii. End of the fourteenth century.

King David with Dulcimer. Painted wood, Smolensk, early eighteenth century.

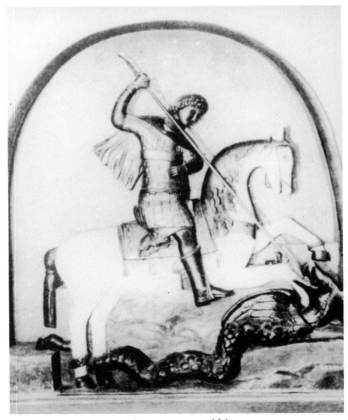

St. George, 1464.

probably an extension of the ancient custom of decorating sailing ships with woodcarving.

Also until the fourteenth century, Novgorodian Slavs used sacrificial dippers shaped as animals. Although these sacrificial objects are among the oldest wooden pieces, birds and beasts are generally not found as decorative ornament on medieval Russian carving. The bird-boat shaped ladles, which were later widespread throughout Russia, had originated many centuries earlier in the North, where wooden boats resembling birds were built and waterways were thickly populated with fowl.

During the Novgorodian period, decoration was primarily a matter of carving, and very little was done with paint. The oldest designs, dating from the seventh through the ninth century, employed either fine gravurelike incising, heavy deep-grooved lines, or simple notches and depressions. The tenth–twelfth century woodcarver was less concerned with details than with the general shape of an object.

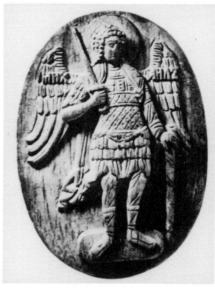

Oak carving of Archangel Michael, second half of the fifteenth century.

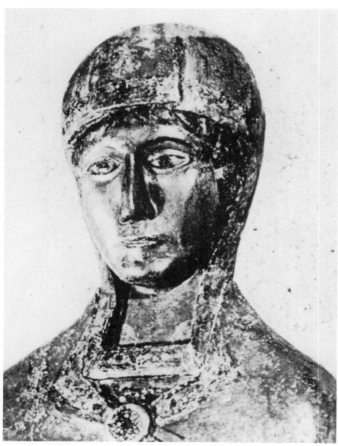

St. Paraskeva (detail). Mid-sixteenth century.

During the fifteenth and sixteenth centuries, the production of woodenware became a definite occupation and was among the best organized professions of Old Rus. Wooden goblets, cups, and spoons were made in Kaluga, Moscow, Tver, Novgorod, and Vladimir, and large shops producing wooden kitchen utensils existed at the Holy Trinity–St. Sergius Monastery, the Monastery of St. Cyril on the White Lake, and the Spaso-Prilutsk Monastery, as well as in many cities, *posady,* and villages. But it was not until the seventeenth century that Russian decorative woodcarving took its characteristic form, and seventeenth-century designs were preserved through the nineteenth century.

Most of the numerous references in Russian art history to seventeenth-century wooden furniture are to church and palace pieces, of which only a few examples survive. The furniture belonging to the ordinary man had little elaborate carving. That folk furniture was usually made by the same carpenters who built the house explains the presence, even in stone houses, of such built-in fixtures as wall benches, window sills, and so forth. Such objects, organically connected to the wall, exhibited a striking rhythm, proportion, and harmony. Designs used in the house itself were repeated in the furniture—e.g., the grating on doors was repeated on the backs of chairs; rounded table legs resembled in miniature the pillars on the porches. Furniture made by carpenters was usually heavy and mas-

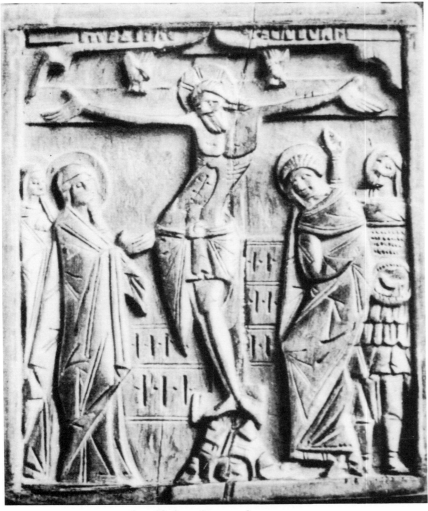

Crucifixion. Sixteenth century.

St. Nicholas of Mozhaisk. Sixteenth century.

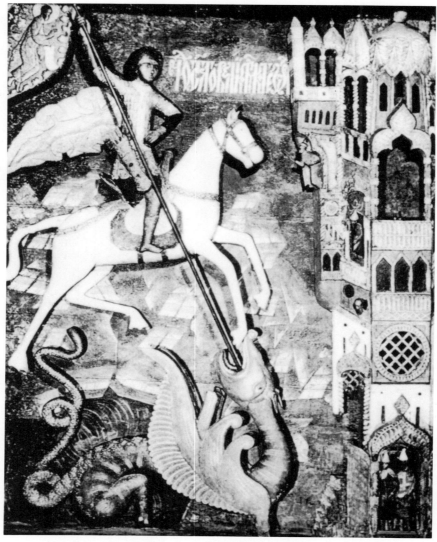

St. George. A blend of carving and painting, Northern
Russia, seventeenth century.

sive and reflected the forms used in building architecture.

Benches, probably a development from the ancient plank-bed, were found in *izba* and palace alike. Benches were constructed according to their function, with corner benches permanently built into the wall. Special benches for sleeping had an elevated part for the head and were made of linden, fir, and oak, and sometimes of nutwoods. Tables were usually made of oak or the less expensive pine or fir. Tables were made in a variety of shapes and sizes—from small ones resembling stools, which were used by scribes to copy books, to monumental pieces.

Storage pieces, popular in Old Russia, were in the seventeenth century commercially produced in various localities, most prominently in Kholmogory, where they were decorated on the outside with seal hide or red leather, and sometimes richly painted and bound with metal. Trunks, chests, and boxes used to store books, documents, clothes, and other articles were made from linden and pine, although oak chests with geometrical carving and metal additions have been preserved from the seventeenth century. Wooden lockers were made by village peasants; painting and metal decoration were usually done in towns. Cupboards were generally massive and, in the seventeenth century, con-

structed on the Western pattern, using linden, oak, nut, or elm.

In Old Russia, holidays and festivities involved the presentation and use of various domestic wooden objects. Beer was served in large wooden pitchers called *laguny*. Saltcellers were important in wedding ceremonies, while distaffs, laundry beetles, and *svettsy* (holders for wooden tapers used to light a room) were part of every bride's dowry. In the seventeenth century, such household objects began to be decorated with sculptural ornamentation—parrots and doves, horse heads, moose, oxen, grape bunches, even human figures—but there are few records of such pieces preserved from the period to give a complete story of their production.

Household objects were made at this time in Tver, Kaluga, and Sergius *posad*. The Ustiug area was an important center in the production of wooden dishes. An entry in the Ustiug tax book for the years 1676–77 records the fact that "Piotr Lobanov from the village of Kuben delivered 6,100 spoons, thirty-six saltcellers, thirty-five birch dippers, and forty-six sieves." Kirillov and its adjacent villages was another large center of carved woodenware; Kirillov dippers, spoons, and saltcellers were sold in abundance in Novgorod or at the Ustiug fair, and its wine vessels were shipped to Tobolsk. Wooden dippers of outstanding shape were produced on the lower course of the Sheksna and Mologa rivers. Wooden spoons were produced at the Ferapon-

Church porch.

tov Monastery. Eleazar, a monk, left the Solovetskii Monastery in 1616 for a hermitage, where he made wooden dishes to maintain himself. Such ware was often purchased by the czarist court. In 1671, for example, fifty spoons were purchased for the royal household from the Monastery of St. Cyril on the White Lake.

During the eighteenth century, the woodworking trades blossomed and spread to the northern and central regions of Russia. Wooden kitchenware was shipped to Persia, Bukhara, and Siberia; dippers from the northern areas, through Archangelsk to Western Europe. That the city of Semyonov alone produced more than 1.5 million spoons, cups, and other dishes annually suggests the quantity of production in the eighteenth century.

Wooden household objects changed very little in shape in the course of time, undoubtedly because peasant craftsmen, having nothing in the foreign line to imitate, adhered to familiar national tradition. For this reason, there are no pronounced stylistic distinctions between periods in Russian folk carving. Development was slow and uneven; in a remote Siberian village, for example, certain ancient methods of woodcarving would survive until the twentieth century. During the eighteenth century, nevertheless, finishing techniques improved; the influence of monumental decorative

Pokrovskaia Church in the Vitegra Pogost, 1708.

Pokrovskaia Church, built in 1764.

Kizhi Pogost, belfry, end of the eighteenth century.

Pokrovskaia Church cupolas.

Kizhi churches before restoration.

Lazarevskaia Church of the Muromskii Monastery, the smallest and oldest of all the wooden churches.

from the sixteenth century onward, the custom of making gingerbreads existed in Russian life to an extent difficult for outsiders to appreciate, and every household possessed a number of the carved molds or stamps with which these cakes were ornamented.

The oldest surviving wooden gingerbread molds date from the seventeenth and early eighteenth centuries and have much in common with fifteenth–seventeenth century tiles. Local characteristics did not enter into them. Designs were usually large, favorite subjects including floral motifs, as well as real and mythical birds and animals. The double-headed eagle was a frequent motif, and some molds depicted the wooden princely palaces of ancient Rus or even whole towns. Others were edged with lettering joined in a continuous single line and strongly resembled the *lubok,* which began to influence folk woodcarving in the eighteenth century.

In general, folk woodcarving declined during the nineteenth century. Painted decoration gradually supplanted household carving; and as form ceased to follow function, decoration became an end in itself. The techniques of carving changed very little; the same tools were used, although nails and glue appeared more frequently; and furniture continued to be produced near large cities that held fairs, such as Moscow, Vologda, Kirillov, Ustiug, and Archangelsk. Nevertheless, carved wooden utensils lost ground, and by the end of the century some pieces were being made exclusively for individual collectors or museums.

Some objects declined with the decline of certain customs. The large Northern Dvina pitchers called *skopkari,* perhaps the best of Russian woodenware at the juncture of the eighteenth and nineteenth centuries, declined together with the custom of celebrating holiday eves. That gingerbreads also declined in popularity is reflected in the carved wooden molds, which became increasingly commonplace in design. Nineteenth-century dippers and saltcellars also declined in quality of workmanship and lost their sculptural form to increased simplification, carving being now more economical than artistic. During the eighteenth century, an object tended to preserve its basic shape while undergoing numerous variations in design. During the nineteenth century, craftsmen more often changed shape than design, with the result that only individual nineteenth-century examples reflect the earlier style.

During the first half of the nineteenth century, especially along the Volga, woodcarving was strongly

carving grew increasingly apparent; and carved sculpture became less angular, more rounded and realistic.

By far the most interesting culinary articles of Old Russia were the carved wooden gingerbread molds. Especially, but not exclusively, in rural districts, the making of gingerbreads was an institution, and no public or private celebration, from the remotest villages of the empire to the czarist court, was complete without them. At individual feasts, family and friends gathered to eat gingerbreads or to make presents of them. Children received small cakes in the shapes of animals; girls received cakes inscribed "I love you" or "In Testimony of Love," and beautifully decorated cakes were made for weddings. For official presentations or other occasions of moment, huge gingerbreads were made, sometimes decorated with the imperial double-headed eagle, and weighing as much as 150 pounds. Especially

Chapel in the village of Lelikozero (Onega Lake area).

influenced by a species of pseudoclassicism. Acanthus leaves, palmettes, and sphinxes were introduced into folk ornamentation, and embossed designs in this style were to be found on very diverse objects, including carts, sleds, and looms; but these designs were not permanently absorbed by peasant craftsmen. Symmetrical fish, often found on nineteenth-century household objects, were favorite motifs, but in the seventies and eighties pictures declined in popularity in favor of floral and geometrical designs. Toward the end of the century,

carving was increasingly replaced by painting on wood, which was cheaper and less time-consuming.

Painted Woodenware

In early Rus, icon painters often undertook the decoration of domestic objects, applying to them *à tempera* imagery more commonly found on icons. Such work was most often to be found where popular icons were made —near the monasteries and the villages of Palehk, Ms-

Chapel in the village of Kavgara.

tera, and Kholui. The earliest known painted wooden objects date from the sixteenth and seventeenth centuries. Early sixteenth-century records of the Holy Trinity –St. Sergius Monastery mention an *oliflenik,* or lay decorative painter, named Varsonofii. Records of the Nagai ambassador in Moscow indicate that painted wooden lockers and bast boxes were sent to the East in 1579. In 1623–24, eight households of icon painters and ten households of dish decorators were registered in the village of Klementev, near the Holy Trinity–St. Ser-

gius Monastery. Monastery records for 1642 register an inventory of 9,570 loving cups painted in cinnabar and red lead, and 17,000 spoons.

The Moscow, Yaroslavl, and Stroganov areas were the centers of seventeenth-century wood painting. The most popular ornamentation exhibited a floral motif sometimes supplemented by real and mythical birds and animals—people painted frontally, animals in profile. Designs were borrowed from illuminated manuscripts of the fifteenth–seventeenth centuries, and colors were

Novgorod wooden chalice, eleventh century.

Carved table legs, eighteenth century.

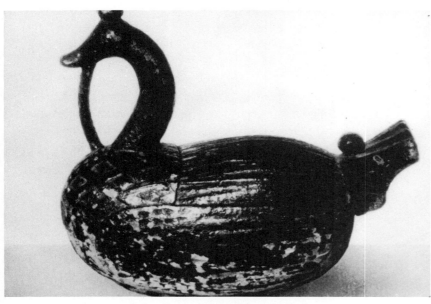

Saltcellar, eighteenth century.

Bird-shaped handsaw handle, 1836.

Jackplane with carved crouching lion, early nineteenth century.

Laundry beetle, end of the eighteenth century.

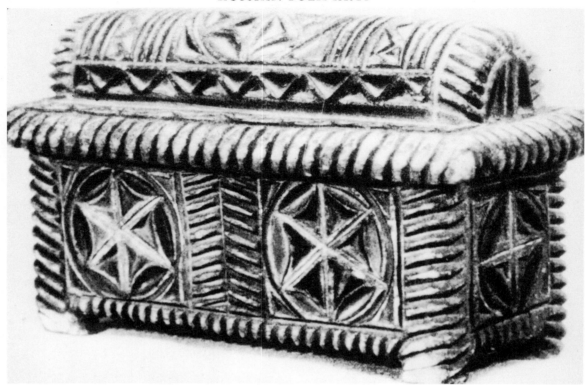

Chest, eighteenth century.

vivid, though limited. Two painting techniques characterized the style: a graphic presentation in sharp black or white outline, with the dark areas colored; and the brushstroke technique used in oil painting.

In the eighteenth century, peasant wood painting developed especially in the Mezen, Northern Dvina, and Nizhni Novgorod areas. Along the Mezen River in the North, designs included straight and wavy lines casually applied to the background, geometrical figures resembling those used in woodcarving, animal motifs, and scenes from contemporary life—especially closely observed hunting scenes remarkably similar in subject matter to some Stone Age murals recently found in the Zaonezhie area. Moving water was another major motif in Mezen wood painting, undoubtedly because the life of the Mezen artist was so closely bound to the river whose waters constantly both threatened his existence and provided him with fish and fur-bearing animals.

Southwest of the Mezen is the Northern Dvina, one of the largest rivers of the North and from time immemorial a major trade route connecting the North with central Russia, Siberia, and (through Archangelsk) foreign countries. Among the cities which developed along its shores and tributaries were Velikii-Ustiug, Kholmo-

gory, and Solvychegodsk—all illustrious centers of folk handicrafts in Russia. Under the patronage of the Stroganov family, the decorative handicrafts here developed greatly during the nineteenth century, penetrating peasant settlements throughout the North.

The Permogore area, on the shores of the Northern Dvina and north of Velikii-Ustiug, was one of the largest centers of wood painting in the nineteenth century. Here, all domestic objects were painted; almost every peasant village was employed in the craft; and the occupation was reflected in such village names as Pomazkino (suggesting "painting" in Russian). Permogore painting characteristically exhibited a light background upon which were painted red grasses or berry branches in a strong carpetlike design. Plant motifs were often supplemented by scenes from peasant life—tea drinking, sledge rides—in small, vivid pictures closely resembling the sixteenth–seventeenth century Stroganov school of icon painting.

Borok (probably named after the Boretski noble family, opposition leaders in Novgorod to Moscow's autocratic policies) was another wood-painting center located on the middle course of the Dvina. People persecuted in Novgorod moved to this remote settlement,

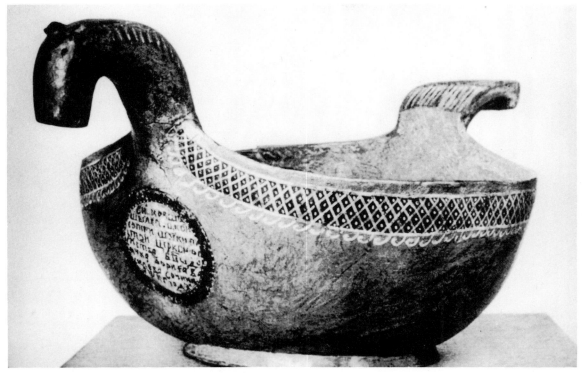

Skopkar, 1753.

where they treasured and preserved Novgorodian traditions of the sixteenth and seventeenth centuries. The Boretski school differs from other northern schools in its use of Greek imagery. Here people are depicted in long gowns resembling ancient Greek attire and are found among tall buildings with portals and statuettes and mythical flowering trees. One Boretski distaff exhibits a shepherd with his sheep by an ancient Greek building.

A special style of wood painting predominated in the northwestern area and upper Volga region, where designs were brushstroked. This school originated in the seventeenth century with the founding of the Vygonskii Monastery, the center of cultural life in the North in the eighteenth and nineteenth centuries. The Vygonskii Monastery was a stronghold of the Old Believers, for whose work in the collection of old church books some one hundred artists were brought together in the eighteenth century. The "Pomorskii style" to develop here among peasant apprentices trained by monks was based on illuminated manuscript and *lubok* designs. Very popular among the peasants of the North, its major motifs—splendid floral designs with birds and berries brightly painted against a blue, black or golden background—survived until the nineteenth century.

Khokhloma, a small fortress in the middle of a forested area northeast of Nizhni Novgorod, is first mentioned in mid–sixteenth-century chronicles from the reign of Ivan the Terrible. In 1618 Czar Michael Romanov presented Khokhloma and its neighboring villages (in what is now Gorky Region) to a court clerk, who, fifteen years later, bequeathed Khokhloma to the Holy Trinity–St. Sergius Monastery. On Sundays the square of this small fortress became a market where peasant craftsmen from the area traded their painted woodenware.

The typical object produced by seventeenth-century Khokhloma craftsmen was a wooden bowl with a circle radiating sinuous lines painted on the interior bottom. The lines, climbing over the rim, decorated the outer wall as well, and the pattern, resembling a primitive drawing of the sun, was known in the vernacular as "the redhead." Later, the square was introduced and gradually transformed into a lozenge. In time, both "redhead" and lozenge yielded to a lush floral pattern. The object was first thinly coated with a special loam for the paint to lay evenly on the surface. It was then

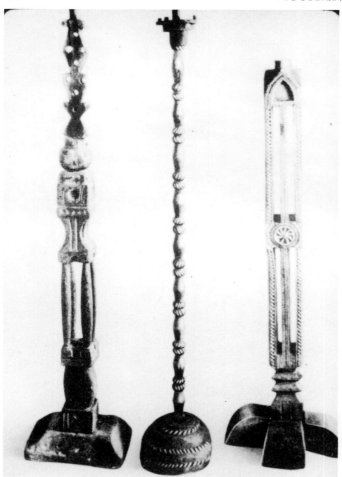

Candlestick, seventeenth century.

piece but by the *pood* (thirty-two pounds) and ton. But the jobbers of Semyonov and Nizhni Novgorod fixed the price paid to the craftsmen so that the latter sank ever deeper into debt. While the artisans worked fifteen hours a day, storehouses proliferated in Semyonov. In 1797, the mayor of Semyonov reported that the population no longer engaged in agriculture. His list of all the painted woodenware that had been sold at the Makariev fair in the course of a year included 500,000 bowls, 300,000 platters, 100,000 cups, and 800,000 spoons.

Although Khokhloma gilded woodenware sold well outside Russia, too, the trade did not flourish long, for in the second half of the nineteenth century it was completely ousted by cheap factory-made china and glass.

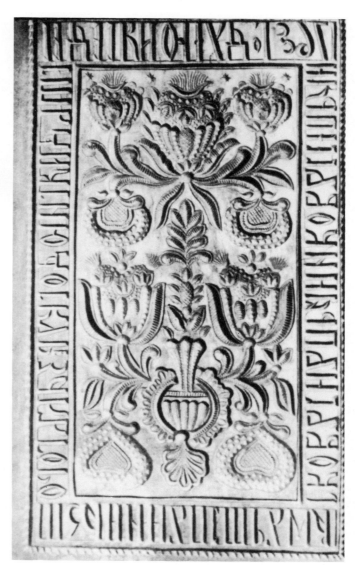

Gingerbread mold, 1763.

bathed in linseed oil to cause the paint to adhere, painted, coated with a varnish made of linseed oil, and oven dried.

Although the origin of "wooden gold" in this area is not known, it has been conjectured that a peasant craftsman may once have come into possession of a pewter platter which he treated as he did his woodenware: cleaning the surface, painting and varnishing it, and placing it in an oven to dry. When he took it out, the oven heat would have caused the varnish to yellow so that the pewter gleamed golden through it. Trying the same device on a wooden platter, he would bathe the piece in linseed oil, rub it with powdered tin, and the ultimate result would appear as heavy and massive as if made of gold.

Soon neighboring villagers as well as merchants from distant parts of Russia and abroad came to the Makariev fair in Nizhni Novgorod to buy this ware, not by the

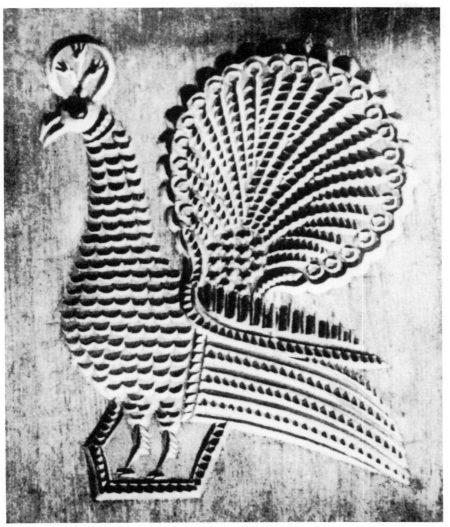

Gingerbread mold, first half of the nineteenth century.

Print block, eighteenth century.

Sled, second half of the nineteenth century.

Whole families of Khokhloma craftsmen moved to the towns in search of a living, and the painted woodenware still sold at fairs diminished rapidly in both quantity and craftsmanship. The craft was gradually revived in the late nineteenth century not from a love for the folk arts but to bolster drastically dwindling tax revenues.

When a craze for everything Russian arose among the Russian bourgeoisie in the 1880s, many artists—including an artist named Durnovo, whom the Nizhni Novgorod *zemstvo* had invited to revive the craft of Khokhloma woodenware—attempted with considerable commercial success to blend traditional elements of Russian folk art with the massive vulgarity of the merchant taste of the period. In architecture, a style that was later sarcastically called the "cockerel fashion" was in vogue. Durnovo began by manufacturing painted furniture whose crudity and *mélange des genres* earned it the name of "tripe" among village craftsmen. To produce faster, Durnovo's artisans reproduced a paper pattern on wood by pricking it out with a needle, and soon massive, cumbersome furniture *à la Russe* appeared in quantity in shops and at fairs.

While most of this was inferior stuff aimed at making easy money, some craftsmen—such as Fedor Krasilnikov, Stepan Yuzikov, and the Podogov brothers—continued to follow the old traditions. Their tables and chairs were decorated with flowers against a red and gold background. At the Second Russian National Handicrafts Exhibition of 1913, Krasilnikov was awarded a medal, which did nothing, however, to improve his lot with the jobber. Other craftsmen fared no better.

Khokhloma ware took a second lease on life after 1917 with the help of Fedor Bedin, a craftsman in the village of Novo-Pokrovskoe, Gorky Region. Contemptuous of the "tripe" motif, Bedin painted the traditional floral motifs on wooden bowls and platters and was soon invited to teach at the newly created cooperative. When repeating the old motifs bored him, Bedin began to produce vases, platters, tables, and chairs with a decorative design of ears of grain, clover flowers, bunches of ashberry, and spruce branches with honey-colored cones. Among his new motifs were

Birdhouse, second half of the nineteenth century.

carved in Rus before the tenth century. According to Ibn Fadlan, an Arab traveler who in A.D. 922 visited the Slavs living along the Volga: "As soon as the ship stopped at the pier, every merchant took bread, meat, onions, and milk to a tall wooden figure with the face of a man, which was surrounded by similar, smaller wooden objects, the whole surrounded by a row of wooden poles." Since most of the wooden idols of this period have long since perished, experts have studied the stone idols of the tenth-thirteenth centuries for information concerning the wooden pieces. The tenth-century Zbruczski idol, a stone sculpture presently in the museum of Krakow, Poland, is one such example.

When Christianity was adopted in Rus in A.D. 988, the church demanded that all pagan idols be destroyed. Until a few score years later, when the church was itself obliged to employ sculptors, any attempt to carve a stone or wooden statue was harshly persecuted as idolatry. The oldest surviving piece of monumental woodcarving is a six-foot iconostasis with images of saints and cherubs in bas-relief, executed by an unknown thirteenth-century master. The figures are enclosed in a highly individual frame, and on both sides of the screen are carved odd-looking lions, like big, friendly dogs, with trefoils at the end of the tails instead of the conventional tassels.

As time went on, woodcarvers attempted to raise their

bunches of grapes, tea leaves, sunflowers, and cotton bolls—all these copied by his students, of whom there came to be some 400. His most gifted pupil, Olga Lushina, preferred a vivid sweeping stroke to Bedin's repeated pattern of small details and sought new motifs in the decorative folk ornament of the Ukraine, Byelorussia, and Central Asia.

Semyonov is today the major center of Khokhloma painted woodenware. Owing largely to the artist G. P. Matveev, in the early Soviet years a school in artistic woodworking was opened in Semyonov, whose first graduates established a cooperative of Khokhloma painters. The cooperative was reorganized after World War II into a factory with large workrooms, drying ovens, kilns, storehouses, and a special educational establishment whose graduates make up most of the factory's present personnel. Typical Semyonov products include cake and cookie trays decorated with ancient, stylized herb motifs, fruit stands, candy bowls, decorative wall platters, and painted wooden jewelry.

Wood Sculpture

Wooden images of pagan deities were extensively

Child's sled. Yaroslavl Province, first half of the nineteenth century.

Crib. Northern Dvina area, mid-nineteenth century.

Chest showing *Sadko and the Girl Chernava*. Northern
Dvina, late seventeenth century.

Painting on cupboard (detail). 1830s.

bas-relief figures higher from the background and undercut deeper. Unfortunately, there are few samples of fourteenth-century wood sculpture extant. Those not ruined by fire were destroyed by priests. The veneration of worshipers was so persistent, however, that the church was finally compelled to accept the carved figures, and three-dimensional images of saints began to appear generally.

Because Paraskeva Piatnitsa was believed to have bestowed the blessing of water on the human race, her icons were everywhere nailed up at wells and springs; but the vicissitudes of weather caused the paint to flake off, and the icons had frequently to be renewed. Therefore, in place of the icons, sculptors were commanded to carve statues that would stand up to the elements, and a number of rudely cut wooden images of this saint and others are to be found in many museums today.

Curiously, the sculptors confined themselves for the most part to three figures. Paraskeva Piatnitsa, who was also the patron saint of brides, happy marriages, and of profitable trade, was very highly esteemed and generally depicted in a gentle, poetic manner. St. George, the horseman who smote the winged dragon with his spear, became for the people of Old Russia a symbol of their struggle against the Tatars. In 1464 a figure of St. George carved in stone by the master Vasilii Yermolin was set up over the gates of the Kremlin's Spasskaia Tower. It became the emblem of Moscow and was later reproduced in wood as a young warrior with spear raised to smite the enemy. The sculptures of St. Nicholas of Mozhaisk were to be found chiefly in frontier towns where he was depicted as a builder and defender of outlying fortresses. In his left hand he held a model of a for-

Distaff with a painting of Alexander I and Elizaveta Alexeevna (detail). First half of the nineteenth century.

Distaff. Yaroslavl Province, first half of the nineteenth century.

Khokhloma vase.

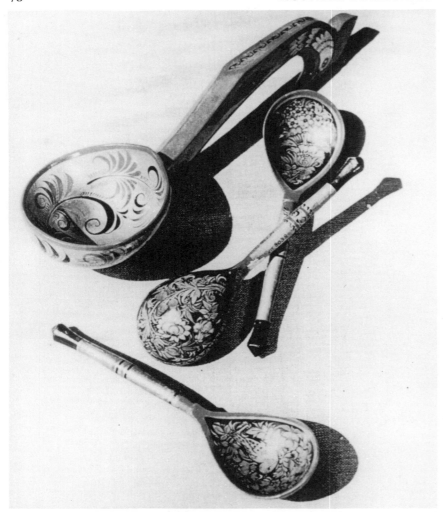

Khokhloma wooden spoons.

"Northern" platter. Birchbark carving by I. Veprev.

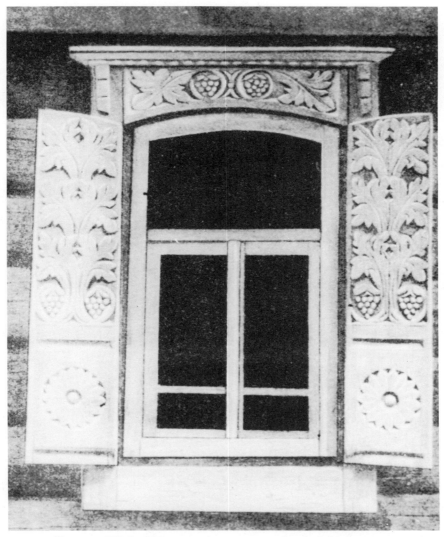

Shutters. Nizhni Novgorod Province, nineteenth century.

tress city; in his right, a heavy sword raised high.

The ancient sculptors always arranged their figures frontally and, violating proportion to a certain degree, extended them upward. Although they did not attempt individual detail, they achieved highly lifelike silhouettes, free of both cold asceticism and unctuous piety.

A craftsman who treated worldly themes was frequently persecuted and his work disfigured. When Christopher Galloway, an Englishman, added four nudes of mythological personages to the extra tier on the Spasskaia Tower, the figures were modestly clothed in caftans: "There were made cloth cassocks for four statues," a chronicler noted, "for which twelve arshins (one arshin equaled twenty-eight inches) of English cloth of diverse colors were used." The church relentlessly commanded

believers to stop embellishing their roofs and gates with carved images of people, animals, and centaurs, and it was not until the end of the seventeenth century that Peter the Great officially sanctioned the erection of monuments and decorative statuary in public parks and gardens.

The richest collection of wooden folk sculpture in the USSR today is probably to be found in the remote Urals town of Perm, whose early native inhabitants worshiped, and made sacrifices to, carved wooden idols for centuries before Christianity was introduced into the area. There was a statue in almost every large Permiak village when Stefan, a pupil of the religious leader Sergei of Radonezh, brought Christianity to Perm in the early fifteenth century. In the early Christian period, however, such

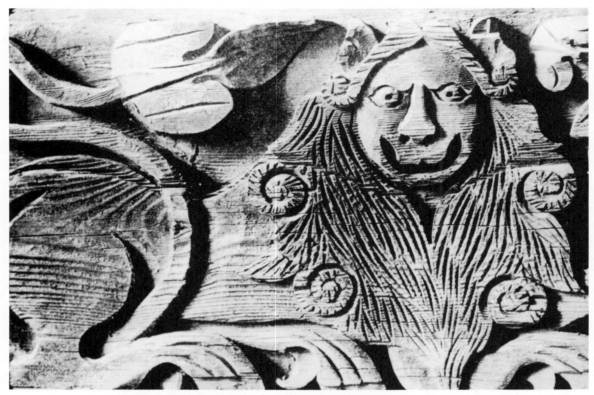

Frieze. Nizhni Novgorod Province, nineteenth century.

images were destroyed. Russian missionaries did not introduce church sculpture in this area until it was in general use in the northern and central regions of Russia.

Crucifixes, often with saints, and an image of the *Seated Savior* were the most popular, widespread, and characteristic wood sculptures in the Perm area. Two of the finest crucifixes are the six-foot seven-inch *Tatar Christ* from the town of Usole—the head beautifully carved, the face calmly spiritual and stylized—and the *Crucifixion* from Vilgort village, a unique reproduction in wood of a typical seventeenth-century bronze cross. St. Nicholas of Mozhaisk is most often exhibited in the Perm collection with a sword in his right hand, and in his left, the symbolic image (in the form of a church) of the town he protects. The popularity of the *Seated Savior* in Perm has been attributed to the fact that the pagan Permiaks had worshiped a seated "golden woman," a subject that will be discussed at some length in connection with the Russian painted wooden *matryoshka* doll.

Almost all of the Perm carvings were done in pine or linden. The older pieces, made of hard pine, are usually severe and monumental and have the effect of charac-

ter studies. Soft linden was used in the eighteenth century, when baroque became the style in Russia, because it enabled the artist to carve delicately elaborate ornamentation in intricate folds of clothing or on complicated iconostases.

Other nationalities in the area—among them the Russians, Zyryans, Voguls, and Tatars—carved wooden images as well, but Perm's wooden sculpture best reflects the social and art history of the area. Art developed in this backwoods community more slowly than it did elsewhere in Russia, but it went through all of the characteristic stages and reached its peak in the eighteenth century. Perm sculpture, like all Russian church carving, was twice officially interdicted by the Holy Synod. Far from the seat of church authority, Perm generally ignored the first interdict of 1722 prohibiting wooden sculpture in large towns. When news of the second Synod interdict of 1832 reached Perm, however, zealous diocesan officials denuded the local churches and chapels of wooden images and carried them off to various repositories, which accounts for the chance collections found in various northern Russian towns today.

Wall painting in a house. Gorodok Village, Archangelsk Province, nineteenth century.

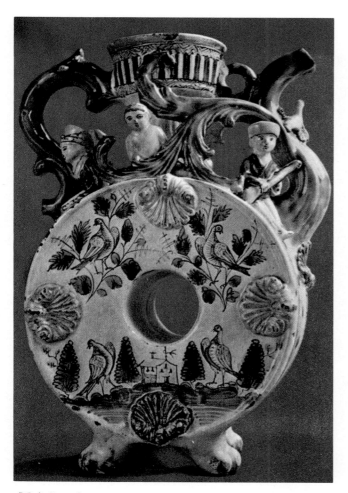

Majolica *kvasnik*, eighteenth–nineteenth centuries.

Girl with Cockerel. First Russian *matryoshka*.

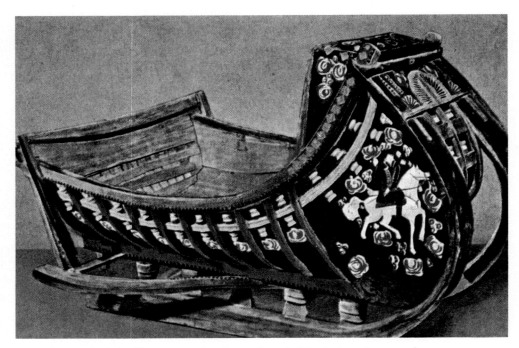

Painted sled. Kostroma Province, first half of the nineteenth century.

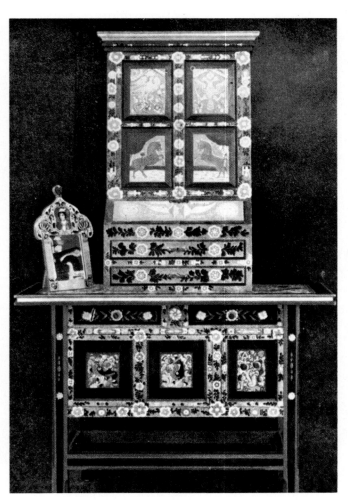

Decorated wooden table, cupboard, and picture frame.
Sergius Posad, end of the nineteenth century.

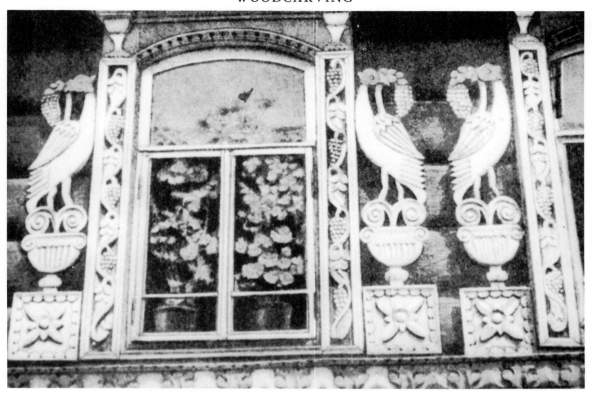

Carved shutters of S. P. Maksimov's house in the village
of Valki. Nizhni Novgorod Province, nineteenth century.

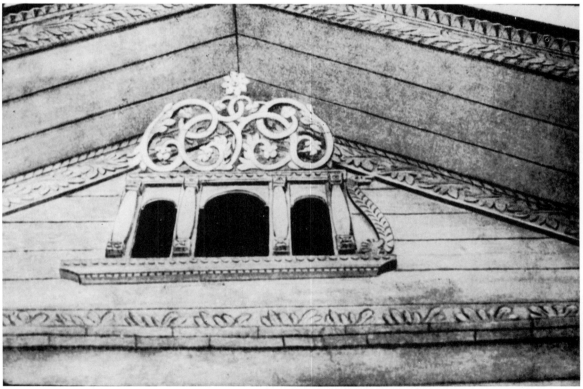

Dormer window in the village of Krasnye Oselki.
Nizhni Novgorod Province, nineteenth century.

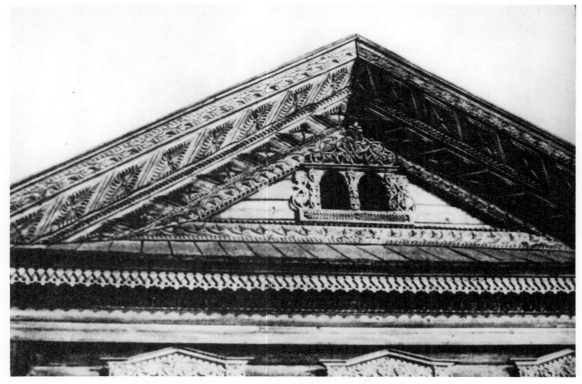

Dormer window in the village of Krasnye Oselki.
Nizhni Novgorod Province, nineteenth century.

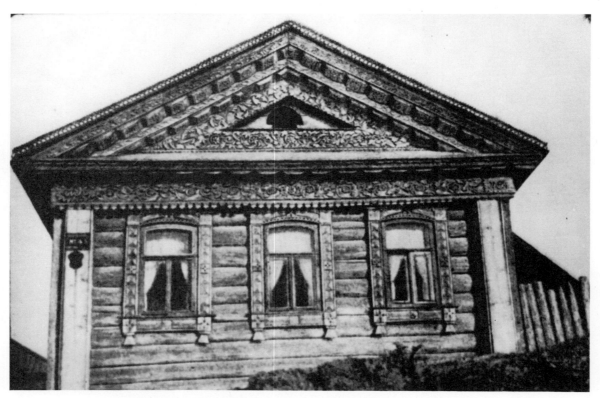

Karelin's house in the village of Barmino. Nizhni Nov-
gorod Province, nineteenth century.

Monumental Wood Sculpture

The decorative carving of passenger ships with the heads and bodies of lions and mythical beasts, which had existed in Russia from ancient times, reached its peak in the eighteenth century. Also very popular at this time were portable wooden stages on which wooden puppets performed to a narrative accompaniment. Church iconostases were elaborately decorated. Among the few to have survived, the 1722–26 iconostasis from Petropavlovsk Cathedral in Leningrad provides a classic example of eighteenth-century skill.

Above all, however, monumental wood sculpture flourished, especially when in 1714 Peter the Great forbade stone construction in Russia outside the city of St. Petersburg. In the 1730s, on orders from Empress Anne, the Italian architect-sculptor Carlo Bartolomeo Rastrelli built a wooden palace known as Annenhof in the Kremlin. In 1753, on orders from Empress Elizabeth, the wooden Golovinskii Palace was constructed by some 3,000 carpenters and 120 woodcarvers.

Although the scope of this book does not permit a detailed account of Russian architectural wood sculpture of the seventeenth and eighteenth centuries, the celebrated wooden Church of the Transfiguration on the island of Kizhi and the wooden palaces of Kolomenskoe and Ostankino are here singled out for special notice.

The 250-year-old Church of the Transfiguration was built in 1714 in Kizhi, one of 1,650 islands in Lake Onega, allegedly to commemorate Peter the Great's victory over the Swedes. According to one legend, the church was personally designed by Peter on one of his trips through the lake area; according to another, it was designed by a peasant named Nestor, who, upon its completion, cast his ax into the lake so that no other such church would ever again be built.

Be that as it may, the island measures roughly two-and-a-half miles by 600 yards. The church, one of two on the island, is a pyramid-shaped structure approximately 120 feet high, with twenty-two cupolas. This very tall, very large structure was built by unknown craftsmen completely of wood, with the ax alone, and has not a single iron nail or other metal part. It was built by rule of thumb and is an astonishing demonstration of the skill of Russian peasant craftsmen.

In 1667 hundreds of serf craftsmen began the construction of a new imperial palace for Czar Alexei Mikhailovich in the village of Kolomenskoe. For two years a wonderland ensemble arose amid the birch thickets

Carving on the N. I. Levashov house, village of Vasilsursk. Nizhni Novgorod Province, nineteenth century.

on a bend in the Moscow River, the whole edifice—galleries and roofed passageways, tower spires, heart-shaped and barrellike rooftops, elaborate openworked eaves, carved pillars, decorative lions and exotic birds—made entirely of wood by Russian carpenters, joiners, and carvers. The celebrated seventeenth-century writer Semyon Polostsky wrote of the Kolomenskoe Palace: "The ancients knew of seven wonders. The eighth, this palace, is of our time." A foreigner named Reitenfels wrote in 1671 that "it is so marvelously adorned with carved work and gilt that one could take it for a toy newly out of its box." The carvers were rewarded, less marvelously, with a length of Hamburg cloth each. As

Kolomenskoe Palace (wooden model). Twentieth century.

the decades passed, however, the palace fell into disuse, and in 1767, one hundred years after it was built, Catherine the Great had it demolished.

Also in the late seventeenth century, Count Sheremetev decided to build a wooden country villa in the village of Ostankino using serf architects, artists, carvers, and cabinetmakers. The steward of Ostankino shortly reported to the count: "Our bonded artisans are working with all conceivable speed, idling neither on holidays nor Sundays, and toiling by candlelight even from four o'clock in the morning until ten o'clock at night. And to expedite their labors, a hussar, not of their parts, has been detailed to supervise them."

By the spring of 1798 Sheremetev's palace was finished, the entire construction made of oak, lime, birch, and nut. Columns were carved from whole tree trunks and plastered and painted to look like marble. Gilded carved work framed windows, doorways, and entrance; vast carved panels were inset in walls. Chandeliers, huge vases, and sphinxes were all made of wood coated with gold and bronze. The scrollwork on furniture, frames, and candelabra; intricately carved flower garlands, roses, cornflowers, daisies, and ears of grain; figures of people, snakes, lions, and mountain sheep—all were made of wood by men unable to write their own names. Stanislaw Poniatowski, King of Poland, wrote in the court diary

the following entry describing his visit to the Ostankino Palace.

As for the carpentry, gilt work, mirrors, window and door frames, and the parquet, all was of superb execution, without a single blemish. Of the several hundred craftsmen and artists that worked there, no more than four or five were foreigners. The remainder were not just Russians; nearly all were Count Sheremetev's serfs. Without confirmation this would indeed arouse incredulity, so elegantly is everything wrought.

The carvers' names remained unknown until after 1917, when scholars studying Sheremetev's personal archives discovered several names in his letters and the accounts of his steward. An entry for May 1796 noted that carver Ivan Mochalin had missed work for three days because of a headache. In September 1796 Sheremetev had ordered several serving boys to be apprenticed to this man. A payroll dated 1802 gives the name of carver Ivan Mazokhin; Fedor Nikiforov and Gavrila Nemkov are another two names found. These names are today inscribed in marble in the palace lobby.

Birchbark Carving

Although carved birchbark objects have been exca-

Saltcellar. Northern Russia, nineteenth century.

work, which merchants used as strongboxes on long journeys. As the ironwork patterns resemble the carved openwork of Kurovo-Navolok, only six miles away, it had been conjectured that Kurovo-Navolok peasants may have reproduced the blacksmith's decorative work in a cheaper and more readily available material; or it may have been the reverse. Commercial routes changed when Peter the Great established his capital at St. Petersburg, and Velikii-Ustiug regressed into provincialism. The fairs and the making of coffers both ceased. In Kurovo-Navolok, however, carving in birchbark continued and prospered. The jobber, as always, bought these items cheaply and sold them at exhorbitant prices both in Russia and abroad.

According to long-established tradition, in May or June Kurovo-Navolok villagers search the woods for twenty-year-old birches, from which they strip the upper layers of swollen bark until they have a stock to last a year. Spread out on tables, the bark is again stripped of a thin upper layer and all excrescences, the remainder being sandpapered and polished. The carver cuts rectangular pieces, impresses onto them a pattern of interwoven flowers or spruce twigs or a simple design of triangles and rhomboids, cuts away superfluous material, and by slow and patient degrees produces birchbark

vated in Yakutia, the northern Urals, in Old Novgorod, and in the vicinity of Orel and Kursk, only the inhabitants of Kurovo-Navolok, a village on the banks of the Shemogsa River in Vologda Region, know today how to make birchbark lace. Precisely why this is so remains a mystery. Noting the resemblance between Kurovo-Navolok openwork and the openwork birchbark "wallpaper" of ancient Novgorod, art scholars compared a modern map with ancient manuscripts and saw that the Shemogsa borders part of the vast territory over which Novgorod once ruled. Thus, Novgorod carving skills may have reached the village by way of the river, although, since birch thickets are abundant throughout the area, why only this one village of the hundreds in Novgorod Region adopted the craft is not known.

The town of Velikii-Ustiug stood for decades at the crossroads of major trade routes to Siberia, China, and Archangelsk (Russia's only seaport until the eighteenth century). Twice a year tradesmen and merchants from all over the country came to the Velikii-Ustiug fair; according to the chronicles of 1618, English and Dutch traders had homes in the town. Velikii-Ustiug craftsmen made heavy oak coffers reinforced with ornamental iron-

Ceremonial gingerbread mold, eighteenth century.

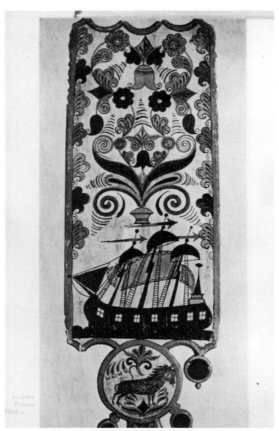

Distaff. Archangelsk Province, 1905.

lace of great complexity, which he glues onto a previous-
ly prepared object.

The State Museum of History, which also has several
of the oak and iron coffers of Velikii-Ustiug, possesses
an early eighteenth-century oval wooden snuffbox inset
on every side with birchbark openwork. The lid, framed
with intricate scrollwork, depicts dogs pursuing a stag,
with tinfoil underneath to set off the picture more
prominently.

Curiously, half the villagers of Kurovo-Navolok at
one time bore the surname Veprev. The glove boxes of
Ivan Veprev were particularly prized in Paris and New
York at the end of the nineteenth century, and his birch-
bark objects earned him a medal and certificate of honor
at the 1900 Paris World's Fair. The first cooperative of
Shemogsa birchbark carvers was established in Kurovo-
Navolok in 1918. Its chariman was Veprev's student,
Nikolai Veprev (a neighbor's son); by 1934 the co-
operative had ninety craftsmen all named Veprev.

Around this time, the birchbark craftsmen, while still
employing traditional methods handed down the gen-
erations, began to introduce such subject matter as the
hammer and sickle and Kremlin towers into their work.
But older craftsmen resisted this, as a result of which
Nikolai Veprev resigned and established another coop-
erative, called Solidarity, in the neighboring village of
Panshino. Both villages produced novel and interesting
birchbark articles in quantity, and the new generation
of carvers that arose after World War II continues to
produce delightful birchbark handiwork.

6

CERAMICS

Early Development

Russian ceramics is believed to date from approximately the seventh century—the time of the Dnieper Slavs—and to have developed as a handicraft by the eleventh century as a result of Byzantine influence. Many village potters made coarse domestic ware, as well as a kind of pitcher called *korchaga*, which they ornamented around its shoulders or along its rounded hip by incising with a sharp tool as the pot turned on a wheel. Stamps were also used in ornamentation, and early Kievan potters glazed ceramic objects. But the early development of ceramics in Kievan Rus was disrupted by the Tatar invasion, and from the thirteenth to the fifteenth century the typical ceramic works were crude brown pots similar to those found in early Slav burial sites.

In the fourteenth century, ceramics began very slowly to develop anew. Old decorative designs were gradually revived, and vessels were now sometimes covered with a fine layer of white slip. Black, smoke-cured ceramics appeared at the beginning of the sixteenth century, while white clay was used for high-quality crockery. Somewhat later, in the 1530s and 1540s, glaze was applied to black, white, and red ceramics, and white slip was sometimes applied to sections of a red object for a kind of checkered effect. Generally, however, a slip-covered surface was painted with a brown geometrical design, and this type of ceramic ware, which developed greatly during the seventeenth century, was gradually transformed during the ensuing centuries into a black crockery that survives to the present day.

Black—or more precisely, dark gray—ceramics were produced by allowing the high temperature of the hearth or stove to drop and then curing the pieces with smoke. Metal elements present in red clay turned black, the pores of the vessel filled with soot, and the object itself turned black. Ancient Georgian artisans were famous for their black ceramics. A contemporary Georgian artist, Revaz Yashvili, who now ranks with the best Soviet ceramists, devoted five years to rediscovering the lost technique of making black ceramics. Yashvili makes carafes shaped as deer, bulls, and chamois, as well as wine cups, ladles, and decorative dishes. The pieces are traditional and modern at the same time and are generally characterized by austerity of line. Yashvili ordinarily does not use glaze but prefers to accentuate the texture of the basic material.

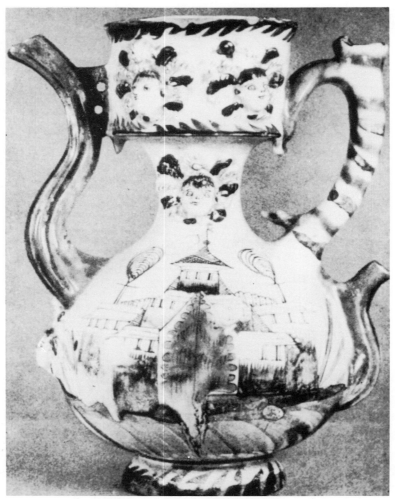

Majolica *kumgan,* end of the eighteenth century.

Sixteenth- and seventeenth-century black glazed pottery was made on the wheel and included various pots, large and small pitchers, dishes and saucers, short spherical bottles with low necks, *endovy* (spouted tureens), and *kumgany* (tall pitchers with trunklike spouts). The word *kumgan* came from the Near East (*kum,* "desert", and *gan,* "vessel"), where these pieces probably originated during the seventeenth or first half of the eighteenth century.

Another popular pitcher (*rukomoi*) was shaped like a stylized ram (or half ram, half horse) supported on four abbreviated legs, with a ring handle on its back. The vessel was filled through a large opening in its back, and water was poured out through a round mouth—it was a superstitious custom of those days to wash one's hands in running water rather than in a basin. At the juncture of the seventeenth and eighteenth centuries, the general type was adopted for use as tableware. Another variety of table utensil was the *kukhlia,* a short-legged barrel with a handle on top. *Kukhli,* transitions to the simpler forms of the eighteenth century, survive in certain low-necked, rounded pitchers of the present day.

Seventeenth-century documents indicate that glazed majolica was sold in the Moscow pottery *sloboda* during the second half of the century. Records mention an L. Kirillov who supplied the court with kitchenware and glazed inkpots made of plain red clay and covered with brown, yellow, and (less often) green glaze. A few glazed vessels and inkpots of the seventeenth and eighteenth centuries have survived, the latter shaped like small boxes with openings for inkwells and, on the side, several holes for quills.

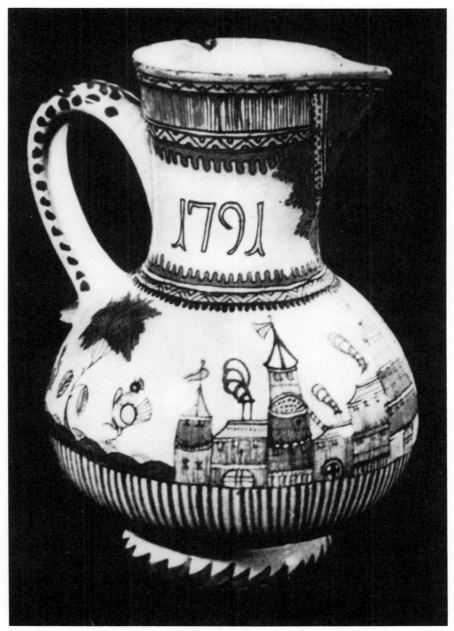

Pitcher, 1791.

Seventeenth-century flasks, though differing in size, were essentially similar in shape and design. Well-proportioned convex discs made up the body, and the vessel had four small conical feet, a small neck, and ears at the sides for hanging. Glazed flasks were differently proportioned, much heavier, and lacked the harmony of profile characteristic of the black flask. They were, however, more elaborately decorated than the black flask with its plain geometric design. Typical folk de-

signs include two birds on a holly tree, mysterious two-headed birds (later transformed into the double-headed eagle), and a single- or six-headed dragon—all well placed within the circle of the flask wall.

Differences in design were partly attributable to different production techniques. Black flasks were made and decorated by hand, while glazed flasks were produced from small carved wooden molds. Although the use of enamel relief was popular during the second half of the

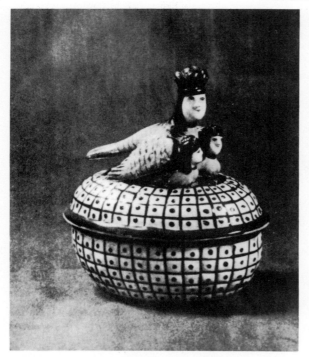

Porcelain butter dish. Gzhel, second half of the nineteenth century.

Among the many toys to have survived from the sixteenth and seventeenth centuries are some horses resembling those depicted in old icons. The general contour of the animal is given without detail; it generally has a broad chest and a swanlike neck and almost always has a saddle. The bear was another popular clay toy, almost invariably depicted standing, with a fat haunch and an open mouth. Some bears are muzzled, and the nose may have a hole for a ring. Despite their primitiveness of execution, these figurines are very expressive. All are made without slip and, as a rule, are fired not to redness but only to dark brown. Many bird whistles have survived, which, having several openings to permit modulation, produce surprisingly complicated sounds. Some bear traces of slip, and some are of relatively complex design—birds carrying fledglings on their backs, for example.

In the seventeenth century, potters near Moscow not knowing how to make porcelain, molded tens of thousands of painted toys out of ordinary clay. Many glazed earthenware statuettes were turned out in the eighteenth and nineteenth centuries; Soviet art historians claim that in the year 1814 alone, more than 70,000 were produced. The village of Gzhel was famous for its clay dolls, and the porcelain influence was especially marked in the nineteenth-century clay toys of Tula. Tula toys are more like figurines, but at one time por-

seventeenth century, that the glazed flasks alone have survived can only be explained by their low cost and greater simplicity of production. The pleasant effect produced by the colored glaze was its own justification.

Ceramic sculpture developed slowly in Russia. Figurines have been found in the Dnieper area representing early pagan gods, some covered with white slip and decorated with simple brown stripes. From the fourteenth and fifteenth centuries there survive a few glazed whistles found in Novgorod and some figurines of horses, goats, and dogs from Radonezh and Moscow. Some of the horses exhibit a starlike design in red, with red stripes on their chest and sides, relating them to an old sun cult. Others, dating from the fifteenth century and found in Moscow, exhibit wavy lines for the mane and a netlike design for the harness. Human figurines of men and women in contemporary dress, riders, and *skomorokhi* (itinerant minstrel-buffoons) are less frequent and very primitive. The potter made a cylinder of clay and embellished it slightly to suggest clothing. Sausagelike limbs were made separately and attached to the body. Noses were made by squeezing a bit of clay; eyes, by poking holes in the clay with a stick.

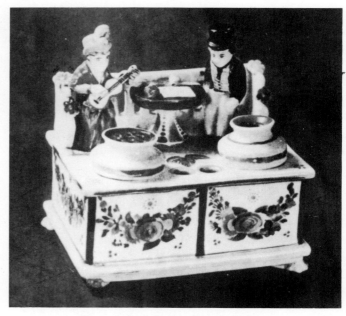

Porcelain inkpot. Gzhel, 1829.

"Dragon" decorative vessel. Skopin, late nineteenth century.

celain figurines (*krasavitsy*) were called toys; and although strict distinctions between the two are difficult to make, both are discussed at length in the chapter on toymaking.

Fine Art Potteries

Chinaware was very rare in early eighteenth-century Europe. Imported from the Orient under exceedingly perilous conditions by caravans that took years to cross Asia to the Atlantic, it is not surprising that merchants sold their goods at exorbitant rates at home. The Grand Elector of Saxony is said to have exchanged a dragoons regiment for a few china vases. In 1709 a German alchemist named Bettherr discovered the principle on which the making of china is based in the course of a search for the "philosopher's stone," an elusive object alleged to transmute base metals into gold. Attempting to keep this discovery a secret, Grand Elector August of Saxony moved Bettherr and his assistants to a remote castle, where they still remained under heavy guard when Europe's first chinaware manufactory was opened.

Because Russia lacked the formula for making por-

"Polkan" *kumgan*. Skopin, late nineteenth century.

celain paste, before Peter the Great all fine porcelain in Russia was imported. It was not until the eighteenth century that Empress Elizabeth decided to set up an imperial factory to compete with foreign establishments. In 1744 Baron Cherkasov was commanded to organize the manufacture of china in Russia. The Imperial Porcelain Factory was started in the spring of 1745, and the first experimental articles were produced the following year.

The two men engaged to solve the china mystery were the German Christopher Konrad Hunger, a supposed expert who had been specially invited from Stockholm for the purpose, and Dmitrii Vinogradov, a scientist and friend of Lomonosov. After countless experiments, Vinogradov in 1747 found the chemical formula for porcelain paste.* Hunger, exposed as a

* In 1950, the Soviet art scholar Alexander Saltykov learned that a Moscow merchant named Ivan Grebenshchikov had discovered the secret of porcelain at the same time as Vinogradov. In early 1747 Grebenshchikov sent the first Russian-made porcelain piece to St. Petersburg. But Baron Cherkasov, recognizing a rival for the empress's promised reward, used his office to demand that Grebenshchikov cease his experiments and destroy the secret.

charlatan, was discharged in 1748. Upon his dismissal, Vinogradov directed the factory for a decade, although its products did not begin substantially to improve until Jean Gottfried Müller was engaged from Meissen in 1758.

In January 1766 an English merchant, Francis Jacob Gardner, founded the Gardner pottery, one of the first privately-owned porcelain factories in Russia, in the village of Verbilka, near Moscow. The enterprise was an immediate success and grew into a large commercial business. By the end of the century two outlets had been established in Moscow and Tver for the distribution of its wares.

By 1762 there were twelve factories in Russia producing porcelain and faience; at the end of the eighteenth century there were twenty. After 1812, new state and private enterprises proliferated until there were more than fifty. Among the notable fine art potteries that opened during the nineteenth century were the Auerbach factory (1809), the Popov factory (1811), and a small private factory started by Prince Yusupov at Archangelsk (1814). The Safronov factory at Korotkii (1830) and the pottery of the Kornilov brothers both introduced decorative statuettes of national types in national dress.

In 1832 the first Kuznetsov factory was established at Dulev. Various members of this family opened their own potteries elsewhere, but in the course of the century they were all amalgamated, and other establishments, including the Auerbach, Gardner, and Maltsov potteries, were absorbed. At the time of World War I, the Kuznetsov enterprises produced roughly two-thirds of all the fine art ceramics in Russia.

Gzhel and Other Provincial Centers

At the juncture of the seventeenth and eighteenth centuries the Moscow pottery *sloboda* was the center of folk ceramics in Russia, but it gradually yielded its place to an area whose seat is the small railway station of Gzhel. Because Gzhel and its neighboring villages were under the direct seigniory of the czar until the late 1860s, the town is mentioned in several imperial testaments, the earliest being the fourteenth-century testament of Czar Ivan Kalita. Archaeologists have unearthed children's toys—cockerels, ducklings, and lambs—made in the fifteenth and sixteenth centuries of what chemical tests have proved to be Gzhel clay. Its reputation as a pottery-making center was

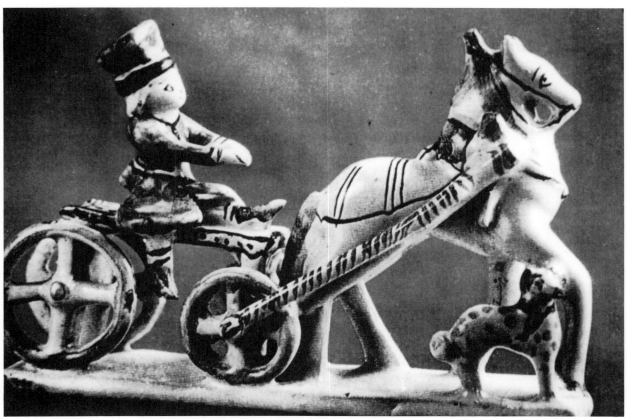

"Drozhki." Gzhel china, first half of the nineteenth century.

Lion. Gzhel china, late eighteenth century.

Kumgan, eighteenth century.

sufficiently established by the seventeenth century that in 1663 Czar Alexei Mikhailovich commanded Gzhel clay to be brought to Moscow for the making of ceramic containers for various medicines.

Hiring several experienced Gzhel potters to work for him, Afanasii Grebenshchikov, a Moscow merchant, opened a factory for glazed earthenware near the Gzhel road in 1724. Grebenshchikov later complained that on the expiration of their contracts, these peasant potters opened their own potteries, and he repeatedly petitioned the czar to have them made his chattels. By 1770 there were, in fact, some twenty-five majolica potteries in the villages near Gzhel, and these remained in operation, substantially improving upon the Grebenshchikov product, after the latter's factory closed in 1774. Their plates, jars, and kvass jugs were greatly esteemed by their contemporaries, and

their blue white tableware, in great demand among the common people, was sold everywhere in Russia. By the end of the eighteenth century, majolicaware had largely replaced its earlier counterparts in pewter and copper.

Gzhel folk craftsmen remained ignorant of how porcelain was made until 1801, when a German named Carl Otto opened a small porcelain factory on the Gzhel road and selected his workers from among the local potters. Although this factory soon closed without producing anything of significance, a Gzhel peasant named Pavel Kulikov, who had worked at Otto's factory for a year, opened a porcelain factory of his own in the village of Volodino.

To keep his lifted secret hidden, Kulikov engaged only one assistant, an old deaf-mute from a different village. His precautions did not suffice, however. One night while Kulikov slept, two men entered the shop through

Khrapunov is a teapot in the shape of a seated monk occupied with a bottle of vodka.

Another Gzhel potter, Afanasii Kiselev, is credited with introducing a number of innovations in the manufacture of porcelain paste and the painting and firing of chinaware. Kiselev was the first in Gzhel to replace the hand-driven potter's wheel by a foot-operated one. He also devised a species of "bronze" ceramics—pottery that seems cast in an old, greenish bronze but actually made of a fine white clay covered with a special colored glaze. Kiselev later entered partnership with the Terkhov brothers in a porcelain factory in the village of Rechitsa, a manufactory that was reputed throughout Russia for its tableware and statuettes of celebrated mid-nineteenth-century Russian actors.

Kvasnik, seventeenth–eighteenth centuries.

Kumgan, 1840s.

the chimney stack, sketched the plan of the furnace, stole samples of the paste and glaze, and fled. Within some twenty years, Gzhel and its neighboring villages composed Russia's largest china center, with dozens of factories producing ceramics that are on exhibition in Soviet museums today.

The State Museum of Ceramics is today housed in a country mansion in Kuskovo, not far from Moscow, that once belonged to Count Sheremetev. The china figurines exhibited in the first few rooms include fops, court ladies, exotic Negroes, Chinese, and shepherds and shepherdesses in gold-embroidered dress. The simpler ware includes statuettes of street vendors, beggars, servants, and peasants—all executed by the self-taught potters of Gzhel. The "Impious Doll"—a figure of a monk bearing on his back a girl concealed in a bundle of straw— was made at the pottery of the Gzhel peasant Nikita Khrapunov (father of one of the men who stole the porcelain secret from Kulikov) in 1821. Also by

The work of certain smaller potteries includes figurines of a drunken peasant playing a balalaika, a fighter with his fists poised, a peasant sharpening a scythe, a bearded *muzhik* carrying firewood, and some girls dancing—all highly stylized, painted in but two or three colors, and not unlike the ordinary clay toy.

With the development of ceramics factories in the nineteenth century, pottery-making moved from the city to the countryside where pottery centers generally developed, a given center being connected with a number of villages that cooperated in production. Although better works were sometimes signed by master craftsmen, most remained anonymous. Because most of the peasant potters employed the same techniques, objects differed more in individual decoration than in shape.

The bluish black pottery known among the people as *siniushki* was very popular throughout Russia, but especially in Yaroslavl Province, in the nineteenth century. The *shchanki*, a black vessel for carrying cabbage soup (*shchi*) to the fields, was a popular object made in Yaroslavl, whose bluish black ceramics stand out for their form and elegance. Pskov Province was distin-

guished by the massiveness of its ceramics and for their rougher, heavier finish. The somber reddish yellow color of Pskov ceramics, especially pronounced under a coat of shiny leaded glaze, was somewhat enlivened by the application of large spots of white slip. Slip was not applied with a brush but poured over an object. In addition to pieces finished in this manner, Pskov was also known for its large, brush-painted squares, stripes, and simple Christmas tree designs, motifs having much in common with those used in folk weaving.

Typical of the Vyatka clay utensils of the nineteenth and early twentieth centuries was the *medennik*, a large pot with a cover, holding a bucket-and-a-half of water —a copy of a contemporary copper utensil of similar size and shape. Potters even imitated the jointed sections of copper *medenniki*, using the divisions for decorative accent. The green color typical of the Vyatka area was obtained by applying copper powder selectively over a surface of white slip, leaving certain red parts exposed for color contrasts.

In 1899 P. Vaulin, working at the Abramtsevo shop, discovered the reduction method of glazing, which gave

Pitchers, end of the eighteenth century.

Beautiful Girl. Painting on cupboard, early eighteenth century.

Nineteenth-century print.

Woman's shirt (fragment). Weaving and embroidery, Archangelsk Province, nineteenth century.

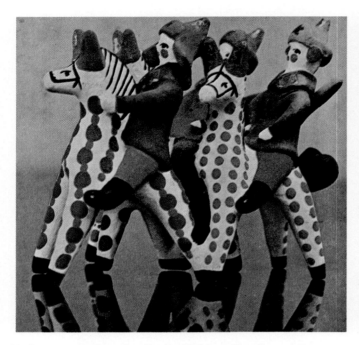

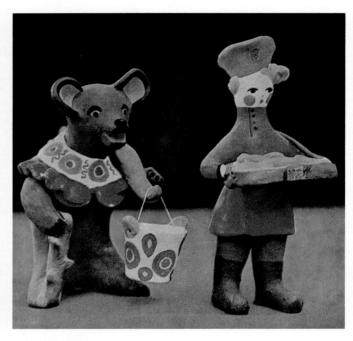

Red army eaglets, by L. G. Fokina. Dymkovo clay toy, Soviet period.

Village peddler, by N. N. Sukhanova. Dymkovo clay toy, Soviet period.

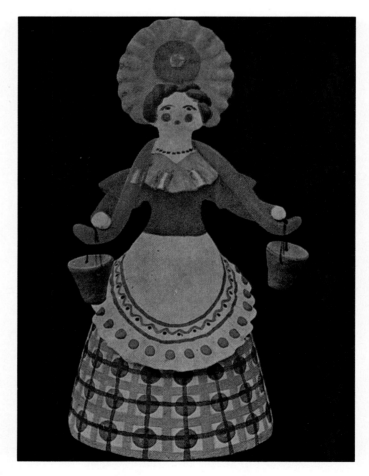

Water carrier, by E. Z. Koshkina. Dymkovo clay toy, Soviet period.

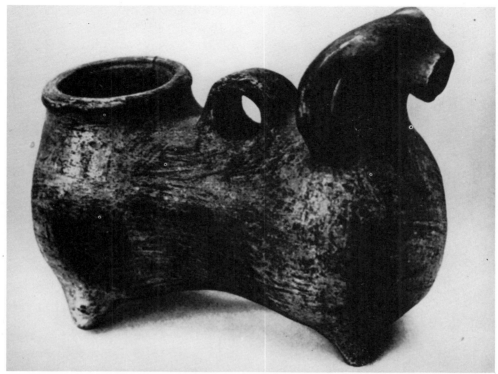

Rukomoi (hand basin), seventeenth century.

objects the shine of metal or of mother-of-pearl in greater or lesser intensity. The reduction method was soon mastered by the Stroganov training school, the Murava shop in Moscow, and the Shtiglits art school of St. Petersburg. At the turn of the twentieth century, many large and small potteries existed in the countryside of each province. Ceramics was developed in from 190 to 200 districts. From 1898 to 1916, according to available data, there were 4,343 master potters in Vyatka, 2,553 in Moscow, and 1,000 in Voronezh. In 1919, however, the largest enterprises and factories were nationalized, and the last of the small private enterprises died at the close of the twenties, when the craftsmen united to form the Artistic Ceramics Cooperative.

Skopin

Since the twelfth century, rich beds of light-tinted pottery clays have provided a natural handicraft for peasants of the villages located where the small town of Skopin (Riazan Province) stands today. At the end of the sixteenth century, when the town was called Ostrozhok, a whole district of potters had developed which supplied both neighboring hamlets and more distant villages with crockery known as *siniushki*, or "blues," for the bluish black tint they acquired in the firing process. Durable and cheap, "blues" commanded a ready sale and by the nineteenth century had reached markets as far away as Rostov and Taganrog.

Skopin potters were also famous for roof tiles, picturesque ceramic jugs, and candlesticks depicting a drunken fiddler or the ubiquitous double-headed eagle. Above all, however, Skopin attracted interest for its trademarks: kvass jars modeled in the form of a local bird of prey—the *skopa,* a kind of eagle-owl, from which the town derived its name—and its earthenware jugs made in the form of the bearded centaur (half man, half horse) of Greek mythology. The image of the centaur had come to the ancient Slav tribes by way of the Scythians, the Greek colonies along the shores of the Black Sea, and from illuminated Byzantine manuscripts in Kievan Rus. Although Russian folk potters of the eighteenth century often decorated mugs, pitchers, and candlesticks with figures of people, animals, and birds, in Skopin alone this bizarre style became a specialty.

Unlike the potters of Gzhel, the Skopin artisan con-

Kvasnik, nineteenth century.

handed down from father to son), by excising, or by incising with a penknife or a wooden graining tool. The vessels were normally decorated in one of three colors —brown, yellow, or green—the potters preparing their own pigments and achieving a remarkable variety of shades of one color.

Skopin potters advertised their wares by placing their work for public view on their gateposts or by playing a tune on a homemade whistle to inform the public that they had a cartload of pottery for sale, the latter practice earning them the nickname of "whistlers." On occasion they would set off for a fair, placing their "advertisements" on top of their cartloads of "blues".

The ceramic kitchen crockery of Skopin was usually firmly constructed, well formed, and beautiful in design, but it was the oddly shaped ceramic objects that sold best at fairs. Especially popular were the *skopa* jars and a variety of kvass jars made in the shape of single, spokeless wheels with round or square sides, and sometimes in the shape of two wheels (the inner part of the wheel held ice wrapped in cloth). The spout of the kvass jar was often shaped as a snake impaled by the talons of the *skopa,* whose wings covered the neck of the vessel.

Skopin ceramic objects are generally prized as follows: (1) large lions, up to two feet in height, reclining or standing, that are copies of the sculptured lions in front of wealthy homes and estates; (2) centaurs with pikes, bows and arrows, probably modeled on those depicted on *lubok* engravings of Polkan the *bogatyr.* These centaurs usually carry some sort of vessel on their backs, at the same time that they are themselves vessels; (3) birds with snakelike beaks and bears with centaurs on their backs, both having handles; (4) birds with open beaks holding the base of a candlestick; (5) candlesticks in the form of the heraldic double-headed eagle; (6) various pitchers or candlesticks in the form of human figures; and (7) geometrical pitchers, sometimes having people, birds, beasts, or fish on their lids.

The Skopin pottery craft died out during World War I when most of the craftsmen were drafted into the army and the demand for Skopin ware declined to negligibility. In 1934 a few surviving craftsmen exercised sufficient determination to revive the production of earthenware; in time their sons joined the Skopin ceramics cooperative, occasionally reproducing the strange old handiwork for museums or exhibitions. For the most part, however, the cooperative produced plain, ordinary

sciously followed the methods of the twelfth century. He took his clay from the same ravine near the village of Petrushki, near Skopin, from which potters are said to have obtained their clay for the past five centuries. He stored the clay at home, kneaded it with his hands and feet, and fired it in a stove occupying half of his hut. The whole family participated in production— men making jars, jugs, and bowls with the assistance of their children, women producing simpler objects, such as toy whistles.

In Skopin, ceramic objects were customarily formed by hand from a kind of clay cord, the body, neck, and base made separately. When the clay was dry, the craftsman added decoration by using a stamp (usually

Rukomoi. Pskov Province, nineteenth century.

earthenware. After World War II, the Industrial Arts Institute decided to resuscitate the craft. A new building was established for the factory, new equipment was installed, and an old master potter, Mikhail Pelenkin, was asked to supervise the workshop. Since 1949 Skopin pieces, mostly imitations of older originals, have been exhibited both in the USSR and abroad.

7
TILES

Early Tiles

The art of architectural ceramics first arose in Russia under Byzantine and Balkan influence for the decoration of exteriors, interiors, and floors of churches and palaces. The oldest tiles—thin baked clay plates with raised or painted designs—date generally from the turn of the twelfth century, although not far from Desiatinnaia Church in Kiev, glazed tiles decorated with wavy lines, loops, and circles were found among the ruins of what is believed to have been a tenth-century castle of Princess Olga.

A great many early earthenware tiles with green, yellow, and brown glazes have been found in excavations in Kiev, Chernigov, Riazan, Vladimir, Grodno, Galich, Polotsk, Smolensk, and elsewhere. In Belgorodok, which once stood on the borders of the Kiev Principality, the floor tiles of the church bore a design resembling parallel brackets. In Vladimir, as in Kiev, yellowish brown floor tiles were decorated with looplike designs, although one early tile bears the image of a cockerel. The Kolomenskaia Church in Grodno has a splendid exterior tile design that survives to the present day. Its floor is also made of tiles of various sizes and shapes: round, semirounded, oblong, and triangular, from three-by-

three to eight-by-eight inches in size, each plate colored with yellow, green, or red glaze.

But 250 years of Tatar subjugation interrupted the cultural growth of Rus, and tilemaking was one of a number of arts that perished altogether, its secrets sur-

Apocalyptic Beast. Early Russian terracotta tile.

100

viving only in a few small towns that later became part of the Lithuanian State. In Russia, tilemaking revived during the fifteenth century. Small, unglazed tiles from this period—called "red" tiles for the color of the baked clay—with raised patterns pressed in wooden molds were unearthed in the excavation of a rich country estate in Old Novgorod. The first typical Russian tiles with raised patterns covered with green slip appeared at the very end of the fifteenth century in the city of Pskov and were used to line the cornices of new white stone churches, fortress towers, and domestic stoves. Such tiles may still be seen on the dome of the Church of Georgii na Vzvoze, built in 1494 on the shores of the River Velikaia in Pskov.

In the Dukhovskaia Church of the Holy Trinity–St. Sergius Monastery, in the Voskresenskii Cathedral in Volokolamsk, in the palace of Czarevich Dmitrii in Uglich, in the Chashnikov Church near Moscow, and in other constructions built at the juncture of the fifteenth and sixteenth centuries, exterior friezes and balusters were made of terra-cotta. In friezes, terra-cotta was used in imitation of carved white stone and always covered with a layer of slip. The plates were about two inches thick and measured up to twelve-by-fourteen inches. They were made in a wooden mold, and the design was given additional work later on for greater clarity. The design stood out from one-half to three-quarters of an inch and included floral and animal motifs. Balusters, made in one piece with a hole in the center for a metal rod, were up to fifteen inches high and about seven inches thick around the middle. Occasionally one encounters balusters without a design, as, for example, in Volokolamsk, where they were probably turned on a potter's wheel.

Tiles covered with green, brown, and yellow glaze are believed to have appeared in and around Moscow only in the mid-sixteenth century. The earliest known Moscow tiles decorate the top of the Cathedral of Pokrov. It is possible that in the 1560s the same masters created monumental tiled bas-reliefs for the cathedrals in the cities of Staritsa and Dmitrov. There are three majolica panels at Dmitrievskii Cathedral: two crucifixions and a St. George, each panel about eighteen feet square. In 1555, on orders from Ivan the Terrible, the church of St. Basil the Blessed was built in Moscow to commemorate the capture of Kazan. The church has eight domes, and it was not until the nineteenth century, in the course of repair work, that it was discovered that tile had been used on the center dome and later

Moscow "red" tile, sixteenth century

painted over.

In the second half of the sixteenth century, small "red" stove tiles—also called "small hand tiles"—appeared in Moscow. These were about six-by-six inches in size, decorated with a simple floral or animal design, and bordered by a flat frame. Because these plates were not glazed, smoke from the stoves they decorated penetrated their pores and caused them to blacken. Repeatedly whitewashed, they nevertheless blackened again, and the design eventually vanished under the layers of repainting. Although this problem was eventually solved by glazing the tile, at first the glaze was applied directly over the clay, with the result that the reddish clay showed through, producing an unattractive effect of rusty stains. In the course of time, however, the clay was coated with a thin layer of opaque white before it was glazed.

In the seventeenth century, production of these tiles flourished. Their size increased to eight-by-eight inches —the so-called "large hand tiles"—and as technique improved, designs became more elaborate, including pictures of flowers and plants, birds and beasts, portraits of saints, war and genre scenes, and fairy tale subjects. The green glazed tile, a transitional step from the "red" to the ornamental tile, continued to be used in the decoration of churches, including the Holy Trinity–St Sergius Monastery, the Joseph Volokolamsk Monas-

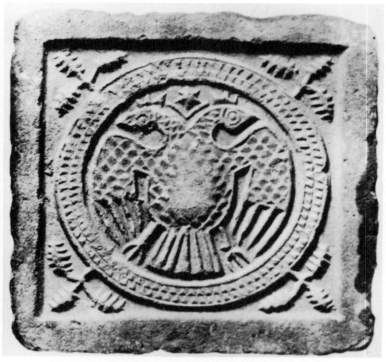

"Red" tile. Clay, sixteenth century.

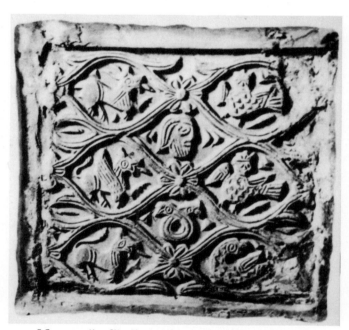

Moscow "red" tile, early seventeenth century.

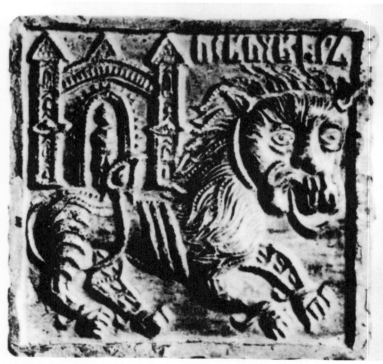

Glazed tile. Clay, green glaze, first half of the seventeenth century.

tery, and the Spaso-Torgovaia Church in Rostov—in fact, the largest known green tiles were used in Rostov in the 1670s. The tiles now found on the walls of the Joseph Volokolamsk Monastery, however, are not glazed but coated with colored enamel. The first colored enamel tiles appeared in Russia in the 1660s, during the reign of Alexei Mikhailovich, mainly near Moscow where Patriarch Nikon was engaged in building a New Jerusalem on the shores of the River Istra.

The New Jerusalem

In 1652 Nikon became head of the Russian Orthodox church, or Patriarch of All Russia. An ambitious man, Nikon sought to exalt the Russian Patriarch over the Pope of Rome, to advance the idea of Russia as "the third Rome," and, not incidentally, to place the Russian church outside imperial control. To this end, in the summer of 1656 he ordered that work be begun about forty miles outside Moscow on a monastery that was to be an elaborate reproduction of the church in Jerusalem where the body of Jesus was believed to be buried. Instead of the fourteen chapels of the original, however, Nikon planned to build 365, one for each day of the year, although he eventually settled for twenty-nine.

In 1654, Nikon sent an agent, Arsenii Sukhanov, to Palestine to obtain a description and model of the shape, dimensions, and ornamentation of the original shrines. Soviet art scholars believe that the patriarch also possessed certain drawings and floor plans of the Jerusalem church which an Italian, Bernardino Amico, had copied in 1596 and published in Rome in 1609. In 1943–44 the Soviet architect A. V. Shchusev compared the measurements of Nikon's temple with Amico's drawings and found them to coincide exactly.

Because marble and granite were rare and expensive in Russia at the time, Nikon decided to base his decoration on multicolored tiles. For this purpose, thirty-two master carvers and tile-makers, including Ignatii Maximov and Stepan Polubes ("the Half-Devil"), were brought to Istra from the Iverskii Monastery in Byelorussia. So great was Nikon's respect for Piotr Zaborski, a master in the making of gold, silver, and copper objects, tilemaking, and in other handiwork who was specially invited from the Lithuanian State to supervise the work, that when the latter died in 1655, Nikon commanded that he be buried at the main entrance inside the church.

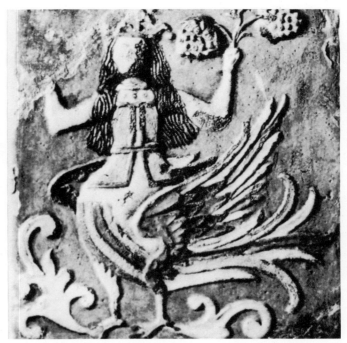

Tile of the fabulous Sirin bird, second half of the nineteenth century.

Under the influence of contemporary Polish art, the masters brought to Istra from Byelorussia were the first in Russia to use solid enamel colors instead of transparent green glaze. Their tiles were not only flat but also formed to fit the rounded parts of the construction, so that the tile became an architectural detail instead of merely a flat plate. They also introduced the innovation of composing a single picture of from four to eighteen tiles, each contributing only a segment of the total design.

The sixty-foot roof of the New Jerusalem temple was lined with tiles. The arches and portals are faced with large tiles composing a vast design of yellow flowers and herbs in flower bowls against a blue black background. The windows are framed with large strips of tiles with the tiled head of a lion above them, the lion greatly resembling the white stone lions at the foot of each column of the twelfth-century Cathedral of St. Dmitrii in Vladimir as well as folk woodcarving in the Trans-Volga area and northern Russia. The seven iconostases—about twenty-four feet high and four feet wide—were for the first time in Russia made not of wood but of blue, yellow, green, white, and rusty brown glazed tiles with raised designs. The tiled head of an angel tops each iconostasis, and there are tiled cherubs above the lacunae

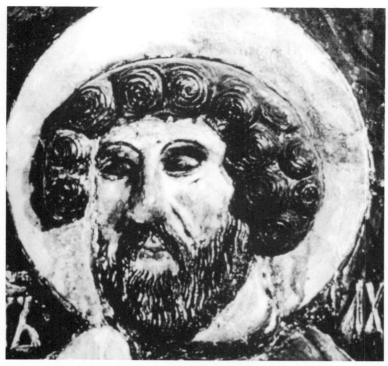

St. Luke and St. John (detail). Tiled bas-reliefs by Stepan Polubes, Moscow, second half of the seventeenth century.

Tile. The Church of Nikola at Arbat, Moscow, second half of the seventeenth century.

Decorative rosette. Clay and colored enamels, Yaroslavl, second half of the seventeenth century.

Stove tile. First half of the eighteenth century.

for the icons in each tier.

When Nazi troops attempted to blow up the temple in 1941, the roof, campanile, and colonnade around the Holy Sepulchre collapsed. The walls, the underground chapel, and many of the side altars are still intact, however, along with 400 of the original 500 tiles made in the shape of winged angels that composed the solid outer frieze.

In 1666 Alexei Mikhailovich exiled the ambitious patriarch to the Ferapontov Monastery in the remote North, and work on the New Jerusalem ceased, although its workshops remained in operation until 1732. The czar ordered the thirty-two tilemakers and master carvers to the Oruzheinaia Palata, where the production of architectural ceramics flourished and spread to other cities, including Kostroma, Riazan, and Rostov, among others. Stepan Polubes and Ignatii Maximov made stove tiles for the royal family, tiles for the new patriarch's private chapel and for friezes in the Kremlin. For the new Church of St. Gregory of Neokresariisk in

Tiled stove (fragment). Moscow, second half of the eighteenth century.

cow pottery *sloboda* produced majolica figurines of angels and apostles that adorned the Solochinsk Monastery near Riazan.

Also in Moscow, O. Startsev and his son Ivan produced, for the most part, neatly detailed architectural tiles, some of which were used in the New Jerusalem project. Another school was headed by one Ippolit, who used his skill in woodcarving in his tile work, which resembles the carving on late seventeenth-century iconostases.

The architectural style known as Moscow baroque stimulated the further development of tilemaking in Russia. New centers of the art arose rapidly—among them Yaroslavl, Vladimir, Balakhna, Vologda, and Kaluga, each contributing characteristics unique to the region or city. Toward the close of the 1670s, tilemaking had become so widespread and popular that even Nikon, the exiled patriarch, asked for a tile stove in his cell.

Stove tile. Clay, colored enamels, glaze, first half of the eighteenth century.

Moscow, Stepan Polubes made hundreds of large tiles repeating designs used in the New Jerusalem temple.

In the second half of the seventeenth century there were several prominent schools of tilemaking in Moscow. The first, headed by Stepan Polubes, produced ornamental tiles with enamel relief, in which the design surface was made slightly concave to prevent an overflow of enamel. Designs were large and bold, colors bright and vivid. Polubes's floral designs were very popular because they greatly resembled those on textiles, embroidery, and other folk arts of the period. Documents also reveal that Polubes's shop in the Mos-

Stove "belt" tiles. Clay, colored enamels, glaze, Moscow, mid-eighteenth century.

Eighteenth-Century Tile Work

In the course of two centuries the Russian tile progressed from unglazed terra-cotta with a raised design to raised patterns covered with a green slip glaze, then to raised patterns in five colors, and finally to enameled tiles in which the raised design lost its sculptural value and was used simply as a divider between the colors. Designs, which had consisted at first of geometrical stylizations resembling those used in white stonecarving, had become florally more diversified and more complex with the introduction of fruits, birds, animals, and human scenes.

At the turn of the eighteenth century, tiles were used almost exclusively for domestic stoves. During the reign of Peter the Great, raised-pattern tiles finally became smooth-surfaced ones with painted figures and bright decoration in green, brownish violet, and yellow. White tiles with blue designs in imitation of Dutch tiles were common during the first half of the century, but the demand for them was slight and production soon discontinued. The new tiles of the eighteenth century often had oval painted frames with legends inscribed at the bottom, but in time both frame and legend disappeared.

The subject matter of the designs was sometimes very complicated, whether a green glaze alone or five-color enamels were used. There were pictures of Czar Alexei Mikhailovich and renditions of the siege of the Holy Trinity–St. Sergius Monastery. Tiles made by the Borisoglebsk Monastery depict horsemen in German, Roman,

and other uniforms. Transitional tiles bearing a raised design of the double-headed eagle are to be seen on stoves in the Uspenskaia Church in Alexandrov. The eagles are yellow against a green background, but there are also horses, lions, and sometimes crowns covered with brown and green glaze. Similar tiles are found on the stove of the Tukhvinsk Church of Alexeevskoe village near Moscow. Seventeenth-century motifs were preserved in the provinces into the eighteenth century.

Introduced to Dutch and Hamburg tiles during a visit to Holland in 1697–98, Peter the Great decided in 1709 to initiate the manufacture of tiles in Russia. Two captured Swedish soldiers who had formerly been tilemakers were sent to the New Jerusalem workshops to produce enough Dutch tiles for ten stoves. Peter was dissatisfied with the result, however; the stoves at his St. Petersburg summer palace bear Russian tiles that testify to the high quality of the tiles produced at the Nevskii brickyard.

Grebenshchikov's potteries in Moscow and, until

Stove tile. Clay, colored enamels, glaze, Kaluga, first half of the nineteenth century.

1732, the New Jerusalem workshops together supplied countless painted stove tiles for the Muscovite nobility. Tiles were also made in Kaluga, Tula, Yaroslavl, Vologda, and elsewhere. In the 1770s there were ten tile enterprises in Kaluga; at the beginning of the nineteenth century, there were forty-five such enterprises in Russia, eleven of them in Kursk.

Notwithstanding the czar's attraction to Dutch tiles, foreign work did not substantially influence Russian tile-making, as Russian craftsmen introduced characteristics of their own. The European imports were white blocks with blue pictures and a frame of straight lines or flourishes. Russian craftsmen immediately substituted a popular floral motif for the frame, introduced the by now traditional five colors of the Russian tile, and borrowed subjects from icons, folk songs, *lubki*, everyday life, and illustrated primers and readers (such as *Symbols and Emblems,* an illustrated collection of German, French, Italian, and Latin sayings and proverbs published in Mainz in 1668 by I. Kamerario, later translated into Russian and issued in large numbers). The czar encouraged the use of tiles for decorating kitchen walls, but this did not catch on.

Stove tile. Clay, colored enamels, glaze, Moscow, early nineteenth century.

Stove tile. Moscow, first half of the nineteenth century.

The growth of Russian trade abroad may have inspired the great popularity during the eighteenth century of "ethnographic" tiles depicting people of various nationalities and of tiles depicting travelers. *Chinese People, Zhur Tribe, French Strolling Player, Persian Merchants,* and *Arab Woman* are among those of the ethnographic class, while *Homeward Bound, Going My Way, Going to My Place,* and so forth, typify the latter group. One traveler tile inscribed *Carrying the Lazy* shows a person seated on an elephant under an umbrella.

Equally popular were musical scenes (*The Flute Player, Playing for Amusement, Music Soothes*), amorous or mythological subjects, and pictures of birds and animals, although hunting scenes were rare. Religious themes, too, were infrequent, although a stove in what was once a local bishop's house in Suzdal was faced with tiles based on biblical themes and texts. A group of "homiletic" tiles depicted women either anticipating, wounded by, or made thoughtful by love, with such inscriptions as *With an Offering of Mead I Go to Greet My Swain, He Has Wounded Me,* or *Too Late to Repent.* Pictures of men had lighter inscriptions: *Drink and Be Healthy* and *Old but Gay.*

Nineteenth-Twentieth Centuries

At the beginning of the nineteenth century Russian stoves were decorated with projecting white tile bearing mythological designs, although colored tiles with folk designs still dominated the countryside. The white tile of classical style resembled ancient marble sculpture, but it lacked warmth and the domestic stove became more solemn than cozy. The emphasis in subject matter was on allegorical and didactic themes with large, pompous pictures in solemn frames. Designs became increasingly laconic; bright colors were replaced by a cold blue in combination with yellow and brown; and a narrow frame replaced the broad ornamental folk frame. The nineteenth century was essentially a period of imitation rather than of original creative effort, and it was at this point that the tile ceased to develop.

In 1835 restoration work was begun on one of the Kremlin palaces, and although seventeenth-century stoves were revived, this did not suffice to revive the colorful old art of the tile. The national movement of the seventies and eighties brought the tile briefly to life once again. In 1874, tiles bearing characters in Church Slavonic were used to decorate the interior of the Slavianskii Bazaar. At the pottery shop of the Stroganov school under the direction of V. I. Vasilev, majolica icons were made for a chapel built near Moscow's Ilinskie gates to commemorate the capture of Plevna. By far the most outstanding achievement in tiles of the Stroganov school was the majolica produced to decorate the entire front exterior of the Lapatin house in Moscow, built in the 1870s. Majolica was also used for panels, as on the Hotel Metropol in Moscow (1900–1903).

At the end of the nineteenth century a number of small private shops produced colorful tiles and decorated bricks, but at the turn of the twentieth century, outstanding work was done only by individual artists, such as M. A. Vrubel, V. M. Vasnetsov, and A. Ia. Golovin, who attempted to revive the craft. Vrubel created a majolica fireplace depicting the *bylina* about Mikula Selianinovich and Volga Sviatoslavich that was exhibited in 1900 at the Paris World's Fair. In 1900–1902 Vasnetsov worked on a number of projects, including the front of the Tretiakov Gallery. These artists worked in connection with the Abramtsevo majolica center, where panels and other building decorations were produced, including majolica plates still used in the decoration of churches in Moscow and elsewhere.

The Murava school, organized in Moscow in 1904,

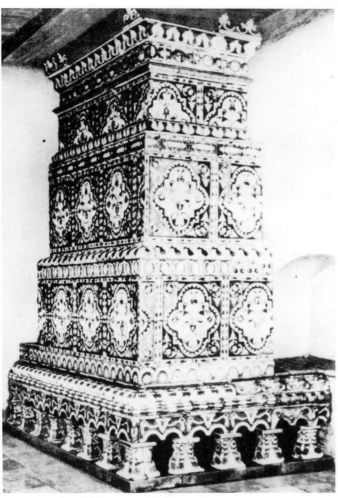

Tile stove, eighteenth century.

A few eighteenth-century stoves faced with painted tiles, but elaborately unusual in shape, are still extant in the USSR. One, now in a Suzdal museum, is about eleven feet high, composed of six tiled tiers separated from one another by tiled cornices, and shaped like a truncated pyramid. The second tier alone is composed of smooth, evenly spaced tiles. The other tiers contain tiles of various shapes and sizes and are additionally ornamented with recessed arches, niches resembling the narrow arched windows of old churches, half-columns, and the small barrel-shaped columns of pre-Petrine Russian architecture.

This stove probably reflects the ultimate in eighteenth-century tile work. Although a demand for multicolored painted tiles persisted among the merchant and lower middle classes in the provinces, at the end of the century tilemaking declined in the cities.

was dedicated to the reproduction of old folk art, and in 1913 this group participated in the restoration of the tiles of the Kruitiskii Palace. But architectural ceramics had already deteriorated into a commonplace craft, and it fell into complete decline in the early twentieth century.

8

TOYS

Wooden Toys

The wooden toy has been known in Russia since ancient times. As early as the ninth century, and perhaps even earlier, wooden toys for children existed among the eastern Slavic tribes that had settled along the Volkhov River. Archaeologists have found wooden toys in the territory of ancient Novgorod and Old Ladoga. In general, they were made in forested areas where wood also served for the making of houses and domestic utensils.

Where woodworking became a basic occupation, toymaking coexisted with the craft of the carpenters, joiners, and turners. In Nizhegorodsk Province, for example, the carving of ships and houses and the painting of carved household utensils produced strong hereditary cadres of master craftsmen with a number of gifted toymakers among them. In many regions—depending upon the availability of material and a ready market—toymaking gradually became an independent craft. Villages which became centers of the craft were generally situated near the Volga or close to towns and highways and the larger markets.

The first written records of wooden toys existing on a large scale in the everyday life of the people, however, date only from the seventeenth century. Palace records noted in 1636 that a "toy cart with wooden horses" had been purchased for the royal children from the Holy Trinity—St. Sergius Monastery. In 1721, Catherine I (wife fo Peter the Great) acquired from the same monastery a toy set including "three cows, two horses, two deer, four rams, two pairs of swans, two roosters, one duck with three ducklings, and a town with soldiers" at a cost of four rubles. Unfortunately such toys were rarely preserved—children then as now outgrowing and discarding them—and there are very few eighteenth-century toys extant. The wooden folk toys of the nineteenth and twentieth centuries are in a better state of preservation, and it is from these and such information as they yield that the history of Russian folk toys has been reconstructed.

Founded in 1337, the Holy Trinity—St. Sergius Monastery (now in the town of Zagorsk, about forty miles from Moscow) was the largest and most important center for the carving of Russian wooden folk toys in the seventeenth century. A woodcarving industry gradually developed in the surrounding villages on the monasterial estates, the local peasant turning to carving for an additional source of income as pilgrims flocking to the monastery sought some souvenir of their visit.

Although information is vague about the inception

111

Panka. Archangelsk Province, nineteenth century.

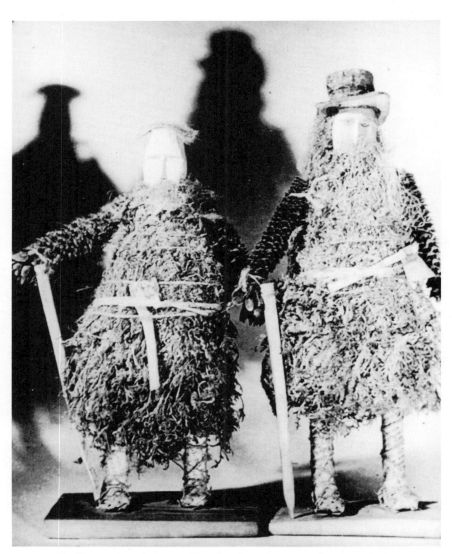

Dolls made of moss. Vyatka Province, early twentieth century.

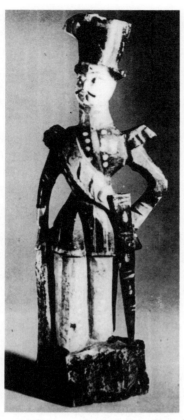

Hussar. Bogorodskoe and Sergius Posad, nineteenth century.

18 June 1822 the czar's cabinet of ministers assembled to discuss a charge by Archimandrite Savva of Saratov Monastery that in November 1821 he had seen at a town fair a china statuette of a monk carrying on his back a sheaf of straw in which a girl was concealed—a clear case of defamation of the clergy. The cabinet brought the matter to the attention of Alexander I, whence an imperial edict was issued confiscating and forbidding possession of the statuette. This figurine, previously mentioned in the chapter on ceramics, was made at the pottery of the Gzhel peasant Nikita Khrapunov. Its wooden counterpart depicts the same lecherous monk; and while no one knows which of the two appeared first, other satirical pieces in wood exhibited at the museum in Zagorsk show plainly that peasant craftsmen enjoyed ridiculing the clergy. Painted wooden figures dating from the mid-nineteenth century depict manifestly pregnant nuns and fat, boozy monks playing the concertina.

Around the juncture of the eighteenth and nineteenth centuries carved wooden toys began conspicuously to

of toy production in this area, it has been estimated on the basis of preserved toys that toys were objects of trade here from about 1750. At this time the work of Zagorsk and Bogorodskoe was virtually indistinguishable. In Zagorsk, toys were carved and painted. Toys were not painted in Bogorodskoe but were taken to the *posad* to be sold and sometimes to be painted as well, so that many toys were the work of craftsmen of both Bogorodskoe and Zagorsk.

In the early nineteenth century clay suitable for chinaware was discovered approximately 100 miles outside Zagorsk. Soon dozens of potteries had appeared in the local villages, most of them producing china figurines in addition to tableware. In the course of time peasant wood craftsmen attempted to imitate these figurines, while the potters, in turn, often asked the carvers to model hardwood prototypes for their china miniatures. Thus, a statuette in porcelain might either be preceded or followed by its wooden counterpart.

The case of the "impious doll" is illustrative. On

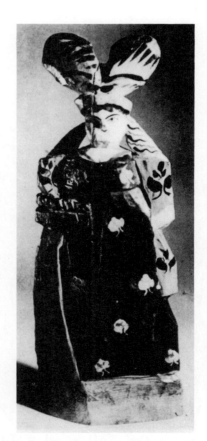

Provincial Lady. Bogorodskoe and Sergius Posad, nineteenth century.

improve in form and technique, and a variety of new subjects was introduced. Objects which had previously been predominantly rural in feeling and origin began increasingly to reflect the influence of urban life and of the West in wooden copies of statues in parks and townhouses and copies of bronze and porcelain household ornaments.

The influence of both French and Russian porcelain is especially evident in certain small wooden figures whose style greatly resembles that of the porcelain groups of the Popov pottery, although folk craftsmen succeeded in incorporating their own individual touches into them. Figures of greedy merchants, flashy officers, and vain gentlewomen characterize the style, the latter series known in the trade as *dury* ("sillies"). These were fifteen-inch figures usually carved from a prism-shaped block of wood, the widest side forming the back, the remaining sides carved into the round face of a complacent pudgy lady. The arms, shoulders, waist,

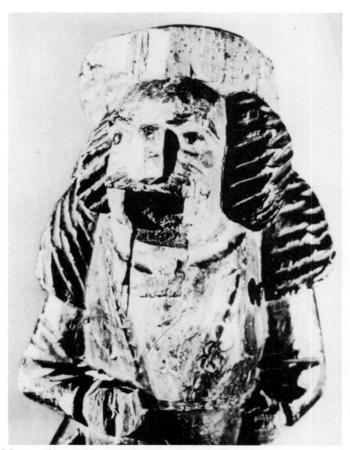

Nutcracker (detail). Sergius Posad, nineteenth century.

and bosom were conventionalized, but the dress faithfully copied smart fashions of the early nineteenth century. Likewise stylized was the hussar fop leaning against a pillar with a spyglass in his hand.

Peasant craftsmen delighted in caricaturing fashionable crazes among the idle rich. When horseback riding became a mania among provincial ladies, they were at once depicted in riding habits astride roosters. Satire was not invariably good-natured, however. A wooden piece dating from the 1905 revolution depicts three fat gendarmes whose heads support a throne in the shape of a snarling monster, on top of which sits a paunchy czar with a church candle in one hand and a bottle in the other. Although authorities instantly banned this toy, craftsmen slyly sold each figure separately, giving the customer the amusing occupation of reassembling the group himself.

During the reign of Nicholas I (1825–55) the Russian folk spirit became more pronounced in toys, and an interest in Russian types began to revive during the reign that followed. The bears, lions, horses, birds, soldiers, and popular national heroes of this period exhibit a genuine folk feeling and are often well carved and modeled. Most aspects of life in Bogorodskoe are reflected in these carved miniatures—from household handicraft scenes to the flogging of a peasant, the chopping of wood, lunching in the field, threshing, and returning from mowing, to mention only a few. The *Village Assembly* group, especially, evokes the feeling of the late nineteenth-century Russian village, with its village elder in town clothes, rich provincials in high boots and peaked caps, and village poor in bast sandals (*lapti*) and ragged smocks. In such mundane folk sculpture, village carvers raised what amounted to an ordinary children's toy to a species of fine art.

Generally speaking, wooden toys for children were simple and roughly fashioned, made with the ax, knife, and various chisels. Following no preliminary plan or guide, the craftsman cut off a block of wood, determining size and shape by the eye. Excess wood was chiseled off, and the toy was completed with a razor-sharp knife. The productions of early toymakers were scarcely more than roughed out and enlivened with painted ornament, but most of the forms were sufficiently realistic to give an idea of the objects intended. Often toys were not made for sale but were made simply to be given to children. Dolls, above all, were a favorite group, followed by horses, birds, and women carved in relief and

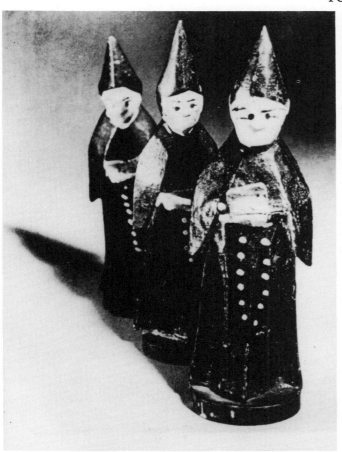

dark red, sometimes left uncolored, they were stylized to suggest the strength of a special breed of strong northern horses. The toy horses of Vladimir were somewhat more detailed in execution and were always depicted in dynamic poses. (Among the other popular toys of Vladimir Province were the *kukly-baby*—carved wooden dolls with shapely figures and brightly painted designs resembling local textile prints.)

Agricultural and woodland dolls. In the agricultural districts of central Russia, children sometimes had straw dolls tied at the neck, wrists, and waist. In forest regions and in the North, dolls were sometimes made of pinecones, birchbark, and rolled dry moss tied with bast —the hands formed from pinecones, the faces carved from linden wood. The feet wore miniature *lapti* and were affixed to a wooden stand. For all their primitiveness, these fragile toys with their long beards and wild hair were very expressive and very popular in the nineteenth century.

Matryoshka. The famous nested doll depicting a girl

Nuns. Sergius Posad and Bogorodskoe, second half of the nineteenth century.

painted. The toy birds probably reflect the handicraftsmen's experience in the making of decoys for hunters.

Panka. The doll called "*panka*" in the northern coastal areas was made from a rounded stump of wood; the head was shaped with an ax into a ball or cone with a flat face and attached to a conical block representing the body. There were no arms or legs, and facial features were schematized like those on the faces of idols; indeed, the dolls of Novgorod remained very close to the old pagan gods once worshiped in the area. Eyes, nose, and cheeks were either slightly carved or burned out with a hot nail. Occasionally a woman's bosom would be rounded, but craftsmen were generally less concerned with proportions than with sturdiness. The body was ornamented with burned-out geometrical designs —circles, squares, lozenges, inclined crosses, and so forth.

Northern toy horses. Like the *panki,* the toy horses of the North were made from a wood stump; and they and the *panki* were similarly decorated. Sometimes colored

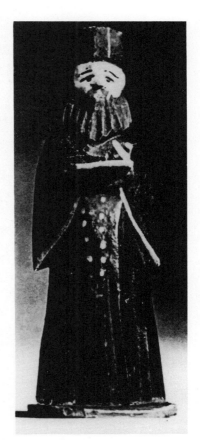

Monk. Sergius Posad and Bogorodskoe, second half of the nineteenth century.

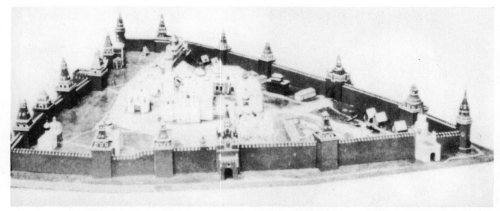

Model of seventeenth-century Moscow Kremlin. Moscow
Province, nineteenth century.

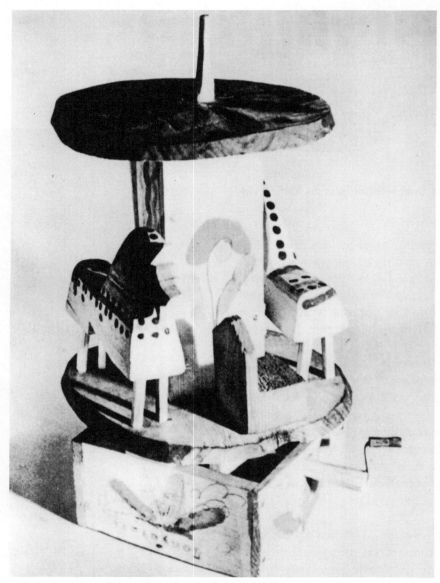

Merry-go-round. Gorky District, 1938.

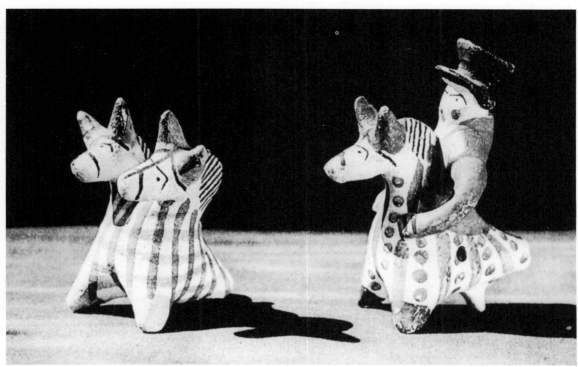

Vyatka clay toys.

in a *sarafan* and kerchief was called *matryoshka,* the diminutive form of the woman's name Matryona. Although the exact date and place of its origin is unknown, this doll was once believed to express the idea of woman as the vessel of new life, containing succeeding generations within herself. But the matriarch lost her place as head of the family thousands of years ago, and Russian mythology identifies no goddess personifying the succession of generations. More recent Soviet scholarship attributes a non-Russian origin to the popular little doll and identifies Jumala, the golden goddess of the ancient Ugrians, as her prototype.

The *matryoshka* came originally from Vyatka, in the Ural foothills, once the center of Ugria, a large northern country which extended up both sides of the Urals to the Yamal Peninsula in the North. The Khanty and Mansi, small nationalities that live today in the woods and marshlands of the lower reaches of the Ob River, are descendants of the Ugrians.

According to ancient Russian chronicles, the Ugrians' principal goddess was a statue of pure gold originally called Jumala. Rumors of a golden goddess had reached Europe as early as the tenth century. Scandinavian sagas described an unsuccessful attempt by Vikings to steal the statue at a time when it stood on the bank of a tributary of the Northern Dvina. According to one saga, Torir the Dog reached the shrine in 1023. But when the Russians reached this area, the Ugrians carried the goddess across the Urals to where the Ob and Irtysh rivers meet.

Sebastian Muenster, Gerard Mercator, and other sixteenth-century geographers had a "golden woman" marked on their maps. When Baron Sigismund Herberstein arrived in Russia in 1549, he was told that the statue had a hollow, "singing" interior and that inside was another figure which in turn contained a third figure. No one was allowed to see the goddess, who stood in a sacred wood; but every Ugrian who passed by had to leave a gold coin, furs, fabrics, or something else of value on a tree.

Every day the goddess's hereditary guards collected the donations, and when enough gold was amassed, it was fashioned into a new shell, and the old statue, together with all it contained, was placed inside. When the English traveler Giles Fletcher visited Moscow in 1584, he sent an expedition to the Urals, but, according to his *Of the Russe Common Wealth,* no "golden woman" was found.

After Herberstein, only four men came into direct con-

tact with the Jumala mystery, of whom the first was Bog-dan Bryazga, a cossack chieftain who took part in Er-mak's conquest of Siberia. On his way down the Irtysh in 1582, Bryazga and his cossacks invaded the territory of the shrine. Terrified, the local tribes gathered in a for-tified settlement, bringing Jumala with them to pray to. But by the time the cossacks stormed the village, the god-dess had disappeared.

In the eighteenth century, Colonel Grigorii Novitskii of Kiev, who had participated in a conspiracy in the Ukraine, was exiled to Tobolsk and sent to the Konda River, where the Khanty and Mansi people had con-cealed Jumala. Determined to find the goddess, Novitskii searched the shaman-guarded local shrines in the forests and bogs until he was finally killed. While exploring the Konda in 1904, another Russian traveler, Konstantin Nosilov, met an old man who recalled the legend about Jumala being carried across the Urals; but he either did not know, or refused to disclose, where the goddess was hidden.

In the 1930s, in the small taiga village of Nyurkoi, an aged shaman told Anton Kadulin, an old hunter still liv-ing in the small settlement of Tiumen in 1967, that Ju-mala had been taken somewhere on a boggy island and hidden with her treasures so that she might never be

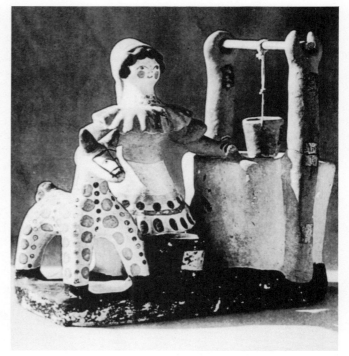

At the Well. Vyatka genre scene.

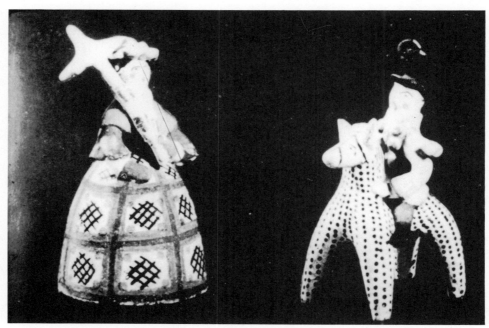

Dymkovo clay toys, juncture of the nineteenth and twentieth centuries.

found again. Reports by Orthodox priests in Siberia concerning the local people's worship of their old gods reveal that the search for Jumala continued until 1917, that no one ever disclosed her hiding place, and that her whereabouts remain unknown to the present day.

The first known *matryoshka*, made by V. Zvezdochkin and painted to the sketches of S. Malyutin, consisted of an eight-piece nest and depicted a girl in a *sarafan* and kerchief. A boy came next, then another girl inside and so on, the smallest piece being a baby doll in swaddling clothes. Despite their high cost, the demand for *matryoshki* was great, and there soon appeared *matryoshki* with baskets, small bundles, sickles, bunches of flowers, and grain sheaves in their hands. There were girls in

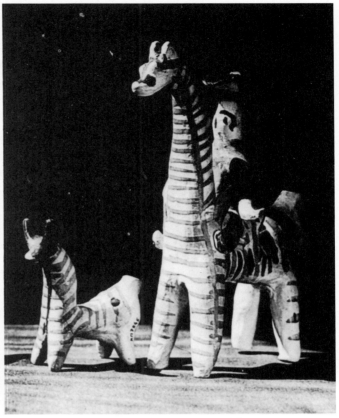

Clay toys from Tula Region.

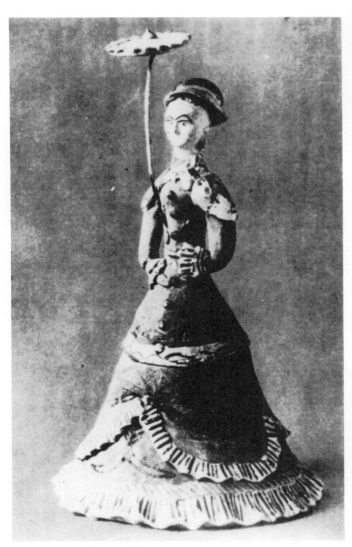

Lady. Tula, nineteenth century.

short sheepskin coats with shawls and felt boots; shepherdesses with reed pipes; old men with broad, thick beards; Old Believers with rosaries in their hands. There were bridegrooms and brides holding candles and a nest of relatives inside them. A boyar series included a stout, bearded boyar in a *kaftan* or fur coat and high fur hat, carrying a staff, and a boyarina wearing a "pearl-studded" *kokoshnik* on her head. There were also a clerk with an inkpot slung from his belt, a falconer, a warrior, and many more.

Historical dates and jubilees were also reflected in the wooden dolls. A whole collection of *matryoshki* depicting characters from his books were made to mark the centenary of the birth of Gogol. Eight-piece dolls depicting Mikhail Kutuzov and Napoleon, with nests of members of their staffs, appeared in 1912 to commemorate the centenary of the War of 1812.

Craftsmen also made *matryoshki* based on the subjects of tales and fables. *The Turnip* depicts an old man with a big turnip in his hands, and his old woman, with a nest consisting of their granddaughter, a dog, a mouse,

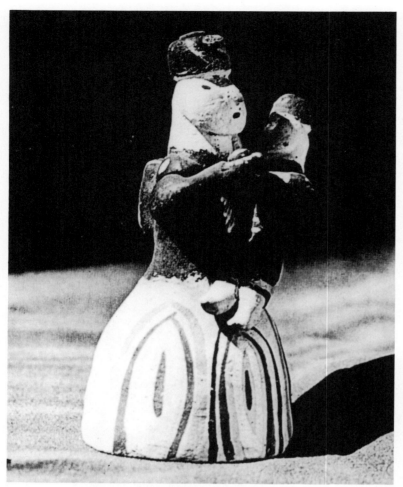

Clay toys from Kargopol, northern Russia.

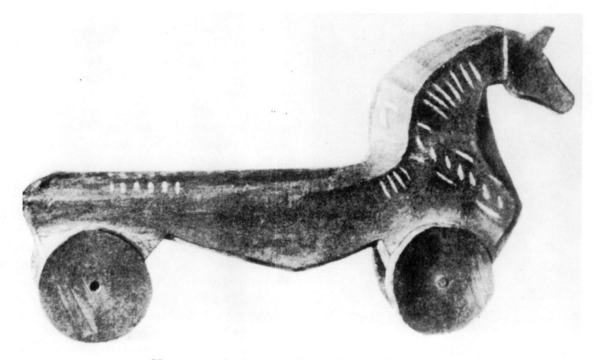

Horse on wheels, end of the nineteenth century.

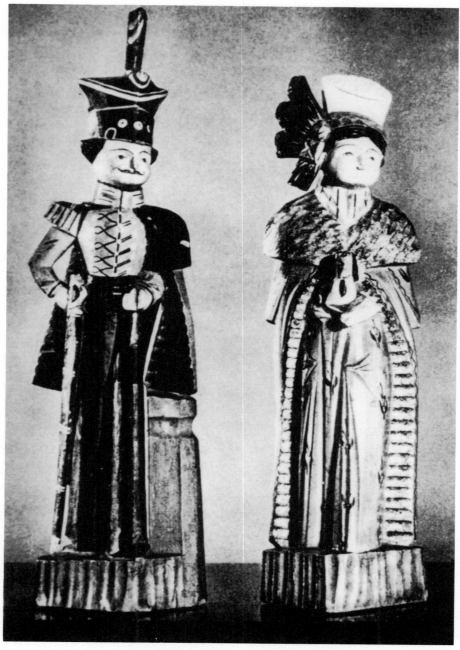

Hussar and lady, nineteenth century.

and a cat. *The Golden Fish, Czarevich Ivan,* and *The Wonder Bird* were among the two- and eight-piece dolls made at the beginning of the twentieth century. The nests of twenty-four, eight, and one were most popular, although in 1913 a nest of forty-eight dolls was made for a toy fair in St. Petersburg.

Animated toys. The group of toys known as *khoziaistva* depict various aspects of rural life, the subjects being drawn from the carvers' familiar surroundings. Some are set pieces; others are animated. In a typical animated toy, a peasant and a bear are affixed separately to two small joined pieces. By pushing and pulling the pieces, the man and bear are made to strike an anvil alternately with their mallets.

Another type of animated toy, known as the *razvod* (literally, "moving apart"), featured a group of animals

or people mounted on a jointed trellis with a scissorlike movement. By pushing and pulling, a herd of cattle or a couple of goats can be made to move or a company of infantry to march in step. Animated toys included a pecking hen, a woodpecker tapping at a tree trunk, a carriage or sleigh drawn by a horse with a coachman up in front. Some mechanical pieces were set in motion by a concealed mechanism in a box underneath. In some cases a handle produced music by activating little spokes and strings. This type of toy was never widely developed, however.

Multifigure groups. As the toy industry broadened in scope, the skill of the carvers grew, and with increasing mastery came the multifigure group, the themes including plowing, flax threshing, cabbage chopping, tea drinking, and various popular festivities. Animation was introduced into these sculptural groups as well. Hung by a thread, a simple plummet caused arms to move; tree leaves, attached by slender spiral, quivered at the touch.

During the reign of Alexander II (1855–81), the Moscow Province, and especially Sergius *posad* (i.e., Zagorsk and its neighboring areas), became the center of

Doll made of moss, early twentieth century.

handicraft toymaking in Russia in both production of toys and volume of trade, a condition made possible by the proximity of abundant forests and of Moscow as a buying center. The production of metal toys developed in the Dmitrovsk District, where such articles as toy boats, trains, windmills, and kitchen and tea sets were made of tin. In the Bogorodsk and Bronnitsk districts, clay and porcelain dolls were made, the smaller toys usually painted. The production of *pisanki* (decorated Easter eggs) and *matryoshki* was concentrated in the districts of Zvenigorodsk, Podolsk, and Vereisk.

The *matryoshka* was usually made from birch or linden, the trees being cut in the early spring and stored near the production center. When the wood was dry enough, it was cut into small pieces, the smallest figure first, then the next larger in size, and so on. Each figure was then sanded and painted. Painting techniques differed: in Zagorsk, the figure was first painted with gouache and then (although not always) covered with lacquer; in the Semyonovsk District, the figure was bathed three times in potato paste, colored with aniline dyes, and lacquered.

Production of all kinds took place in Sergius *posad;* from here, pilgrims and merchants carried toys to all corners of Russia. In 1879, according to D. I. Vvedenskii's *U Sergievskogo igrushechnika,* 767,808 pounds of toys were shipped to Moscow from the Sergievo station. At this time, 1,055 craftsmen were employed in Sergius *posad* producing toys in 333 toy shops. Papier-mâché toys occupied an important place in the toy industry of this area. Glued paper was fitted over a wooden model and allowed to dry. When dry, it was cut in half for removal, then glued together again, and painted. The models of birds, domestic animals, and people were used over and over again. The satirical models of human beings were mostly carved in Bogorodskoe and are especially interesting insofar as they reflect the fashions in clothing of the early and middle nineteenth century. In Sergius *posad,* dolls were dressed; here, too, were the artisans called *iashchichniki* (boxmakers) who made little boxes and doll furniture.

The time came when there was virtually no province in Russia where handicraft toys were not produced for sale at fairs and bazaars in the immediate local area. Russian carving also enjoyed great success abroad; but the greater the interest, the less the carver was rewarded. Peasant craftsmen sold their work to a jobber, who naturally sought as great a profit as possible. A skilled carver had to work fifteen or sixteen hours a day, and he

Dancing bear, early twentieth century.

still could not compete with the increasing flood of factory-made toys. The more toys he made, the less attention he gave to quality until bright coloring replaced clever carving as their chief attraction.

In 1891 the government of Moscow Province organized a workshop in Zagorsk, in which artisans were given on-the-job training, supplied with new toy samples, and their toys bought from them for distribution. Young people studied at the workshop for three years, from the ages of fourteen to seventeen. The workshop training resulted in an improvement in the overall quality of papier-mâché and clay toys and in the production of unbreakable dolls.

By 1913 there were approximately 4,000 people engaged in toymaking in Moscow Province, not count-

Hard-working bear, Soviet period, twentieth century.

ing Zagorsk and its surrounding areas, where there were 550 households producing toys. The main form of production involved the small family unit, with women and children participating in the division of labor, each assigned to a particular detail. With the help of the government of Moscow Province, the experienced dollmakers were organized in 1911 into a group specializing in historical costume dolls, whose various national costumes were based on sixteenth- and seventeenth-century Russian patterns.

In 1913 approximately 200 men, women, and children were engaged in toymaking in Bogorodskoe. The craft here is believed to have been given impetus by the Russo-Turkish War (1877–78), during which a popular Bogorodskoe carving of General Skobelev was sold throughout Russia to the most remote areas of the empire. Other major factors influencing the development of toymaking in Borgorodskoe included the proximity of Zagorsk and its training workshop and, later, the handicrafts museum organized by the local government, which provided the artisans with new toy samples and thus helped to expand the variety of toys. A Russian national exhibition held in Nizhni Nov-

gorod helped to make Bogorodskoe toys better known on the market.

At one time, handicrafts did not predominate over agriculture in Bogorodskoe; the two went hand in hand, as peasants spent all their free time making toys. Bogorodskoe toys were, nevertheless, considered to be unique in Russia. Each artisan was a sculptor in wood, some among them very gifted, capable of producing whole groups of figures of museum quality. These were more than playthings as far as workmanship and cost were concerned; some were sold at ten rubles a piece.

In the early twentieth century the Bogorodskoe craftsmen formed a cooperative, which, by the beginning of World War I, was manufacturing some 150 different kinds of toys and carved miniatures. During the Revolution and Civil War in Russia, however, some carvers joined the army, others returned to farming, and the cooperative came to a standstill. The post-Civil War period was largely characterized by a search for ways to combine old techniques with new forms.

The labor conditions of toy craftsmen changed radically after the Revolution. In 1918–19 artels ap-

peared one after another, which united many folk crafts-men who until then had mostly worked alone. A toy museum was opened in Moscow in 1918, and a work-shop set up at the museum made the first Soviet toys. In 1928 the handicraft-industrial artel at Sergius *posad* was reorganized into a big toy factory, known today as the Zagorsk Toy Factory No. 1. The world's first scientific and experimental institute of toys was opened in Zagorsk in 1932. In addition to traditional fairy tale subjects, the 1930s—heavy on socialist realism—saw the appearance of carved wooden pieces with such titles as *A Collective Farm Meeting, The Civil War Girl Guerrilla,* and *The Chapayev Machine-gun Carriage.*

World War II brought patriotic figures of Soviet women—partisans, blast furnace operators, nurses, and collective farm members. A. Pronin produced a toy depicting a bearded partisan herding a Nazi soldier into captivity at bayonet point. When a catch is pressed, the partisan pricks the Nazi's posterior. The artisan's son, M. Pronin, elaborated upon the subject, carving a large group which shows partisans resting around a forest bonfire after a battle. From the fifties to the present, traditional pieces have increasingly yielded to modern novelty: a bear cub chatting over the phone, a hare taking a snapshot, a bear on a tricycle, a bear launching a rocket or gaping at a model of the globe with a sputnik zooming round it.

Vyatka: The Dymkovo Clay Toy

The popular Vyatka clay toy, like much of the oldest woodcarving in Russia, had its ultimate origin in pagan worship. Excavations of ancient Slavonic shrines have unearthed the remains of idols dating from the ninth and tenth centuries. The Arab traveler of the tenth century, Ibn Fadlan, has described Slavonic idols carved from tree trunks. Wooden images of pagan deities are also mentioned in the ancient chronicle *Povesti vremennykh let* ("Chronicles of contemporary years"): "And when Prince Vladimir was enthroned in Kiev, he placed on the hilltop a wooden Perun and idols of Dazhbog and Stribog." Excavations in Kiev and Novgorod have yielded, in addition to the large wooden idols, miniature clay figures for household use which greatly resemble small clay statuettes found in excavations of ancient Greek towns and trade markets on the northern coast of the Black Sea.

Among the principal deities of the ancient Slavs were the mermaid, revered as the protectress of mead-ows, plowlands, and hearths, and the Sun God, often symbolically represented as a flaming red horse with two or three heads (in post-Christian Russia, the sun symbol fused with the image of Elijah being borne aloft in his three-horse chariot). The circle, another symbol of the Sun God, was eventually transformed into a stylized rosette often ornamenting the backs of furniture, distaffs, and various frames.

The Kiev doll (symbolizing the protectress of the hearth) and the three-headed Novgorod clay horse (symbolizing the Sun God) are primitive and look like unpainted apprentice pieces from Vyatka (re-named Kirov in 1934). The Moscow Arts and Handi-crafts Museum also exhibits clay toys from the Tula vil-lage of Filimonovo and a remote northern village near the Karelian town of Kargopol. All of these toys have much in common, including a similar orna-mental motif of sun circles and rings, but they are today regarded not as toys but as objects of pagan religious worship.

After the evangelization of Rus in A.D. 988, the Or-thodox church ordered that all idols be destroyed. In the course of time, most of these clay images of pagan gods came to be regarded as toys, which saved them from destruction by the church. Despite the church's campaign against paganism and idolatry, however, echoes of pagan worship persisted in folk rites and cus-toms and in the folk arts as well.

Khlynov-Vyatka. Before the devastating Tatar in-vasion of the thirteenth century, two dynamic seats of power had developed in ancient Rus—Kiev in the South and Novgorod in the North—both competing to extend their territories. Novgorod, the more remote of the two areas, attempted as well to maintain a quasi-democratic form of government based on the absence of feudal overlords and the presence of a unique com-mon council (*veche*). Seeking fortune, and in the gen-eral drift of expansion, early Novgorodians moved be-yond the Urals, and by the eleventh century Novgorod ruled over areas that now make up Karelia and the Archangelsk Region. In 1174 a group of Novgorod-ians reached the Vyatka River. At the mouth of the Khlynovets River nearby they established a small fort which they called Khlynov.

In these new territories, largely unmolested by Ta-tars or the boyars of Moscow, Novgorodians preserved their own way of life along with the customs and rites

Horse, by A. A. Muzrina. Dymkovo clay toy, Soviet
period.

of their forebears, molding clay images of the protectress
of the hearth and celebrating the festival of the Sun God
in spring. Chronicles report that every 23 May the com-
mon folk assembled to dance and chant heathen songs.

In 1418, however, the angry boyars of Moscow, who
called these people the "thieves of Khlynov," persuaded
the governor of Ustiug and his son to attack Khlynov on
the festival night. Throughout the night of the festival
eve, Ustiug troops neared Khlynov; but sentinels rang
the alarm bell just as they were about to storm its gates
and walls. The enemy was defeated, but the battle had
been bloody, and 23 May became a day of commemo-
ration of the dead.

The townsfolk chanted masses for the dead from early

morning. Toward evening, however, and after a good deal of drinking, the Sun God's holiday was celebrated with (according to one chronicler) "whistling, booing, and howling" for as long as three days. For this occasion, local craftsmen molded three-headed horses and earthenware images of the protectress of the hearth as well as substantial quantities of birchbark whistles and clappers. Although Khlynov was still celebrating 23 May at the turn of the eighteenth century, by 1780, when Catherine the Great renamed the town Vyatka, the holiday had been taken over and reinterpreted by the church.

Vyatka clay toys reflected other long-standing local customs as well. After Sunday morning service, for example, the daughters of the local "aristocracy" gathered at the pond for water while prospective husbands lined the road to look them over. A small clay figure called *The Water Carrier* depicts one such young woman wearing the traditional bell-shaped checkered skirt, a yellow blouse, a small apron, beads, and a red bonnet. Her water pails are orange, the yoke green and touched with gold leaf.

Stylish Western and urban fashions had never before been seen in Vyatka when a number of Polish revolutionaries and Russian intellectuals were exiled there in the 1830s and 1840s. Shortly after their appearance, women with pretensions to fashion had contrived an odd amalgam of their own design, which induced craftsmen to produce hundreds of miniatures of the local swells—corseted ladies in frills, flounces, ribbons, and bows, and top-hatted men in fantastic frock coats—for one of their spring festivals.

Production of these clay toys peaked in the mid-nineteenth century, the secrets of the craft handed down from one generation to the next. In 1856 there were fifty-nine families of toymakers in Vyatka, all living in Dymkovo, a neighboring village across the river—hence, the common, and still current, name of the Dymkovo toy.

In summer, red loam and fine sand were gathered from pastures, meadows, and the river, the loam soaked in water, mixed with the sand, and kneaded. On the completion of field work in autumn, the entire household participated in making batches of these figures, each individual specializing in a particular part—the head, the shoulders and arms, the skirt, or the yoke and pails. When the parts were joined and the seams rubbed with a damp rag, the batch was set out to dry for several days while the family undertook a new batch.

When dry, the figures were baked in a stove for several hours—the duration determined by hit or miss—to impede crumbling and to prepare a surface for the ground. After the firing, they were bathed in a solution of crushed chalk and milk, which gave an even, thin white ground for the paint. The painted doll was coated with egg white; tiny bits of gold leaf were glued on for sparkle, and the completed figure was set aside for the jobber, or middleman.

Casting such toys from plaster of paris molds was faster and easier, and the attempt was initially successful. But because the paint lost its luster on plaster of paris, these pieces did not sell. At the end of the nineteenth century, the industry fell into total decline, and the craftsmen began to seek other work.

After 1917 the surviving craftsmen were no longer bound to the jobber, but they doubted that, under new conditions, there would be much demand for clay dolls and whistles. At this time, A. A. Denshin, an enthusiast of the Dymkovo toy, wrote numerous books to popularize the ancient craft, painting all the drawings in each printed copy by hand. Later he went to Dymkovo to persuade the few remaining artisans to keep the craft alive.

In 1936 the Soviet government commissioned Dymkovo artisans to decorate a pavilion at the USSR Agricultural Exhibition. The old craftswomen of Dymkovo were awarded a certificate of honor at the 1937 World's Fair; at the 1939 World's Fair in New York, Vyatka toymakers were awarded gold medals. The Dymkovo toymaking shop is housed today in the center of Kirov, whence every month hundreds of clay dolls are shipped to shops in the USSR and abroad. Samples of the toys are to be found in the folk art museums of the Soviet Union, where they are now rightly regarded as folk sculpture.

9
METALWORK

The story of the peasant metalcrafts in Russia is difficult to bring clearly into focus. Unlike wood, clay, stone, fiber, and other materials, until roughly the fifteenth century metals were largely unavailable to the peasant of Old Rus. Although limited quantities were produced in the Tula region in the fifteenth century and in the Urals later, the greater part was imported. Large-scale production of metals began in the eighteenth century under Peter the Great, but metal remained an expensive material and was not readily accessible for folk handicraft work.

Many objects purely utilitarian in character so closely resemble their wooden counterparts that there is no need for a detailed description of them here. A large number of monumental objects—including bells, cannons, and wrought iron and steel furniture —though often of distinctive and original design and influenced by traditional Russian motifs, are not, strictly speaking, examples of folk art. The exquisite work of Russian goldsmiths, silversmiths, and jewelers passes in the eighteenth century into the history of the Russian fine arts, while much of what remains becomes either a species of industrial art or a special genre of decorative work. Of folk metalwork, therefore, it must suffice here to call attention to certain characteristic pieces that may serve to suggest continuing national tastes and trends.

Jewelry

Jewelry, for example, is as old as historic memory in Russia, has always been greatly prized among the peasantry, and was invariably a part of the ceremonial national costume. The burial sites of southern Russia especially have yielded fine examples of old jewelry influenced by Byzantium, Scandinavia, the Tatars, and later by Europe. But information about early jewelry remains incomplete, and to reconstruct early decorative patterns art scholars have recourse only to the few surviving objects and to chronicles and pictures.

Early Russian costume was influenced by Byzantine clothing, which, being rich and vivid in color, called for elaborate jewelry, including headdress decorations, earrings, chains, bracelets, and rings. In early Rus there was no distinction between jewelry for men and women; necklaces, beads, and other objects made exclusively for women appeared only at the end of the eleventh century. The *druzhina,* or princely retinue, wore fine jewelry, and a prince would often use jewelry to decorate a warrior for valor in combat.

were flat and others were three-dimensional. The technique of making the latter was unique. A model was made from ropes soaked in wax; then a clay mold was made around the model, and the model was melted down and burned out. The mold was then cleansed and filled with metal. This technique was widely used in northeastern Rus until the eleventh century.

At the juncture of the tenth and eleventh centuries in the Dnieper area, earrings, amulets, and medallions were made by embossing predominantly geometrical designs on fine metal leaves. From the mid-eleventh century, the period of Kiev's dominance, jewelry was made of gold, precious stones, pearls, and enamel. Enamel dominated ornamental jewelry at the beginning of the twelfth century, although later in the century jewelers would return to silver, which was now used with niello (an alloy of sulfur with silver, copper, or lead, and a deep black color).

In the eleventh century an ornament called a *kolt* was made exclusively for women. Very popular in pre-Mongol Rus, *kolty* were made of two convex shields with an opening at the top for affixing them. Women wore them on their headdresses above the temple and often placed within them a cloth saturated with fragrant oil. Golden cloisonné *kolty* represented the height of old Russian jewelry fashion and are interesting for their mixture of pagan and Christian imagery. Mainly decorated with marriage motifs, some bore

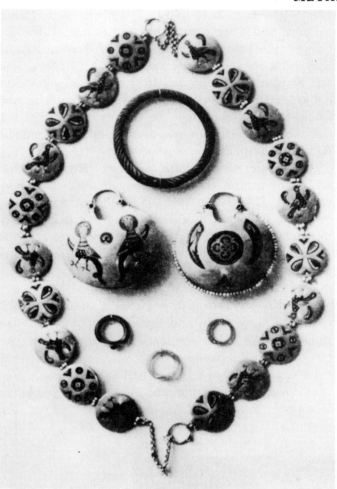

Kolty, necklace, and other jewelry, eleventh–thirteenth centuries.

Some objects recovered from pre-Mongol Rus suggest a ritual or symbolic function. Amulets were worn to protect their owner from evil spirits or to promote happiness, wealth, or fertility. Chains with small birds, keys, or spoons appended were in common use. A spoon symbolized satisfaction; a key suggested that everything in the house was secured. The horse, decorated with little circles enclosing dots, symbolized happiness and goodness and was connected with the previously mentioned pagan sun cult. Some objects were made to be attached to rope and displayed at the chest or waist, such ornament being common to all the Slavic tribes.

Jewelry made in the tenth and eleventh centuries was usually massive and made by casting or forging objects from silver, copper, or their alloys. Some objects

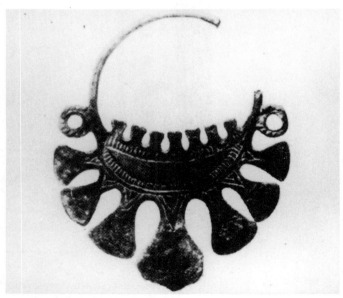

Seven-bladed temple ring. Viatichi, twelfth century.

the image of a young woman in a rich headdress; others, the images of saints, which were also to be found on collars and diadems. The *kolt* was decorated on both sides and occasionally ornamented with pearls. Some motifs—such as two birds perched on either side of a stylized tree of life—were also found in folk woodcarving, weaving, and embroidery up to the twentieth century.

The artistic quality of personal ornament increased during the twelfth century. Collars became lighter and more elegant; ceramics was sometimes used with metal; and Kievan jewelers began to use glass. During the second half of the twelfth century, cloisonné decoration was increasingly replaced by niello, of which the best work was to be seen on bracelets.

Large-scale casting developed in the thirteenth century, with the result that pieces previously available only to boyars and princes were now accessible to the people as well. Molds were made from soft stone, which permitted the carving of fine details. By the thirteenth century, collars had become elaborate, some consisting of a chain of medallions, and would soon be made of three interwoven metal pieces.

Geographically, Old Rus may be divided into three major jewelry-making centers: southern Rus (Kiev, Volynia, and Chernigov), then the center of Russian cultural life; central Rus (Vladimir, Suzdal, Riazan, and Moscow); and northwestern Rus (Novgorod and Smolensk). Niello was used by the Vladimir-Suzdal artisans only on raised surfaces to prevent a ground from being entirely black; the image itself was gilded, and the same technique was also typical of the middle Russian principalities.

The jewelry of the North, mainly of Novgorod, was similar to that in the South, though somewhat more elaborate. During the period of Mongol domination, much Russian jewelry was destroyed and many craftsmen taken into captivity. But Novgorod, free of Tatar occupation, preserved its early traditions and, after the liberation of Rus, was instrumental in reviving the old crafts.

The Kievan Principality included areas in which the Krivichi, Viatichi, and Rodimichi tribes lived, and some of these tribes developed distinct styles in jewelry. The typical headdress decoration of the Rodimichi was a six-pointed star with ball tips. The major Viatichi ornament was a ring used as part of the headdress. Decorated with deeply-grooved, linear geometrical

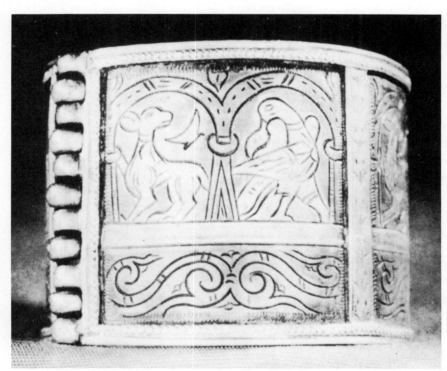

Bracelet section with representations of hare and bird.
Silver, twelfth century.

Kolt pendant (front and back). Gold and cloisonné
enamel, twelfth and early thirteenth centuries.

designs, the ring had a crescented lower portion from
which seven hatchetlike blades projected. After the
thirteenth century, these rings were simplified into a
shield-shaped object upon which three blades were
embossed as part of the design. The upper portion of
the shield depicted miniature birds or horses by a cru-
ciform tree and resembled the ritual motifs of Kievan
gold and silver work.

The best jewelry, however, was from Old Riazan, a
center of culture, handicrafts, and trade for northeast-
ern Rus until it was destroyed by the Tatars in 1237,
never to be rebuilt. Excavating an ancient burial site
behind its ramparts in the summer of 1966, Soviet ar-
chaeologists found a cache of copper jewelry for wom-
en that included bracelets, neckrings, clasps, and pen-
dants which, attached to the clothing, tinkled as they
moved.

Uncovered on a bank of the Oka were the remains
of a large log structure which yielded various utensils,
clay and bronze vessels, bits of Eastern glass, a book
clasp, and jewelry, including a seal ring, silver plates
from necklaces, two chain bracelets of twisted silver,
and two broad silver bracelets known as *naruchi*. The
latter were composed of two jointed semicircles, with
figures of people, exotic animals, birds, and plants en-
graved on a dull black background and framed with
gilded-wire arches and rectangles.

The more interesting of the two bracelets depicts
the principals of a typical "clown play" of the period—
two *skomorokhi* and a dancer—one *skomorokh* hold-
ing a cup and a flutelike instrument; the other, wear-
ing a decorated shirt and high boots, strumming a *gusli;*
the dancer dressed in a *panyova* (an outer skirt and
apron over a long-sleeved blouse) and drinking from
a cup. An animal mask such as was employed in
the mask games played at folk festivals lies at the danc-
er's feet; the *naruchi* themselves were worn over the
billowing sleeves of a dancer's costume. Although the
Orthodox clergy relentlessly denounced such "clown
plays" and pagan rites, they persisted, especially in the
Viatichi country, at wedding parties, funerals, prince-
ly feasts, and peasant festivals.

Handicraft jewelry making, which all but disap-
peared from Rus during the 250 years of Tatar occu-
pation, reappeared in the sixteenth and seventeenth
centuries in rings, earrings, bracelets, buttons, clasps,
and other effective additions to ceremonial dress. Al-
though older forms of ornament remained in use in the
North until the seventeenth century, in the central ar-
eas of Rus older forms began gradually to change in the
sixteenth century. The very wide, very heavy *naruchi,*
for example, were replaced by light, round, purely or-
namental bracelets and chains.

By the sixteenth century, earrings had become a
characteristic feature of the Russian costume, and dur-
ing this and the succeeding century their construction
remained essentially the same. Variety was achieved
by means of different silhouettes and color combina-

Kolty and necklaces, eleventh–twelfth centuries.

Bracelet. Kiev, twelfth–thirteenth centuries.

tions and in the use of enamel and precious stones. The typical earring was of pierced metal on tassels of metal beads, or formed of pendant beads, stones, and pearls on twisted wire mounts. Another group was formed of variously combined strings hanging from crescent mounts and divided at intervals with acorns or little filigreed bird forms. These were made by women at home, were greatly prized, and were obviously related to earlier ornamental forms.

Perhaps the greatest variety was to be found among enameled earrings, of which there were several types. In central Rus especially, cloisonné was favored. The leading colors—blue, black, white, and green—were supplemented, for vividness, by the addition of colored dots, a technique applied to buttons and small ornamental crucifixes as well. The enameled earrings of Moscow exhibit bird motifs painted against dark enamel and resemble the Viatichi earrings of the

twelfth to fourteenth centuries. From the Solvychegodsk area in the seventeenth century there came earrings bearing realistic floral designs in warmer enamel hues—yellow, reddish orange, and a warm green against a white background. The entire earring might have been a small bouquet of garden flowers.

Rings for both men and women enjoyed great popularity during the seventeenth century. Among these were seal rings, sometimes inscribed, depicting birds, animals, and crosses. Such rings, produced by casting, were quite massive and heavy. Ornaments were welded onto more expensive rings made of gold and silver. The stones used in decoration were rough (as the technique of polishing stones was not yet developed), set fairly high, and were often less valuable than the settings.

Belt clasps for men, used on both leather and textile belts, were usually round and relatively primitive in workmanship. Metal parts were soldered onto the inside to keep them on the belt. Ornamentation, again, included animal and floral motifs. Buttons, the most common decorative ornaments of early Russian clothing, came in a variety of shapes, sizes, and materials. Townspeople wore buttons of silver and gold touched up with niello. For villagers, less decorative buttons were made from copper or lead. In the seventeenth century, buttons were treasured for their beauty, and, as they frequently cost more than the costume itself, it is not surprising that people transferred them from their old to their new clothing.

The overall appearance and details of Russian national dress have been preserved through many generations, the garments of the nineteenth century changing very little from those of the seventeenth and eighteenth centuries. It is largely the peasant who retains national costume, and this was particularly true of Russia, since from 1700 to 1725, Peter the Great forbade residents of Russian cities, regardless of class, to wear native-style clothing. After Peter's death, this edict lost its force, and the national costume returned to favor among many townspeople of the working and middle classes. Nevertheless, during the twenty-five-year period during which Russians wore Western-style clothing, foreign influence left its mark on traditional styles.

Fashion became paramount. According to Academician I. Georgii in his study of the empire at the end of the eighteenth century, provincial noblewomen and their maids alike attempted to follow the latest chic. These changes in dress and fashion had a substantial effect upon Russian jewelry and the jewelry-making trade. From the time of Empress Anne a craze for precious stones grew until Russian jewelry may be said to have passed almost entirely into the history of the Russian fine arts.

Still, handicraft jewelry making persisted, especially along the Volga, in the provinces of Kostroma and Kazan. In 107 villages near Kostroma, more than 5,000 people were occupied in jewelry making in the nineteenth century. Until the early twentieth century, the center of handicraft jewelry making in Russia was the village of Bolshoe-Krasnoe (Kostroma District), where peasants engaged in the craft for twenty miles along both banks of the Volga. Before the nineteenth century, Bolshoe-Krasnoe had been called Dvortsovoe, and its population had engaged exclusively in agriculture. Only after 1812 did the villagers begin to produce small objects of silver. Such nearby cities as Moscow, Nizhni Novgorod, and St. Petersburg provided a good market, and by the 1830s the trade was brisk. Objects from Bolshoe-Krasnoe found their way to India, Persia, Central Asia, and Afghanistan. Made mainly of copper, silver, and white gold (yellow gold was used only for gilding), the pieces included rings, chains, crosses, brooches, and bracelets, as well as forks, saltcellars, and tea services.

Official records indicate that 3,544 persons were occupied in handicraft jewelry making in the Krasnoselskii region in 1883. By 1909, this figure had dropped to 2,145 persons. Jobbers who bought low and sold high were responsible for the decline; and although a special school was established in Bolshoe-Krasnoe at the beginning of the twentieth century, even trained craftsmen remained unemployed because the craft had fallen into such decline.

The village of Rybnaia Sloboda on the right bank of the Kama in Kazan Province was another center of jewelry making in the nineteenth century. The Tatar population in adjacent villages also engaged in the craft, and the products of their trade school, established by the Kazan *zemstvo*, were sold in the city of Kazan. The earrings, brooches, bracelets, necklaces, chains, and clasps produced here were influenced by Asian tastes and geared for the local population, which was mostly of Asian origin.

Shortly before the 1917 Revolution, both centers along the Volga concentrated increasingly on modern styles designed mostly for collectors. At this time there were still some 4,500 jewelers working in vil-

lages near Moscow for the Muscovite market.

Ecclesiastical Metalwork, Bells, and Cannons

From the tenth to the twelfth century, copper numbered among the more important metals of Rus and was much used for church bells and various ecclesiastical objects, including icons, crosses, manuscript bindings, and details of interior church design. Churches in Vladimir-Suzdal were lavishly decorated with metal. Frescoed cathedrals built in the twelfth century by Andrei Bogoliubskii and his successors had floors and doors made from heavy copper plates, gilded copper cornices, and gold and silver cen-

sers. In the North, and in Novgorod especially, metalwork developed in the eleventh and twelfth centuries, and the Byzantine influence here is abundantly present in such objects as the *Bolshoi Sion,* or large tabernacle, a replica of the Cathedral of St. Sophia in Novgorod.

Here too were used *kartiry,* ancient two-handled vessels used in both Byzantine and Novgorodian churches for mixing wine and water. The design is predominantly floral; the handles are stylized plants curled around a daisylike flower. In the eleventh and twelfth centuries, the ornamental motifs of Pskovian metalwork were similar to those of Novgorod, the floral motif, especially, remaining on the metal objects

Censer used by Father Superior Nikon, 1405, Holy Trinity-St. Sergius Monastery.

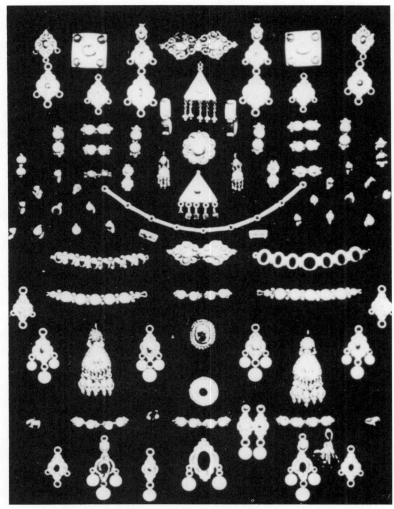

Handicraft jewelry of white metal. Kazan Province, beginning of the twentieth century.

of Pskov until the seventeenth century.

From Suzdal of the thirteenth and fourteenth centuries there survive icon *nimbi*—crownlike settings placed on top of icons—made from fine leaves of repoussé gold and silver. In the goldsmith work of the fifteenth to seventeenth centuries, many ecclesiastical objects, especially censers and tabernacles, reflect the prevailing architectural styles of the period. Examples are the large and small tabernacles made in 1486 for the Cathedral of the Assumption in Moscow.

Important work was also done in the production of illuminated church books, some of them dating to the early eleventh century. The first Russian books—until the fifteenth century written on parchment made of the finest skin and bound with boards wrapped in leather—represented the work of many hands: copyist, miniature painter, and special gilder, although there were undoubtedly cases when all the elements of the manuscript were executed by a single individual.

Monks learned the craft of copying in special schools of calligraphy and often handed down the skill from father to son. The miniatures—some of which are thought equal to the best icons of the period—were for the most part the work of eminent artists, including Theofanes the Greek, Andrei Rublev, and Dionysus, who also did icons and church murals. Most of these books reposed in monastery libraries, but some were bought by peasants and tradesmen, the latter sometimes commissioning a jeweler to make a rack of gold and silver ornamented with rare stones or pearls.

Although the art of bell casting dates in Russia from the tenth century, bells were still relatively rare at the time, a more common device being a six-foot-long metal rod that was struck with a hammer. But bells became increasingly important in Rus: they sounded an alarm in the event of fire or military invasion, summoned the people to meetings in the city square, sounded warnings to travelers day and night during snowstorms, and even came to be regarded as military bounty. In the mid-eleventh century, bells were installed in the Cathedral of St. Sophia in Novgorod and at the Church of the Tithe in Kiev, the latter about twenty-two inches tall and weighing approximately seventy pounds.

By the fourteenth century, bell casting was fairly widespread, and bells were produced weighing as much as one-and-a-half tons. There were good foundries in fourteenth-century Moscow, and in the fifteenth century the *Pushechnyi Dvor* ("cannon foundry") was opened for casting both bells and cannons. In 1532 Nikolai Nemchin produced a bell weighing over seven-and-a-quarter tons. Chronicles record that in 1560 Ivan Afanasev produced a bell whose strength had never before been heard in Novgorod. Bell foundries spread throughout Rus, with prominent centers in Moscow, Voronezh, Kostroma, and Eniseisk. Master founders accompanied by their assistants would often travel to a particular church and cast a bell on the spot, as in 1690, for example, when Nikifor Baranov made a sixteen-ton bell in Novgorod.

Some bells were in disgrace with the Russian czars. There is a legend that on a visit to Pskov, Ivan the Terrible's horse was frightened by the bell at the Church of St. Nicholas and that the czar commanded the bell's ears to be chopped off. Because one of the bells in the Kremlin had been used during the mutiny of 1771, Catherine the Great ordered its clapper to be removed so that it stood silent for thirty years. This bell, made by Ivan Motorin in 1714, is now in the Oruzheinaia Palata.

Some bells were recast under different rulers. A bell made originally in 1556 for the Cathedral of St. Sophia in Novgorod was recast by order of Empress Anne in 1730 into a new bell weighing six-and-a-half tons. Wishing to leave something behind her that would be remembered forever, in 1730 she also ordered that a giant new bell should be cast from old metal scraps. Ivan Motorin was commissioned to do the job, and on 26 November 1734 approval was given to begin. After

numerous difficulties, the work was completed on 24 November 1735. But during a fire in 1737 the structure around the Czar Bell ignited, and when water was poured onto the hot bell it chipped mightily—the chip weighed eleven-and-a-half tons. The Czar Bell is about nineteen feet tall, has a diameter of approximately twenty feet, and weighs 200 tons.

Bells and cannons were often made by the same masters—indeed, during the war with Sweden when copper was in short supply, Peter the Great authorized the collecting of church bells so that their metal might be used for cannons. In this way, 130 tons of copper were collected, from which 268 cannons were made. Russian bells were usually composed of 80 percent copper and 20 percent tin, the ratio varying according to the purity of the metal.

Both bells and cannons were elaborately decorated. Bells bore floral designs in relief along their shoulders and lips. The bells produced by the Andreev brothers in Moscow in the sixteenth and seventeenth centuries exhibited interwoven branches with lions, elks, griffins, and birds among them. In the second half of the seventeenth century, such imagery was largely replaced by biblical motifs—saints and angels—and coats of arms. In 1596 Andrei Chokhov decorated the barrel of the Czar Cannon with a floral design, and other cannons in the Kremlin were likewise decorated, with side grips shaped like dolphins, for example. When cannons were given names—Eagle, Lion, Unicorn—their bodies were decorated accordingly.

Tula

Tula Province was the metallurgical center of Russia from the mid-fifteenth century. The first cast iron enterprise was organized in 1637 in the village of Torokhova, fifteen miles from Tula, by a Dutchman named Venius, and in 1696 Nikita Demidov, a blacksmith, opened a cast iron enterprise at the junction of the Tulitsa and Upoi rivers. Domestic metals were still limited, however, and before the eighteenth century most of the metals used in Russia were imported. During the eighteenth century domestic metals began to be produced at new metallurgical centers in the Urals. At this time metal was more often used for domestic objects and, indeed, often replaced earlier objects made of wood.

Metal *svettzy* (holders for wooden tapers used to

engraved. Decorative imagery included dragons, the Sirin bird, mermaids, lions, peacocks, cranes, *skomorokhi*, musicians in Western attire, and armed horsemen—some taken from *lubki* and others from the walls of the cathedrals of Vladimir.

Distinctive furniture in wrought iron and steel was made in Tula in the eighteenth and early nineteenth centuries. Chiefly chairs and tables, but also fireplaces for the European market, these pieces closely resembled the wooden furniture of the period, except that they were less massive and gave an impression of lightness by a polish that produced a high shine. Later nineteenth-century metal furniture exhibited less national character except when it openly imitated seventeenth-century Muscovite or peasant models.

Tula was above all an important center of weapons production, and during the War of 1812 enterprising

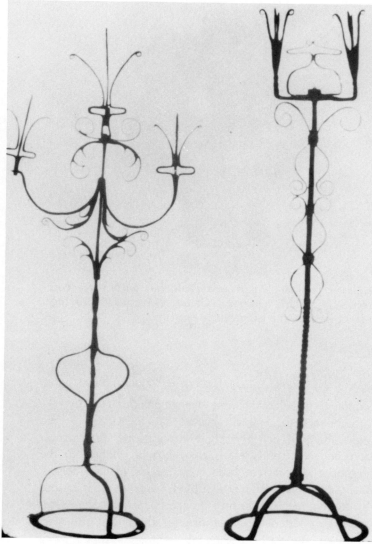

Svettzy, seventeenth–eighteenth centuries.

light a room) were now made in the shape of mythical plants and sometimes constructed to be used as candlesticks as well. Eighteenth-century copper candlesticks had three branchlike cups, such designs dating from the seventeenth century when floral work was very popular—the prototype is believed to be a silver candlestick made in 1668 for the Cathedral of St. Sophia in Novgorod. In the second half of the eighteenth century, candlesticks grew more modern in shape and were often ornamented with the double-headed eagle.

Decorative copper locks for strongboxes were made in the village of Pavlov on the Volga in the eighteenth century. The locks were cast and their designs

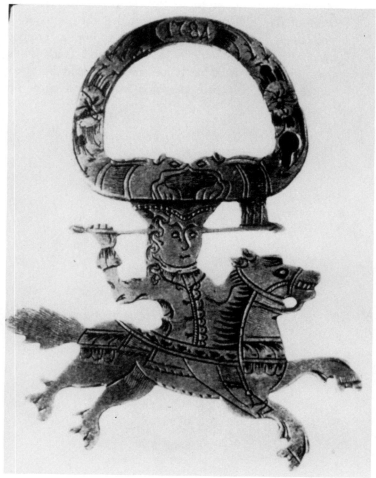

Figured lock. Nizhni Novgorod Province, second half of the eighteenth century.

peasants connected with the Tula metallurgical works occupied themselves in the production of arms, copper buttons, and other objects needed by the army. When military needs declined after the war, these craftsmen turned to the production of samovars. Samovars were also made in the Moscow area, the Urals, and Siberia, but Tula's reputation as the leading center of samovar production was firmly established in the nineteenth century.

The samovar, generally two to three feet high with a diameter of about one foot, is a metal urn in which water is boiled and kept hot for tea. Charcoal or wood was burned in a vertical pipe through its center, and at the top of the urn there is a holder for a small teapot in which a strong concentrated tea essence is brewed. Some of this essence is poured into a tea glass, and the glass is filled with hot water through a spigot at the bottom of the urn.

The *shitennik,* shaped somewhat like a kettle but provided with an internal heating pipe, was an early form of the "self-boiler" that preceded the samovar. It was used for brewing and keeping hot a popular mead drink made with sage, spices, and Saint-Johnswort that was made at home and also sold by street vendors. The *shitennik* persisted in Russian daily life

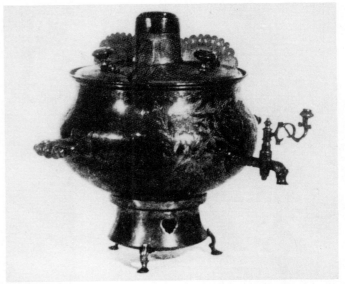

Samovar cooker shaped as a cauldron, with three compartments. Dark copper, Nizhni Novgorod Province, second half of the nineteenth century.

even after the invention of the samovar, as the drink remained popular through the nineteenth century.

Samovars came into general use in Russia in the mid-eighteenth century, their proportions, ornamentation, and structural details changing in relation to the dominant decorative tastes and usages of the period. Early examples often resembled vases in shape, and as the eighteenth century favored the baroque, samovars were often made of ornate silver. But the classicism of the early nineteenth century stripped away heavy ornamentation in favor of copper and nickel samovars with simple lines.

Shapes and sizes were determined by considerations of convenience as well as aesthetics. In the second half of the eighteenth century a samovar-cooker shaped like a cauldron appeared in the North. A great convenience, this cooker had three compartments for preparing three dishes at the same time. Samovars intended for use on journeys were of medium size and shaped like cubes or octagonal prisms. The curved legs were removable and could be fitted easily and securely into special sockets. Such "traveling" samovars were made throughout the nineteenth century, the later types having heavier proportions and a nickel-plated surface.

An ovular samovar upheld by curved rods, the whole resting on a figured base with ball feet, was

Copper *shitennik.* Nizhni Novgorod Province, second half of the eighteenth century.

among the more popular types in use in the early nineteenth century. In the early twentieth century, cylindrical samovars were the most widespread variety because they were easy to make and their production cost was considerably less than that of other types.

In Tula, samovar production began around 1820. At first dozens, and later hundreds, of factories and shops, both large and small, vied with one another in technical and artistic mastery, and this competition accounts in large part for the high quality and exceptionally great variety of shapes and ornamentation in Tula work. Here, as elsewhere, samovars were handmade whether made by cottage craftsmen or in a factory. Although they were made by both, those bearing the maker's mark are far less common than those bearing the stamp of a factory owner.

The making of samovars was essentially simple. A large cylinder for the main body of the urn was made from a sheet of brass, then two smaller cylinders for the interior pipe were constructed, and the whole was put together by means of forging. The final assembly and finishing touches were done in the shop. Among the jobbers in the wholesale trade, samovars were commissioned by the dozen, but only in the following specific sizes: two 22-inch, three 24-inch, three 26-inch, two 28-inch, and two 30-inch—the size based upon the diameter of the lid.

At the end of the nineteenth century there were about forty samovar shops in Tula producing approximately 630,000 samovars annually at a total cost of about 6,000,000 rubles. At century's end the factory founded in 1840 by the Batashev family was producing about 110,000 samovars annually. The average handicraftsman could produce ten samovars per month.

Painting on Metal

The craft of painting on metal household objects—tables, buckets, lockers, dippers, bread and sugar containers, and especially trays—began in the eighteenth century and was mainly concentrated in the Urals (more precisely, in the Nizhetagilsk and Neviansk shops of the Demidov family), in Moscow Province, and in the city shops of Moscow, St. Petersburg, and Mittau. A document dating from the 1830s indicates, however, that the general line of metal household objects produced in the Urals at this time was not profitable but was in fact rusting in storage. This led gradually to the production of more durable materials

Painted metal tray. Nizhni Tagil, second half of the nineteenth century.

in the area, mainly iron, and in turn to the birth of painted ironware. As early as the eighteenth century, artistic castings in iron were made in the Urals town of Kasli. Cast iron provides an excellent medium for the reproduction of small details, and the foundrymen of Kasli still cast statuettes that serve as handsome table ornaments.

The art of lacquering metals is believed to date in the Urals from approximately the beginning of the nineteenth century; in fact, legand has it that a lacquer for metal was invented by a native of Nizhni Tagil. By 1812 several generations of expert metal painters already existed in Nizhni Tagil, and in 1825 *Aziatskii vestnik* ("Asiatic News") reported that metal painting was well known among the peasants of the Demidov shops. Other documents of the period indicate that specialization had begun to develop among handicraftsmen—painters, lacquerers, and makers of metal objects. The making of metal trays involved only a few simple steps: giving a sheet of metal the shape of the desired object, preparing a ground for painting, decorating with oil paints, and, finally, covering the object with several layers of transparent lacquer.

Most of the surviving pieces date from the nineteenth century and range in their style of decoration from folk to academic because the people employed in the craft were of differing professional backgrounds.

Tsar Cannon (detail) by Andrei Chokhov, 1596.

Tsar Bell, by Dmitrii Motorin, 1685.

Some studied the trade by observing the work of their more advanced colleagues; others had been professionally trained in the fine arts in St. Petersburg and Moscow. The Demidovs had a large collection of eighteenth- and nineteenth-century paintings and gravures which may have inspired local artisans, and it is possible that the Old Believers brought their gifts in icon painting to the decoration of metal objects in the area.

The oldest surviving trays from the Urals are rectangular, oval, or octagonal, with high, fastened sides often with a cutout design. Designs were floral, geometrical, and generic, sometimes bearing ornamental palmettes and other motifs dear to classicism. Many subjects were adapted from other pictorial sources with their compositions altered to accommodate the object being decorated. Gravure adaptations would be given a red or black background with gold and black decoration along the edges. Such "frames" added much to the general artistry of the piece and sometimes involved complicated fruits and flowers, flowerpots, and heraldic animals.

Plant motifs were especially favored in the Urals. In the early nineteenth century they covered the entire surface of a tray, with a major group in the center and the remaining areas lightly garlanded. Attractive effects were achieved by contrasting full-blown forms with the light calligraphy of bending branches, leaves, and grasses. Some of the flowerpot motifs were of ancient origin; others were derived from the urban decorative arts of the eighteenth and nineteenth centuries, though they were given a laconic expression more in keeping with the traditions of folk painting. Colors were few and simple—warm reddish oranges contrasting with deeper reds and browns or cold blues and greens.

In the course of time Nizhni Tagil, like so many other Russian handicraft centers, underwent a great many changes in its social, political, economic, and industrial character. The Demidovs lost interest in their enterprises; the local training school was closed, and craftsmen-painters on metal became increasingly fewer in number. At the same time, growing competition from Moscow forced the Urals craftsmen to simplify their methods of ornamentation and speed up production, with the result that decoration was often done with stencils and the fingers as well as with the brush. Paintings on metal became larger and wider because it was faster and easier to do them that way, and women participated in the coloring of trays.

At the Kondratev, Labutin, and Gerasimov shops in St. Petersburg, trays were made from a single sheet of metal with decoration covering the entire tray—flowers, fruits, and birds distributed among golden curlicues, shells, and grilles. The best of such "city trays" were done in a pseudorococco style.

Painting on metal trays was a very popular craft in the villages of Ostashkovo, Zhostovo, Troitskoe, Khlebnikovo, Novosiltsevo, and elsewhere in Moscow Province, but the craft differed here from that in the Urals in strongly resembling the papier-mâché work which had begun in the eighteenth century in Fedoskino. When Muscovite craftsmen became acquainted with the trays from St. Petersburg, Nizhni Tagil, and Mittau, they changed from papier-mâché to metal. Decorated metal objects from Moscow are first mentioned in the records of the Russian National Trade Exhibition of 1839, which suggests that the changeover from papier-mâché to metal took place during the mid-nineteenth century.

Muscovite trays were typically oval or rectangular, and the influence of the urban decorative arts of the nineteenth century was strongly marked in their decoration. Motifs included landscapes, floral bouquets framed in gold with garden flowers and fruits realistically depicted, and scenes from peasant life, the latter subjects borrowed from lacquered miniatures and *lubki*.

10
EMBROIDERY

Ecclesiastical and Early Folk Embroidery

The manufacture and decoration of fabrics was one of the chief branches of Russian folk art. Embroidery, especially, was rich in variety and ranged from the working of sacred imagery on linen and silk and the embroidering of shrouds to the ornamentation of sheets, tablecloths, handkerchiefs, and clothing. Peasant national costumes existed in great variety throughout Russia, differing from district to district and from one national group to another.

Some of the earliest textiles associated with Russia were discovered in the 1860s in Crimean grave sites and are believed to date from immediately before the Christian era. These are not, however, regarded as truly Russian works, which date from a much later period and are divisible into two sharply defined classes: sacred and civil, the latter referring to peasant embroidery having its roots in pagan antiquity. Peasant embroidery remained comparatively simple, though wonderfully ornamental, with traditional patterns worked in vivid colors. Ecclesiastical embroidery, on the other hand, was a highly developed adjunct of the art of the icon, reflecting formal Byzantine-Christian iconography.

As revered icons were supposed to be untouched by human hands, it was customary in earlier times to cover them with sacred veils, a practice confined in later days largely to the Old Believers. These icon covers, grouped with altar frontals under the general name *peleny,* were for the most part square-shaped ecclesiastical pictures bordered in satin, velvet, damask, or other rich material, and made use of embroidered appliqué in colored silks, gold thread, seed pearls, and sometimes precious stones.

Funeral palls or "winding sheets" belonging to a class known collectively as *plashchanitsy* were used in the morning service on Good Friday to symbolize the rite of the Easter Sepulchre and generally represented the dead Christ, weeping women, and angels. *Plashchanitsy* were almost always large oblong panels with a border of stylized Slavonic lettering reflecting sacred texts or dedications, sometimes including the donor's name and a date. The subject treatment was Byzantine in origin; subordinate details varied in individual examples, but all followed tradition in general composition.

Earlier specimens were, on the whole, simpler and more stylized than later examples. *Plashchanitsy* of the sixteenth century, for instance, exhibit a severity of

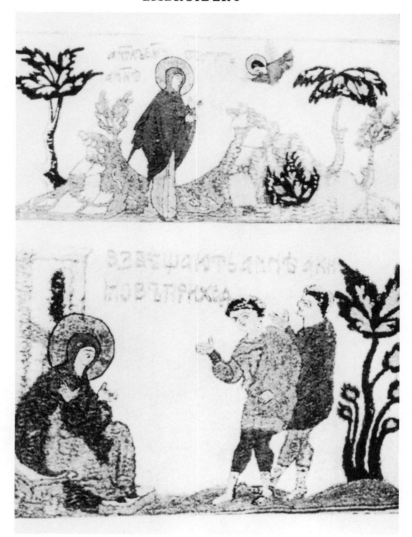

Pelena (fragment), fifteenth century.

treatment and a linear stiffness that is relaxed by the seventeenth century, when forms are softer, poses more natural, and faces more expressive. From the seventeenth century onward, silver and gold thread is abundantly present in ecclesiastical work, usually in imitation of brocade. Because of their perishable nature, however, few early specimens have survived. Some of the more famous examples still extant include a *plashchanitsa* worked by Grand Princess Marie of Tver in 1399, a *plashchanitsa* in Moscow's historical museum dated 1545, several *plashchanitsy* in the Monastery of St. Cyril on the White Lake, and a colored *pelena* of the Holy Wisdom.

Russian peasant embroidery, however, is much nearer the soul of Russia, preserving, as it does, a very valuable repository of early folk traditions in design, color, stitchery, and garments. This old and genial domestic occupation undoubtedly owes its origins in part to the punishing climate of Russia, a vast, lonely land covered for months by relentless snow that cuts off village from village. The long snowbound evenings were times for conversation, the telling of ancient tales, and for domestic employment, such as the embroidering of household linen and garments. It was customary for the friends of a betrothed girl to help prepare her trousseau while the bride herself embroidered handkerchiefs which she would present to her husband, the best man, and her own male relatives on her wedding day.

Certain domestic articles were embroidered to dec-

Pelena: "Decapitation of St. John the Preacher," 1490.

Vozdukh (detail): "Conception of the Virgin," 1485.

Clay goat whistle, nineteenth century.

Geometrical carpet on black background. Kursk Province,
nineteenth century.

Summer Troika. Cigarette case miniature, end of the nineteenth century.

"Bogatyr" carpet. Tver Province, early twentieth century.

Panyova (fragment). Orlov Province, 1850s.

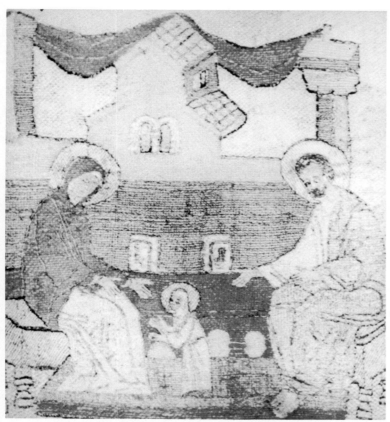

Pelena: "First Steps of the Virgin Mary," 1510.

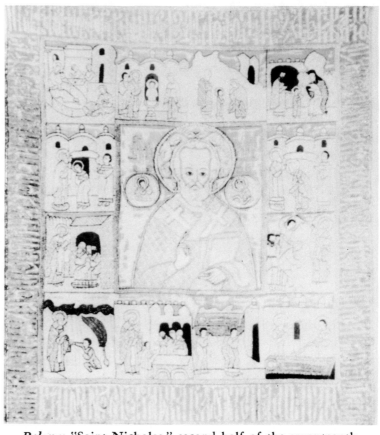

Pelena: "Saint Nicholas," second half of the seventeenth century.

orate the *izba,* or peasant hut, on holidays. Towels, especially, draped the mirrors, covered the icon in the "holy corner" of the room, and decorated the wedding carriage or sledge. The placing of embroidered towels upon the crosses often found at crossroads and upon the branches of nearby trees reflects a pre-Christian custom of decorating the temples of idols and sacred trees with similar cloths as votive offerings.

Although these embroideries were comparatively simple in technique, they were not primitive in workmanship. In one of the oldest types, known as *dvukhstoronnii shov,* both sides of the cloth were worked simultaneously, using the oblique and the checkerboard stitch (in which blocks of stitches are worked in horizontal and vertical directions alternately), with ancient patterns carried out in red, or occasionally blue, cotton thread. Towels, sheets, pillowcases, aprons, shirts, and other garments were also generally worked in red cottons, although silks, wools, and linen threads of many colors were often used as well. The cross-stitch, adopted relatively late, was favored for most designs, although the running-stitch, double-stitch, and mosaic-stitch are also found.

With only slight variations, traditional designs were handed down for generations. The various motifs range from the geometric designs prominent in central, western, and southern Russia, to the floral forms, trees, men, and animals found in the North, in Novgorod, Tver, Vologda, and elsewhere. In embroidery, as in woodcarving, a considerable number of motifs arose originally from the mists of popular superstition; many others have their roots in Far Eastern sources and native images reaching far back into antiquity. There can be no certainty about the ultimate origins and diffusion of the lions and griffins, panthers, unicorns, and mermaids to be found in Russian folk art. In the course of time, in any event, the folk artist forgot the symbolic meaning of the double cross, rosette, naiad, mermaid, and horse but used them as pure decoration to demonstrate his or her skill in traditional stylized ornamentation.

Eighteenth Century

The eighteenth century saw a continuing evolution of the great variety of designs and techniques developed earlier, and the embroidery of this period greatly influenced other branches of Russian folk art. Gold-thread embroidery increased in sophistication.

Used among the peasantry primarily on holiday headdresses, it was employed to a much greater extent by the nobility. Headdresses were often ornamented with pearls, and the use of pearls was especially pronounced in ecclesiastical embroidery. In eighteenth-century gold work, pearls were often used to outline embroidered motifs. On the whole, however, needlework with gold and pearls occupied a very small place in Russian folk embroidery—although, because of the costliness of the technique, objects so ornamented were zealously preserved and quite a few have survived to the present day.

Drawn-thread work—a form of embroidery in which certain threads are withdrawn from the fabric and the remaining threads are then embroidered or tied together in decorative patterns, giving a very fine lacelike appearance to the work—first appeared in Russia in the eighteenth century and soon occupied a leading place in needlework. As too much thread-drawing weakened the material, the technique was generally confined to fairly narrow borders; but very elaborate compositions were to be found on the borders of sheets and, somewhat abridged, on towels and aprons as well.

Embroidery on net—an elementary form of lacemaking in which the type of design is governed by the texture of the net—was another popular technique of the period and was found almost everywhere in Russia. A square-meshed net calls for a geometrical design, while hexagonal and diamond meshes allow a freer, more delicate design. Filet darning, consisting of patterns woven or darned upon a square mesh, was very popular in Russia in the 1780s, primarily among young noblewomen, although it was also practiced by specially trained village peasant girls known as *devki-fileinitsy.*

In canvas embroidery, also popular in eighteenth-century Russia, the background was entirely covered with needlepoint stitches of different types and sizes, as well as with the cross-stitch and a variety of long and short stitches in definite patterns. Being strong and hard wearing, canvas work was used for wall hangings, chair seats and backs, stool tops and cushions, banners, and various ecclesiastical items. In still another type, to embroider *tamburom* or *v tambure* meant that outlines were chain-stitched in either white or colored threads on thin white linen, the figures filled out with another kind of chain-stitching worked so closely that it resembled satin-stitching. Be-

Plashchanitsa (detail), 1561.

cause the chain-stitch has a tendency to pull on the fabric, one had always to use a small embroidery frame called *tambour* in French because it looked like the top of a drum.

Satin-stitching—straight regular stitches touching one another and used for solid fillings—reached a high degree of proficiency in the eighteenth century, although it was still used mostly by city people; peasants employed very simple variations of the technique. This method differed from the others primarily in its introduction of a stitch of one color among stitches of other colors, producing an effect of gradual shading. During the eighteenth century, many tablecloths exhibited large, chain-stitched medallionlike figures filled with satin-stitched geometrical motifs or with alternating satin-stitched images of the Sirin bird, the double-headed eagle, and floral motifs.

Much eighteenth-century folk embroidery was devoted to the poetic depiction of nature and of various natural phenomena, such as sunsets and rainbows, thunder and lightning. The awakening of spring was represented by the figure of a woman among birds,

blossoming plants, or sacred objects, or with sun symbols in her upraised hands. Men and animals alike—the latter very often mythical creatures personifying natural forces—bowed reverently before a many-branched, heavily foliated tree of life. Such motifs, worked in red thread on both sides of the cloth, adorned clothing, sheets, towels, tablecloths, and bedspreads. Although few specimens from the period have survived, their presence in different geographical areas suggests that this type of work was widespread in Russia.

In addition to floral designs, representations of trees, human figures, ships, and real and mythical animals, scenes of deer and bear hunts were very popular in the eighteenth century. Figures were for the most part symmetrically disposed and united by their rhythm rather than by any logical connection. Many pictorial subjects were suggested by contemporary gravures and *lubki,* the motifs on gingerbread molds, and figures from folk and fairy tales, although the latter are sometimes obscure in embroidery renderings. One finds a mysterious cat on a chair near a tree with a

Sheet border, end of the eighteenth century.

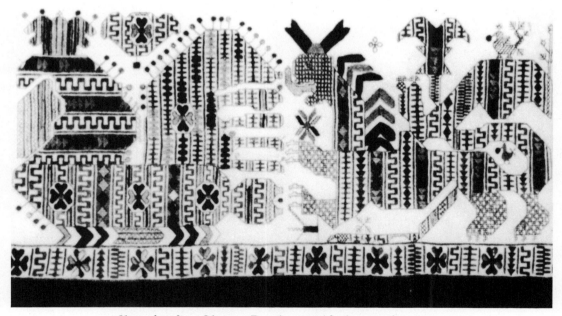

Sheet border. Olonets Province, mid-nineteenth century.

Towel edge. Kostroma Province, mid-nineteenth century.

ship anchored nearby, or coaches approaching a palace from two sides, with birds as large as the coaches on some pieces.

Architectural scenes and ornamentation, quite popular in the second half of the eighteenth century, often reflected wooden architectural design of the seventeenth century. Between buildings one finds trees with large rosette crowns and, in the foreground, plants and odd combinations of animals, such as a horse, a lion, a tiger, two camels, a fox, and a hare, the less familiar animals somewhat awkwardly represented. Architecture itself was worked out by means of a dense cover of thread on the light areas, with spiderweb stitchery over the dark areas, and uncovered material suggesting windows and gates.

One such architectural sheet border embroidered on net depicts park pavilions and tree-bordered alleys. Three buildings are set on a horizontal line, with tall pedestals and flowering urns behind and in front of them, and a number of trees bearing highly individualized leaves between them. The building on the right has a cupola; the center building has towers and a fence with plants showing behind it; the building on the left is enlivened by the presence of human

figures with flags. In the center a gentleman bows to a lady; on the right a couple stroll under the trees. There are men and women near the side pavilions, and, in the arches of each building, a woman (probably a nanny) is holding an infant—all the figures in eighteenth-century dress.

Nineteenth Century

By the nineteenth century, gold embroidery was mostly confined to the monasteries, although it continued to exist among the people in the Torzhok, Arzamas, and Gorodets areas. In Torzhok especially a small-leafed rose motif was worked in gold for *kokoshniki* (ornamental headdresses), while the same motif, with the addition of grapes, predominated in the kerchiefs of Nizhni Novgorod and Olonets. But such gold work was strongly influenced by the urban arts of the period, and except for Archangelsk and Vologda, where gold-worked headdresses remained in use longer, gold embroidery generally declined in the nineteenth century.

Embroidery motifs remained much the same, traditional folk ornamentation surviving longer in the

South than elsewhere. The floral compositions of the North, with their full flowers and leaves and heavy bent stems, were reminiscent of certain expensive imported fabrics of the seventeenth century, of Solvychegodsk enamels, and of various kinds of church decoration. The scenes of holiday festivities widely used in Vologda were probably borrowed from *lubki.* The snow leopard, a favorite subject for white-thread embroidery in the North, was outlined in red in the Upper Volga region. Women, horsemen, snow leopards, birds, and the tree of life were all found in the embroidery of central Russia, where they appeared in repeated horizontal bands.

Red stitchery was characteristic of most Russian folk embroidery, although black was more common in Tambov Province, where the local girls wore articles decorated in black, gold, and silver. White, red, and blue dominated geometrical designs in Tula, red and green in Kaluga. Although in the North the sun was

generally symbolized by a lozenge (because it was still difficult to produce rounded forms in embroidery), the work of Smolensk was more suggestive of the sun by its sunset coloration in bright orange, red, and gold, with touches of blue and black.

Until the 1860s and 1870s cotton, linen, and silk threads colored with vegetable dyes were used in northern and southern embroidery alike, but the reds were not bright. Cotton threads were a soft, creamy red; linen threads were reddish brown; and specially colored silk threads offered a sandy pink, terra-cotta effect. During the late nineteenth century, colors became brighter and more vivid as peasant women began to use chemically dyed cotton threads.

Certain new trends in embroidery in the nineteenth century were first observable in central industrial areas where city women, merchants' wives, and even rich peasant women began to wear *sarafany* made from imported materials and shirts whose mus-

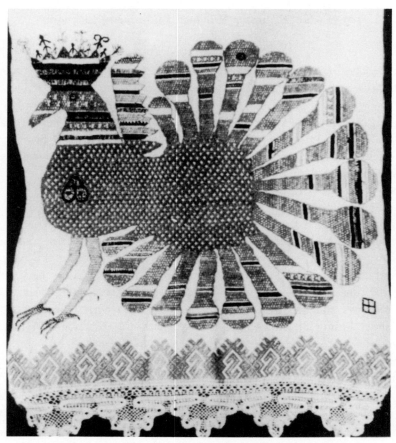

Towel edge. Yaroslavl Province, beginning of the nineteenth century.

Towel edge. Tambov Province, first half of the nine-
teenth century.

lin sleeves were covered with the same fine chain-stitching that adorned the dress of noblewomen. At this time chain-stitching was widely practiced by peasants in the provinces of Vologda, Yaroslavl, Olonets, and Novgorod for the ornamentation of clothing and towels; it was soon the most popular technique in the North. In Kostroma, Nizhni Novgorod, and Moscow provinces, kerchiefs were decorated with chain-stitched floral bouquets and garlands. In Novgorod, chain-stitching did not follow the threads in the fabric, with the result that forms were rounder and not unlike the designs on painted wood or Novgorodian tiles.

The working of continuous linear pictures on net, which had been carried over, although increasingly simplified, from the eighteenth century, was relatively rare during the nineteenth century. In the 1870s white linear embroidery on very fine net became popular for floral designs in Novgorod, Kostroma, and Vladimir. At the end of the century, however, geometrical designs largely replaced floral ones, and guipure was brought from the cities and adopted by local embroiderers. At the juncture of the nineteenth and twentieth centuries hand embroidery was increasingly supplanted by manufactured bands and strips that were simply sewed onto an article.

Northern National Costume

Old women say that in the old days the Russian peasant woman dressed like a *boyarina* and led her husband to church by the hand. Centuries-old traditions governed the national costume of Russia, and it is in the peasant national costume above all that Russian folk embroidery is seen at its most characteristic and best. Except for the *kosovorotka*—a long shirt opening on the left and worn with a belt, with geometrical embroidery at the bottom, the neckline, and the sleeve ends—men's shirts were either wholly white or solid colored and undecorated. The woman's costume, on the other hand, was most elaborate.

For the peasant woman, the major article of apparel was a long wide shirt (*rubakha*) usually gathered at the neckline and wrists. The shirt was followed in importance by the apron (*perednik*), *sarafan* (or variation), and headdress. Although special attire was worn for church holidays, weddings and funerals, and for such occasions as the beginning of harvest or the first

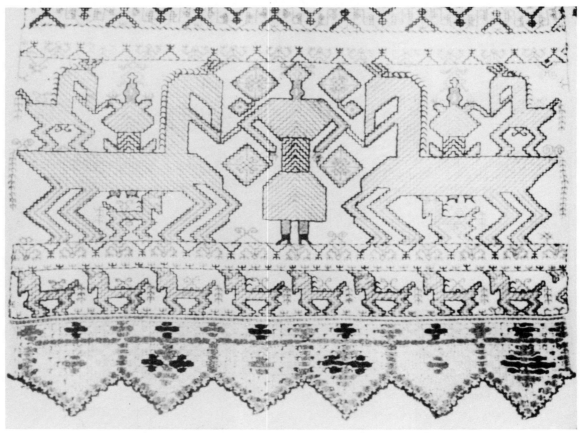

Towel edge. Olonets Province, mid-nineteenth century.

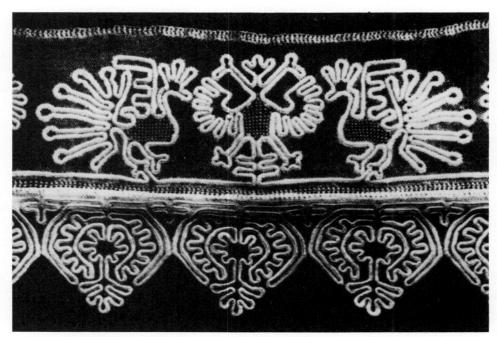

Towel edge. Nizhni Novgorod Province, beginning of
the nineteenth century.

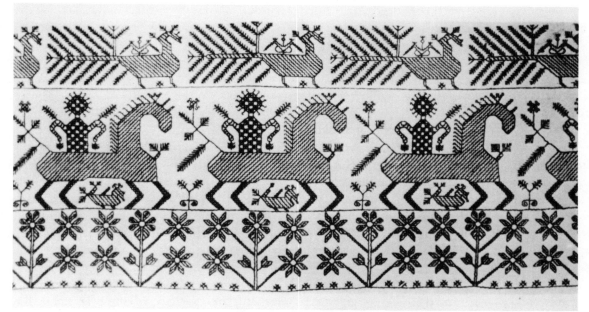

Sheet border (fragment). Archangelsk Province, nineteenth century.

seasonal driving of the cattle into the fields, for peasant women such clothing was identical in shape to that worn every day, differing only in its embroidery and other decoration.

In Old Rus the words "red" and "beautiful" (for both, *krasnyi*) were synonomous, and clothing made of red material was considered to be the most festive. The material most commonly used for clothing, however, was white linen decorated with red embroidery, a color combination favored by the Krivichi and dating back to the twelfth–fourteenth centuries. The northern peasant woman especially used red thread skillfully, obtaining a variety of shades by thickening or thinning her design, sometimes supplementing it with small bits of calico on sleeve ends and apron frills, sometimes introducing small quantities of blue thread as well.

Along with the usual variety of geometrical forms, decorative motifs included the female figure and blooming flowers, representing the fertile earth; birds, representing the approach of spring; and lozenges, representing the life-supporting sun. In folk embroidery one also finds a design composed of lozenges in which four intersecting lines extend beyond the edges of the figure. Some scholars believe this represents the earliest form of the *izba* foundation, and it is possible that this motif, on women's clothing, was originally connected with bridal garments and symbolized the start of a new home and life.

Peasant clothing in the North was more picturesque, if perhaps less colorful, than in the South. The vast expanses of the North, populated by Ugro-Finnish tribes in the eleventh and twelfth centuries, were gradually settled by Russians from Novgorod, Vladimir-Suzdal, Muscovy, and the South, and the northern costume reflected these influences. In the sixteenth century, trade with Holland, and later with other countries, enabled northerners to make clothing from imported as well as domestic materials. From the eighteenth century, however, the Far North was outside the new commercial trade routes and far from industrial centers, with the result that peasant embroidery, like other folk arts in the area, remained relatively undisturbed until the late nineteenth century.

Images dating back to the pagan Slavs were worked with red thread upon linen on the clothing of peasant women in Olonets, Archangelsk, Vologda, Tver, and Novgorod. Northern embroidery depicted the deer, bear, lion, and unicorn, and sometimes a two-headed horse with the heads facing opposite directions, or a two-headed bird eventually to become the double-headed eagle. An old pagan motif depicts a horseman with raised arms addressing a mother deity. Often there were smaller, subordinate figures

and a sky (the free space of the background) filled with heavenly bodies shaped as lozenges, circles, and rosettes. A zigzag line symbolizing water was sometimes found at the bottom of the composition, and when the original meaning of such imagery was forgotten, it was often composed into a stylized geometric pattern.

Shirts. In the North, the best peasant embroidery was to be found on women's linen shirts, of which the best were preserved in the Kargopol area. Kargopol was once a center of the Northwest through which trade passed to the White Sea from Novgorod, the Urals, the Volga, the Caucasus, and Central Asia, and this movement of trade and people greatly influenced the folk art of the area. Embroidery especially reflected the influence of imported textiles and rugs.

Bold embroidery was worked on the bodice front, shoulder pieces, and sometimes the sleeves and necklines of Kargopol wedding and harvest shirts, but the most complicated work appeared on a twelve-inch horizontal band, bordered by a thin solid or multicolored line, at the bottom of the garment. Design subjects included large peacocks fanning their plumage, large two-headed birds, and figures of women and trees, the outlines stitched in red and filled in with lines and squares, zigzags and coronas in a different stitch, using colored silk or woolen threads.

The oblong shoulder pieces of Kargopol shirts resembled miniature Caucasian rugs enclosed by a thin border of design work. Embroidery from the shoulder pieces to the end of the sleeves, around the neckline, and along the bodice front resembled the needlework on the lower portion of the shirt, except that it was smaller, lighter, and simpler. Again, reds predominated—from carmine to a dark brownish red—but blue, green, black, yellow gold, and gold were to be seen as well.

Fragments of shirts from other areas of northern Russia exhibit less complex needlework. Shirts from the central Archangelsk area and the northern part of Tver Province had a wide embroidered band at the bottom, linear outlines, and the usual imagery, although it was smaller and more unified, and alternated in groups of two (woman and tree, birds and tree, woman and horseman, and so forth). Deer and horses were less frequent than a cross-stitched snow leopard, and the tree of life was not a flowering tree as in Kargopol, but resembled a pine. The horizontal band was bordered with narrow geometric ornamentation, and adjacent to the upper border one encountered figures, or half-figures, of women with crooked elbows and lozenge-shaped heads, a motif common to both northern and southern cross-stitch embroidery.

Aprons. The aprons of the North, and especially the northeast of Vologda Province, were richly ornamented with both pre-Christian and sixteenth–eighteenth century motifs. Although all the designs worked on white linen were essentially similar in the

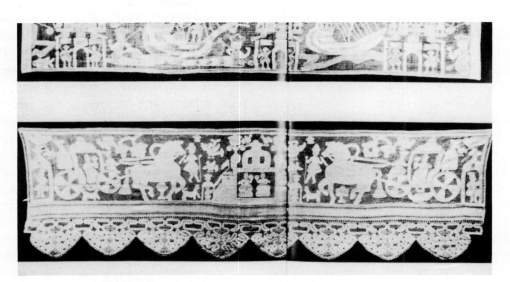

Sheet border (fragment). Vologda Province, eighteenth century.

first half of the nineteenth century, many more motifs were used on Vologda aprons than on its shirts, and apron designs, worked in the double cross-stitch, were not found on other parts of the clothing. The majority of Vologda aprons followed a set scheme of decoration: at the bottom, a large horizontal band bordered by ornamental lines; the central section, either solid black or occupied by designs as well. Designs did not ordinarily cover the entire surface of shirts or aprons of white linen; unworked areas of white usually dominated the embroidered areas. Frills, narrow at the sides and wide at the bottom, bordered the apron, which became in effect a self-contained composition.

Sarafany. In the early nineteenth century the typical *sarafan* of the North was made from a solid color material such as blue linen or red or black wool, was narrow at the top and wide at the bottom, and was essentially a long-sleeved or sleeveless tunic. At this time *sarafany* were not embroidered. A vertical row of copper or lead buttons or a strip of tinsel lace (*pozument*) was sometimes sewed down the front, but during the second half of the century *pozument* was replaced by ribbon trim with a woven design of pink carnations against a dark yellow ground. Peasant women could buy this trim ready-made, and its design and colors remained the same for almost a half-century. In Olonets, Archangelsk, and Vologda provinces, the lower portion of the garment was not decorated; along the Upper Volga and in Smolensk, Vladimir, and Moscow provinces it was ornamented with colored trim or other materials.

Older types, without seams or buttons, were very rare in the North in the nineteenth century, although *shushuny* (an older type made from red linen) were used in Olonets and Pskov, and *kostolany* (white linen with red embroidery) in Tver. The old Slavic *shushun* has been dated in the Northwest to the Novgorodian period, while Russian ethnographers ascribe a pyramid-shape type to the Muscovite period because it was popular in the sixteenth and seventeenth centuries in areas that were once part of Muscovy, as well as in the Urals and Siberia. There is a legend that "golden *sarafany*" of silk and gold embroidery were once made near Kargopol and that the "golden girls" who wore them were considered to be very desirable brides.

In the first half of the nineteenth century, however, the most popular peasant costume in the North fea-

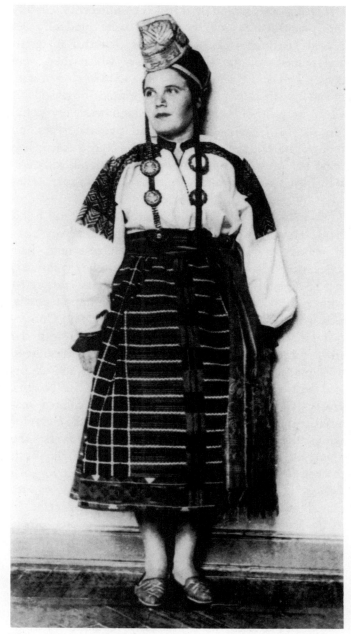

Woman's costume. Voronezh Province, second half of the nineteenth century.

tured a white linen shirt embroidered in red and a *sarafan* made of dark blue material. The complex needlework on the shirt was heightened by the dark tunic, while the entire costume—the shirt with its long, wide sleeves; the *sarafan* narrow at the top, wide at the bottom, and sometimes ornamented with vertical trim—lent a certain majesty to the Russian female figure.

During the second half of the nineteenth century the plain *sarafany* of the North were gradually replaced by those made from more colorful materials and named for the materials from which they were made: *kumach* (bright red cotton), *kashemir* (cashmere), *nabivalniki* (suggesting printed material). A white or yellow design on blue linen was very popular for both the bell-shaped and pyramid types, although the latter, now worn only by old women, had gone out of style. Prints were usually floral, although folk bird motifs were also popular, and factory prints were increasingly used as models.

Headdresses. The traditional Russian peasant headdress for women dates back to the pre-Christian Slavic tribes, among whom various headgear and hair styles were related to certain customs. The *kokoshnik*, or traditional crescent-shaped headdress decorated with embroidery and sometimes with imitation pearls, was worn on festive or ceremonial occasions. Unmarried girls wore the *polotentse*, a linen towel with the ends tucked in. The *obruch*, a hooplike headdress, was made of bark, covered with fabric, and decorated with colored feathers, glass, and (in the North) pearls. The *poviazka* was a headband of colored material, usually embroidered with gold, with ends for tying; the *venok*, a wreath of artificial flowers; the *platok*, a kerchief. On holidays, and before the birth of her first child, a married woman wore a *rogataia kichka*, a headdress that covered the hair (as required by custom for married women) and came in many shapes, some with hornlike projections, others smooth and worn with a *kokoshnik*. Some headdresses, such as the *roga* ("horns") and *soroka* ("magpie") were named for their shape. Those suggestive of birds and animals were very old.

During the last quarter of the century, the old, heavy headdresses were gradually replaced by light kerchiefs. Shirt sleeves became shorter (sometimes extending only to the elbow), much wider, and were increasingly made of cotton, calico, or other colorful material. Shirts and *sarafany* were more inclined now to match than to contrast; and although white, red, and blue still predominated, shirt hems, originally embroidered almost exclusively in red, now exhibited cornflower blue, lemon, green, black, ebony, orange, and violet worsteds as well, all united by the red in the main design. In some areas ready-made worsted bands were sewed onto garments, but these were inferior to hand embroidery.

Southern National Costume

The clothing of southern peasant women was very colorful in the first half of the nineteenth century. At this time the component parts of the costume—shirt, apron, *panyova*, *nagrudnik*, and a kind of chemise— were produced exclusively from homemade fabrics and were decorated both with embroidery and with woven designs. All parts of the costume were decorated in the South, and ornamentation was for the most part geometrical, variations on the lozenge being especially popular. Examples showing flowers, trees, men and women, birds, and animals were less common here than in northern embroidery and were strongly geometrized. Symmetry and the use of many colors were characteristic of the southern costume, but the dominating feature was the ubiquitous horizontal band varying only in width and degree of ornamental profusion.

Such variety as there was in women's clothing in the South in the early nineteenth century has been attributed to various migrations of people through the area. A first migration from the South to the North was a movement away from encroaching nomads, but this trend was reversed in the sixteenth century when Moscow began to annex rich lands in the South. Each southern village lived its own life, but its costume tended to reflect the areas from which its people had come.

The *sarafan* existed, but was not common, in the South, a more popular and widespread article of women's attire being the *panyova*, an outer skirt and apron worn over a long-sleeved shirt. In Orlov Province in the 1840s, serf women wore the *panyova*, while nonserf women usually wore red skirts. Women from Riazan and Tula brought the *panyova* to any areas they came to settle. In Riazan, Kursk, Tambov, and Voronezh provinces, some women wore woolen skirts in which red was invariably present in differing intensities—pink against gray material, bright red against yellow and green.

Shirt. Northern and southern shirts were much the same in shape but differed in ornamentation during the first half of the nineteenth century. The lower portion of the southern shirt that showed under the *panyova* was less lavishly embroidered than in the North, but very elaborate horizontal bands generally covered the shoulder pieces and the entire length of the sleeve. The widest band usually exhibited a lozenge

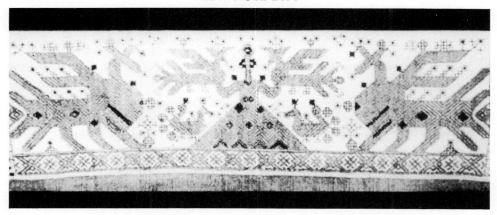

Shirt (fragment). Archangelsk Province, first half of the
nineteenth century.

design, and the bands gradually diminished in size
toward the middle of the sleeve, sometimes alternat-
ing with bands of pink or white, or separated by in-
sertions of handmade peasant lace. Until the second
half of the century, ready-made ornamentation for
shirts was very little used in the South.

Apron. The apron was a prominent part of the
South Russian peasant costume, and very often its en-
tire surface was covered with embroidery or woven
designs. Horizontal color bands, in which the dia-
mond motif predominated, generally increased in size
from top to bottom. Woven and embroidered bands
alternated, and appliqué was not uncommon. The or-
namentation of southern aprons was closer to towels
than to shirts.

Panyova. Southern *panyovy* were always made of
wools, sometimes lined with linen, and were general-
ly made from square-meshed fabric in dark blue, al-
though the size and coloring of the squares differed
from area to area. *Panyovy* exhibited the same geo-
metrical designs common to other South Russian cloth-
ing, and their vertical ornamentation against a dark
background offered a sharp contrast to the horizon-
tal bands on shirts and aprons.

Nagrudnik. The *nagrudnik* was an ancient, jacket-
like article made either wholly or partly of wool or
linen and was worn over the shirt or *panyova.* Gen-
erally slipped over the head, some *nagrudniki* opened
in front and were worn as part of the summer cos-
tume. Black and yellow *nagrudniki* were to be found
in Riazan Province; in Tambov and Tula provinces
they were red or reddish brown with blue embroi-
dered insertions on the bodice and at the bottom of
the garment.

The shirt and apron, *panyova,* and *nagrudnik,* with
the addition of a multicolored belt and complicated
headdress, made up the most popular peasant cos-
tume in the South. The general looseness and hori-
zontal character of this costume had the effect of em-
phasizing the ornamentation at the same time that it
caused a woman to appear shorter and heavier than
she was. When *sarafany* were worn in the South at
all during the first half of the nineteenth century,
they were worn mostly by Russian girls, but not by
girls of other nationalities; in some areas only mar-
ried women wore them. There were, however, some
lovely black *sarafany* to be found, decorated with red
material, braid, sequins, and red embroidery.

Footwear. Although the tall leather or felt boot is
usually regarded as a traditional component of the
Russian national costume for both men and women
—and richer peasants did, in fact, wear leather boots
daily—the more basic footwear of country people for
everyday, as well as for holiday use, was *lapti*—san-
dals woven from linden, elm, or birchbark, and worn
with *onoochi,* or cloth that was wrapped around the
feet for warmth. *Lapti* varied from area to area ac-
cording to the technique of their production, and in
some areas of the North and Siberia footwear was
made from animal hides and fur. There were a num-
ber of customs connected with *lapti.* In the Urals, for
example, the Old Believers buried their dead in *lap-
ti.* In Kursk Province, matchmaking began when a
girl accepted a pair of *lapti* presented to her by
a prospective bridegroom. In Orlov Province, a *lapot*
was hung in the chicken coop with a stone to suggest
to the hen that eggs should be laid at home.

the white background was no longer visible. Decorations proliferated until as many as ten different types might appear on a single garment—woven designs, embroidery employing any number of different stitches, calico appliqué, variously colored bands of material, ribbon trim, and so on.

At the juncture of the nineteenth and twentieth centuries, in many southern areas the upper portion of shirts and aprons was made of calico or cotton and decorated (as in Tula) with geometrical embroidery. In some villages of Voronezh, shirts were virtually covered with large geometrical designs alternating with smooth colored bands. Black was much used in combination with red, orange, lemon, and ultramarine, but such color combinations were less typical of Russian work than of contemporary Bulgarian weaving.

The *sarafan* became popular in Tula in the 1840s and 1850s and in some areas gradually replaced the *panyova*. *Sarafany* were shaped like a pyramid, made from blue linen or cotton fabric, and were almost always decorated at the bottom with bands of bright material and colorful silk ribbon trim. Still relatively new among southern peasant women, who ordered them from seamstresses or from the monasteries, they eventually became more popular here than they had been in the North. In the decoration of *nagrudniki,* embroidery was secondary to the use of calico, black ribbon trim, and locally produced lace. In some areas of Riazan, black wool *nagrudniki* were decorated only with calico and pearls.

Around the turn of the century, city clothing began to penetrate the countryside near industrial centers and in parts of the North, appearing in the South much later, in some areas only after the Revolution. Also during the late nineteenth century, factories began to produce clothing with old embroidery designs. At the beginning of the twentieth century, printed design sheets in the pseudo-Russian style were distributed by merchants to their customers at no cost, and this contributed widely to the gradual decline of traditional peasant hand embroidery, although the Russian national folk costume continued to exist in rural areas into the twentieth century.

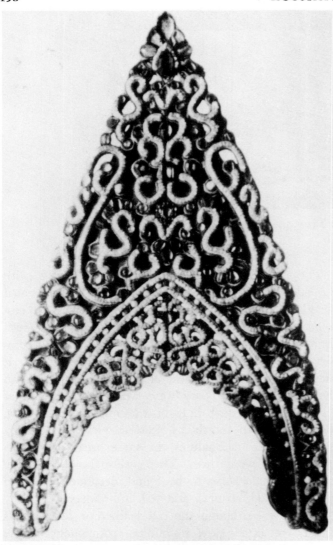

Kokoshnik. Kostroma Province, eighteenth century.

During the second half of the nineteenth century, the peasant costume remained much the same as it had been, although it became even more colorful, made increasing use of commercially produced cotton and calico, and exhibited worsteds colored with aniline dyes in all the colors of the spectrum. In some southern areas, sleeve decoration was so heavy that

11
WEAVING AND PRINTS

HANDICRAFT WEAVING

Flax, hemp, and wool were woven in Russia from time immemorial. Records indicate that at the peak of its development, Kievan Rus exported fabrics in exchange for other goods and that in the fifteenth century Russian linen was exported to the Asian markets and even to India. There was much handicraft weaving around Moscow during the sixteenth and seventeenth centuries, and although textiles were increasingly produced in factories during the second half of the nineteenth century, hand work continued in the villages into the twentieth century.

While certain old designs were widespread throughout Russia, peasant weaving, like embroidery, varied from area to area. The majority of woven fabrics exhibited a double-faced red design on a natural or white base, although there were exceptions since a number of techniques permitted the use of an unlimited number of colors. The *palasnaia* technique, for example, was in principle like a technique used in carpetmaking in the Caucasus and Central Asia and was probably borrowed by the Russians from the peoples in the East. White on white was popular in Olo-

nets, Vologda, Novgorod, and Pskov. Geometrical patterns—especially variations on the diamond—in horizontal bands predominated in peasant hand weaving. Naturalistic imagery was rare and, when present at all, was geometrized almost beyond recognition.

The abundance of handicraft fabrics at the Second Russian National Handicrafts Exhibition of 1913 was astonishing. Virtually every area of the empire—including the Ukraine, Lithuania, the Kingdom of Poland, and the Grand Duchy of Finland—had produced fabrics reflecting its own character, local conditions, and supplies, the fabrics ranging from simple peasant broadcloth to better quality woolens and linens with more sophisticated original designs.

The people of the northern areas sent towels, tablecloths, sheets, and pillowcases made either wholly or partly of linen. The splendid colors and designs of previous days had begun to disappear in the North, however, and the magnificent peasant dresses of the northern women were becoming the property of museums. Peasant women had ceased to wear their beautiful headdresses, peasant shirts were no longer in fashion, and weavers, encountering no demand for these articles, had stopped making them.

Sixteenth-century print.

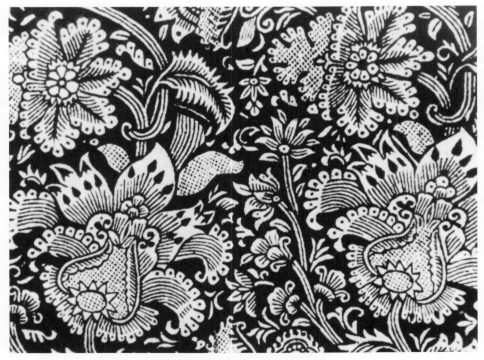

Seventeenth-century print.

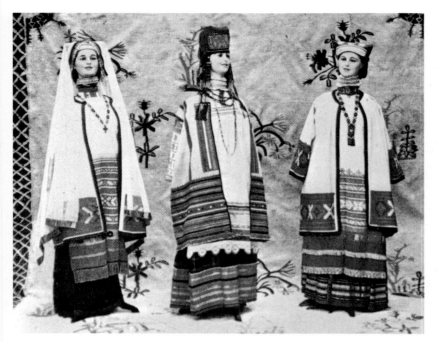

Women's costumes. Riazan Province, end of the nineteenth century.

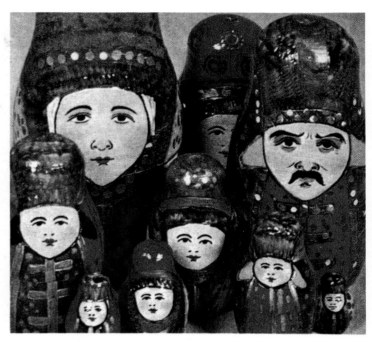

Boyarina and Boyars. Nested doll.

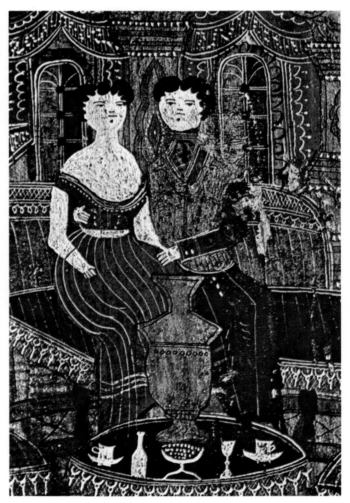

Painted Dontze (detail). Late nineteenth century.

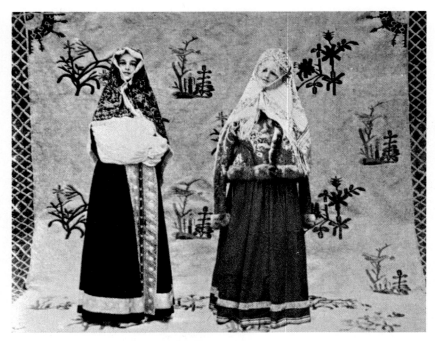

Women's costumes. Kostroma Province, end of the nineteenth century.

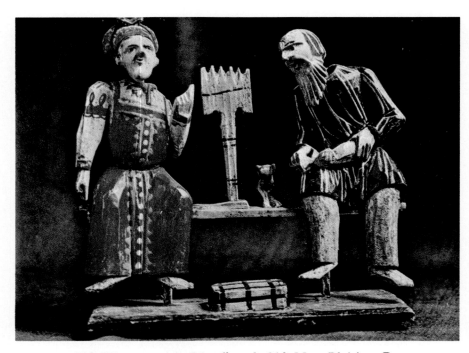

Old Woman with Distaff and Old Man Plaiting Bast
Shoes. Bogorodskoe, eighteenth century.

Seventeenth-century print.

The processing of fabrics, the quality of which ultimately determined their sale, presented a formidable difficulty to the weavers of the period. Although cotton and linen were less dependent upon processing, it was impossible for craftsmen to sell unprocessed woolen goods. Small enterprises engaged in the processing of fabrics in the handicraft areas very often ruined woolens because they lacked good machinery and experienced workers. Large factories, on the other hand, generally refused to process handicraft work because such fabrics were of high quality and, with professional assistance, presented serious competition to manufactured goods. Plans were made among handicraftsmen to organize their own process-

ing plants, but to do this required prohibitively large sums of money.

Craftsmen sold their fabrics through special local outlets. They took orders from training shops, crafts warehouses, and special work distribution centers (similar to trading posts), which supplied them in turn with the necessary materials. If the craftsman lacked equipment, he could obtain credit and repay the loan when he turned in his work. The substantial increase in the number of craft artels during this period had little effect upon handicraft weavers, of whose artels there were probably no more than ten in Russia at the beginning of the twentieth century. In the oldest weaving centers, weavers were totally

Seventeenth-century print.

Curtain (detail). Oil-on-linen print.

Printed objects. Moscow Province, end of the nineteenth century.

dependent on the work distribution centers located in the provinces of Moscow, Riazan, Yaroslavl, Kostroma, and Saratov.

Of the training shops that influenced the quality of fabrics in the northern areas, the two most important trained instructors and were supported by the provincial office of agriculture. The school organized in 1898 in the city of Vyshnii-Volochek (Tver Province) taught as many as forty trainees at a time and produced linen tablecloths, towels, and rugs. A school for women in the village of Sosnovitsa (also in Tver) came into existence in 1900. With approximately thirty students and twenty weavers at a time, it produced linen, woolen, and silk fabrics. In addition to these, weavers' artels were established in the cities of Sarapul (Vyatka Province) in 1893, Staraia-Russa (Novgorod Province) in 1895, and Tambov in 1904.

The northern areas for the most part produced unornamented white fabrics. The southern areas, on the other hand, produced rich, beautiful designs. Weaving was highly developed in Poltava Province, which had seventeen training shops for weavers at the time of the exhibition and occupied first place in the country for high-quality products.

The main center for the improvement of weaving in Poltava Province was the Degtiarev training shop, opened in the village of Degtiari in 1897. This shop

offered a complete course of instruction in the theory of weaving and dyeing, had a special information center for handicraftsmen and its own work distribution center, and employed approximately 500 weavers. All the weaving instructors in Poltava were its graduates, and some of them instructed in other provinces as well.

The largest weaving information center in the province, in the town of Reshetilovka, provided work for 1,500 craftsmen. The Olefirovsk shop in the village of Olefirovka distinguished itself by its large production of *plakhtovyia* (southern homemade) fabrics and attractive designs. This shop had its own dye works and served the other shops and individual craftsmen in the area, who received orders through it and from private customers as well.

The fabrics produced in Krolevets (Chernigov Province) were famous but valued somewhat less for their artistic appearance. Goods produced by Krolevets weavers were sold at the *zemstvo* (local government) handicrafts store in the city of Krolevets and included hangings, rugs, curtains, tablecloths, towels, and bed linen. The town of Novyi-Bazar was another weaving center in Chernigov. Linens of varying quality, ranging from fine fabrics for dresses and embroidery to heavier fabrics for furniture and hangings, were made in varied patterns and mild colors pro-

duced in its own well-equipped dye house. White and colored linen fabrics with durable dyes were produced by the weavers' shops of the Nenadykh Agricultural Society (Kiev Province) and sold at the Kiev handicrafts warehouse.

TEXTILE PRINTS

Early Prints

Cloth was printed in Russia from early times with the aid of carved wooden blocks, a popular decorative technique because it was less laborious and time-consuming than weaving or embroidery. At least one Soviet art scholar believes that textile printing originated in Russia during the tenth century because in the course of excavating the area of Old Chernigov fabrics were found bearing a printed Byzantine pattern. There is, however, no material evidence of the development of textile printing in Russia before the sixteenth century.

As evidenced by numerous ecclesiastical vestments found in a wooden church at Velikii-Ustiug at the end of the seventeenth century, as well as by the many written references to printed cloth made during the period, the early seventeenth-century textile print was a kind of black and white gravure on linen and of surprisingly high quality. Another Soviet art

Sarafan (detail), nineteenth century.

historian has suggested that the first print patterns were made by icon painters, and documents in the Oruzheinaia Palata indicate that icon painters were often asked to do such decorative work.

Two simple processes were involved: carving a design on a woodblock and then imprinting the design on cloth. Among seventeenth-century peasants, these tasks were performed by the same person; during the eighteenth and nineteenth centuries, printmakers could buy ready-made design blocks. The blocks were made of hard elm, nut, or pear wood. In the sixteenth and seventeenth centuries they usually measured twelve-by-fifteen inches and were cut in a solid block (metal parts did not appear until the beginning of the eighteenth century). A design was carved on both sides; for multicolor prints, a separate cut was required for each color.

In Old Russia the most popular colors were black and reddish orange on unbleached linen. Black was produced from soot; ocher was used with red and orange; and there was a Russian indigo of vegetable origin. A craftsman would sometimes touch up a part of his design by hand with a natural dye, such as a solution of saffron. Prints were seldom made in gold or silver.

There were, in the main, two methods of printing. In the first (used in the nineteenth century in Kaluga, Vologda, and in the Ukraine), designs carved on woodblocks were covered with oil paint, and the blocks were placed against wet linen and pressed with a wooden roller. In the other method, the craftsman held the block in his right hand, pressed it against a paint-saturated cloth, and then placed the block against the fabric, tapping it with his other hand or with a hammer. The first method is believed to have been more commonly used until the eighteenth century.

Although there is insufficient information to identify all the specific areas of textile printing in sixteenth- and seventeenth-century Russia, old records indicate that it was closely connected with the dye industries and generally concentrated in *posady,* cities, and trade centers. Prints were made both by special printmakers and by peasants who dyed linen for their own use, in the North (Archangelsk, Vologda, and Velsk) and along the Volga (Yaroslavl, Rostov, and Kostroma). It is believed that in 1628 there were about forty persons engaged in coloring cloth in Kostroma, possibly including some textile printers. Other early centers included Suzdal, Vladimir, Tver, and mainly Moscow.

The numerous textile prints of the sixteenth and seventeenth centuries were applied for the most part to church objects, and since craftsmen continued to work with woodblocks for a long time, it is not surprising that old designs were long preserved. Among the simpler designs were geometrical motifs—squares, circles, crosses, diamonds, and stripes—sometimes combined with the flowers, foliage, and berries often found in embroidery and woodcarving as well. As the naturalistic images were generally rendered without finicky detail, they tended to blend easily with the geometric patterns. Among the favorite Russian motifs of the period was a double-outline six-pointed star with a circle in the center, resembling a stylized snowflake. Moscow's historical museum has samples of seventeenth-century linen printed with a fish-and-flower pattern, the background of black oil paint. The fish is boldly but laconically drawn, and the sample typifies the best type of Old Russian work.

Print blocks. Vologda Province, end of the nineteenth century.

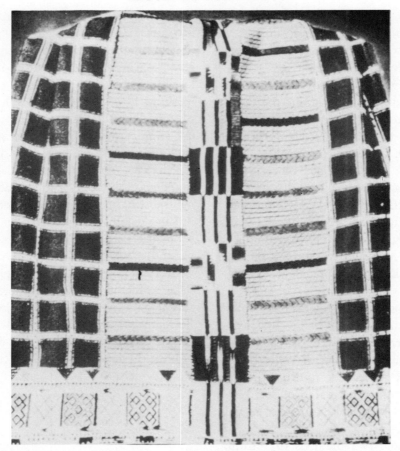

Panyova. Weaving and embroidery, Voronezh Province, nineteenth century.

Seventeenth Century

In the more complex designs of the early seventeenth century, elaborate plant branches, large flowers, fruits, and vegetables tended toward clarity and simplicity. On fabric complicated tulips and carnations became flat rosettes, daisies, and cornflowers, and simple branches were substituted for more complex foliation.

Prints of the second half of the seventeenth century exhibit a greater realism in the representation of floral shapes. Designs were now hatched and shaded like gravures, and their resemblance to the earlier woodblock designs was less pronounced. The inner lining of Czar Alexei Mikhailovich's tent, now in the Oruzheinaia Palata, is an outstanding example of characteristic textile printing of the second half of the century.

Since many expensive fabrics were imported from India, Persia, Turkey, Venice, and Spain, a certain foreign influence is sometimes evident in seventeenth-century Russian prints. The Russian craftsman did not, however, simply copy what he found but adapted it to the Russian taste. The characteristic stripe designs of Old Russia, for example, came originally from the East but were modified in Russia by the addition of small stars, flowers, triangles, and wavy lines over the stripes.

Seventeenth-century prints are typically saturated with decoration; even the simplest peasant prints stand out by reason of their prolificness and picturesqueness. This was not achieved, however, at the expense of clarity, sharpness, or variety. By not slavishly adhering to precise symmetry and by striving toward a dynamic liveliness of design, the artists generally avoided monotony. The design varied, of course, with the article. Smaller, simpler designs were used on *sarafany* and other clothing, while for a czar's tent,

for curtains and covers, much larger, more elaborate designs were employed.

The old textile printers tended to regard fabric less as fabric than as a surface to be decorated, and this view induced in fabric designs a certain decorative wholeness. Textile prints were flat; and although the design was usually silhouetted, a certain sense of depth was nevertheless present. In seventeenth-century fabrics, a feeling of space was obtained by using different colors in the representation of different sizes and scales.

While the use of black against a plain linen background was characteristic of older textile prints, the background of seventeenth-century Russian fabrics was not just a neutral surface for the laying on of design. Background and foreground ornament were interwoven, and some sections of background might be treated as separate parts of the ornamentation. This is especially pronounced where the background is studded with peas, dots, and squares which also figure prominently in the main design.

In seventeenth-century prints ranging from solid colors to three or four colors, the background color always agrees with the main design, never draining or dominating it, and the sections of background filled in with small ornaments tend to soften the transition

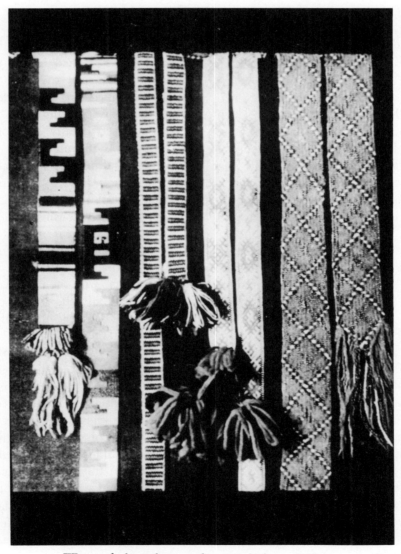

Woven belts, nineteenth–twentieth centuries.

from dark to lighter colors. A black or other solid color design might be enlivened by retouching, or the overlay designs might be printed in vivid blue or green. The natural hue of the fabrics was an important consideration as well: large, bold designs made with oil paint, for example, were especially well-suited to coarse homespun linen.

Eighteenth Century

In the eighteenth century the Russian textile print declined in popularity at court but increasingly penetrated the life of the city and its merchants. Peasant craftsmen continued to work with woodblocks, oil colors, and linen, and colored fabrics continued to be made for clothing, tablecloths, and curtains. About the handicraft article a good deal was written in 1771 by I. Lepekhin, a member of the Academy of Sciences who had traveled extensively throughout Russia. P. I. Chelishchev, visiting the Archangelsk village of Rakolskaia in 1791, found an outstanding peasant craftsman, Danilo Radionov, skillfully printing fabrics with designs he had himself cut on woodblocks. Chelishchev noted that the peasants of Ustiug and Krasnoborsk districts sold simple colored fabrics. It is doubtful that peasant-made prints differed substantially from those found among the other population groups in Russia. Folk prints changed very slowly and, in the eighteenth century, coexisted with factory-made fabrics and prints.

Early eighteenth-century textile prints exhibit simple geometrical patterns, the elaborate floral forms of an earlier period, light floral designs, architectural designs, and even characteristics of the *lubok*. The traditional peasant print employing oil on linen is still abundantly present. This style is identified with no single period but is related in general to the seventeenth-century inheritance from the older folk art tradition. Factory prints of the second half of the eighteenth century, however, differ considerably from these in reflecting more recent tendencies in art. At this point Russian textile prints divide into two classes—handmade folk prints and factory prints—even though early shop methods were themselves based on experience gained from the peasant handicrafts.

The eighteenth-century print tends to combine old and new motifs, the two often existing side by side and influencing one another. Among the oldest peasant prints of the early eighteenth century are a number depicting the female figure with upraised arms;

along the sides are horsemen, ducks, and cockerels placed in symbolic proximity to the sun. Many of these motifs, which Russian folk art experts relate to the old pagan Slav tradition of nature worship, survived to the twentieth century.

Among the newer subjects were genre prints depicting ladies and gentlemen feasting and horsemen in the uniforms of the Petrine period. During the first half of the eighteenth century, *lubok* cuts were often used in the printing of cloth. Later special cuts were prepared for textile printing, but these still strongly resembled those for *lubki*. Among the numerous prints of the period are some closely resembling designs used on early eighteenth-century tiles.

In the eighteenth century, too, the old oil print on linen was joined by the new factory print on cotton. The new cotton print industry developed among peasants and settlers in the early handicraft centers, such as northern Russia and the middle Volga, as a result of experience gained in the use of homemade unbleached linen. At the same time that homemade prints remained in use, factory-made cotton prints were used by peasants from the end of the eighteenth century, usually for holiday dress, but also to decorate walls, furniture, and even books.

On orders from the imperial manufactory office, in 1755 a cotton factory was created in Krasnoe Selo, near St. Petersburg, by two English merchants named Chamberlain and Cousins. In 1763 another member of this enterprise, a man named Leman, founded a cotton factory in Shlüsselburg. In 1758 the czarist government forbade small local enterprises to produce textile prints with commercial dyes; they were allowed to use only the old oil-on-linen method. Nevertheless, the number of small handicraft enterprises was great in the 1770s and 1780s.

From roughly the middle of the century the Shuiski District villages of Ivanovo, Kokhma, Shun, and Teikovo became prominent in weaving and textile printing—especially Ivanovo, whose handicraft work was already known in the seventeenth century. By the beginning of the eighteenth century, Ivanovo peasants were selling their printed cloth in Moscow, St. Petersburg, Astrakhan, and Kazan and at major fairs in Rostov, Makarov, and Kholui. The first linen factories in Ivanovo were organized in the first half of the eighteenth century; the first cotton print factory was founded here by a peasant named Ishinskii in 1762.

Ivanovo peasants also worked in small handicraft

Print block, wood and metal, nineteenth century.

shops in St. Petersburg, and some worked at the Leman factory in Shlüsselburg, where they learned the new methods of dyeing cotton which they brought back to Ivanovo. By 1776 the network of handicraft print enterprises in Ivanovo had grown rapidly. On the estates fo Count Sheremetev, 224 shops involved in cloth and print production were in operation in the eighties. The transition from oil paint to commercial dyes was gradual.

The fashionable motifs of contemporary art gradually entered eighteenth-century textile print design, and the cotton prints of the second half of the century differ considerably from their early, peasant-made predecessors. Although the traditional floral forms are still scattered freely over the surface of the fabric, they are now represented realistically; there is an artistic wholeness of composition; and the design is generally better adjusted to the size and mutual relationships of the individual elements.

Colors are more vivid than in earlier prints. Factory designers were better acquainted with contemporary gravures and paintings than were their peasant counterparts, but they succeeded, to their credit, in preserving a folk lushness of color in their work. Amateur and professional alike made free use of the *lubok* and the floral designs common to other genres of Russian decorative art, and at the end of the eighteenth century the Russian textile print was much more colorful and picturesque than it had previously been.

Existing records indicate that textile prints were manufactured by two methods in eighteenth-century Russia. In the *rezerv* method, the design was affixed to the cloth by means of wax, clay, or starch. The cloth was then dipped into a pigment, and the design was washed, leaving the covered areas white. The *protravlenie* method utilized certain mordants and acids which combined firmly with the dye on the cloth to produce a similar result. Multicolor cottons were still produced by using different blocks for each new color.

Woodblocks gradually increased in number during

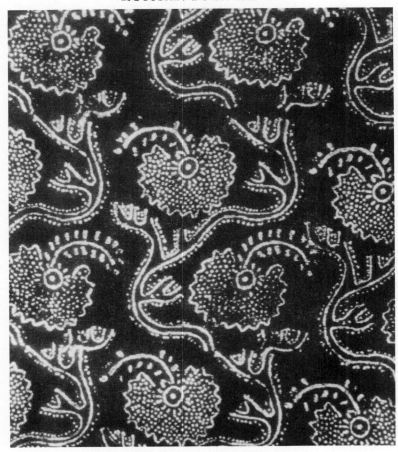

Nineteenth-century linen print.

the eighteenth and the beginning of the nineteenth century, and new details included brass plates on the sides of the block and small metal nails driven into it to produce new patterns. The blocks became gradually smaller and narrower, and cotton gradually replaced linen and sackcloth until finally unbleached linen was used only by peasant handicraftsmen.

Unbleached linens with oil color designs applied in heavy layers tended to pucker, did not wash well, and were not good for clothing. Cotton fabrics, on the other hand, were softer and more absorbent of dye. The demand at the juncture of the eighteenth and nineteenth centuries for beautifully decorated fabrics thus led to the widespread use of cotton.

Nineteenth Century

Textile printing remained a popular peasant handicraft during the nineteenth century because it was work the peasant could do himself and also because printing, along with embroidery and weaving, was among the few ways there were of imparting design to fabric. Hand-printed cloth was used in the nineteenth century for pillows, bench covers, curtains, wall hangings, and clothing, including shirts, aprons, *sarafany,* and kerchiefs. Printed cotton kerchiefs occupy a special place in factory designs. The Leman factory in Shlüsselburg developed special designs for kerchiefs. In Ivanovo during the 1870s, kerchief prints were made on coarse Bukhara calico.

Since carved woodblocks could now be purchased at fairs, designs were often transferred great distances for reproduction elsewhere. Cloth printers would often leave their villages in a group, carrying their gear and samples of their work with them. At the beginning of the nineteenth century, peasant prints were widespread throughout Russia, and although these were increasingly replaced by factory articles toward

the end of the century, the handicraft survived in the more remote areas of the country.

At this time the most artistically executed prints came from the North—Archangelsk, Vologda, and Olonets provinces. At the beginning of the century handicraft printing was concentrated in the Velsk District of Vologda, where prints were made from both large and small woodblocks with an embossed metal design. Archangelsk and Vologda produced wide linen prints with their own characteristic designs from locally made woodblocks. Many of these designs diminished in size, beauty, and wholeness during the course of the century as handicraftsmen, increasingly obliged to produce prints similar to those made popular by the factories, began to absorb shop designs into their work.

Although design subjects increased during the century, old patterns persisted as well, since a woodblock was a family treasure passed on from father to son and new blocks were cut in imitation of old ones. In general, handicraft motifs were based upon the peasant's observation of nature, especially of the plants and animals typical of the Russian landscape—hence the proliferation on fabrics of ducks, doves, horses, wildflowers, berries, and evergreen branches. Genre scenes—a hunter with his dog, tea drinking around a samovar—were also common. Old pagan motifs were combined with later ones, and borrowings from the *lubok* were evident.

The peasant artist represented his subject emotionally rather than realistically. A flower was rarely depicted with botanical verisimilitude, as was sometimes the case in eighteenth- and nineteenth-century factory prints. Because a folk artist did not attempt to preserve natural proportions, attempting rather to depict an expressive relationship between objects, a bird might be as big as a vase, a fantastic peacock several times larger than a horseman. Proportion was subjugated to design, and realism to feeling.

Designs existed in numerous variations. Some nineteenth-century peasant prints differ according to the artel in which they were produced; at the same time, certain individual peculiarities of the craftsman are to be seen in, for instance, uneven outlines or uneven distribution of ornamental dots over the surface of the cloth. Although the purpose of these dots differed, they had the general effect of softening the contrast between light and dark and thus helped to unite the overall design. All of this reflects the hand of the folk artist, who could at times produce very unusual color shades simply because he had not applied even pressure to the woodblocks during the printing process.

Factory mass production of textile prints had the effect of lowering artistic quality generally, and only individual artists continued to produce works of high quality. Gradually the nineteenth-century folk print lost its dynamic quality and became increasingly dull, static, and imitative.

12
CARPETS

Although rugmaking has been preeminently an art of the Eastern peoples, its beginnings have been traced to southern Siberia. The earliest known carpet was discovered in 1949 in a Scythian burial site at Pazyryk in the Altai region, about fifty miles from the Outer Mongolian border, where the burial sites are believed to date from about 500 B.C. The art of the knotted carpet was already highly evolved in pre-Christian times. It is now believed to have originated not in imitation of animal skins, but as a mobile substitute for mosaic, though whether mosaics inspired the designs of carpets or whether carpets were adaptations of mosaic is not known.

TAPESTRY

For all practical purposes, the history of decorative rugmaking in Russia began with the introduction into the country of Gobelins tapestry. Tapestries originated in Western Europe and were not known until the seventeenth century in Russia, where their history was closely connected with the personal interest of the ruling family. Tapestry production in Russia dates from the beginning of the eighteenth century and is associated with the reign of Peter the Great, who is regarded as its founder.

Peter the Great became personally acquainted with the making of tapestries and with the Gobelins works during his visits to France in 1716 and 1717. To establish the trade on a domestic basis, a number of French artists were engaged at his command to come to Russia. The first group, which included the painters Louis Caravaque and J. M. Nattier, the sculptor Pinault, and *tapissiers* from the Gobelins factory, arrived in St. Petersburg in 1717 headed by the reputed architect Louis Le Blond. From these artists Peter ordered a tapestry depicting the Battle of Poltava from a drawing by Caravaque. In July of the same year a second group of artisans arrived from France, and a five-year contract was drawn up which would initiate the domestic production of tapestry and have native Russians trained in the craft.

But actual production was delayed by a lack of equipment and high-quality wool, and for the first two years Russian tapestries were exclusively the work of foreigners. From 1719, after the death of Le Blond, tapestry production was under the administration of the ministry of mines, and major emphasis was placed on the training of native craftsmen. In 1722 Peter the

Smooth carpets. Kursk Province, end of the nineteenth century.

Great ordered the foreigners home, and by 1723 only a few of the original French artisans remained in the country. By 1724 there were ten Russian apprentices aged fifteen to eighteen; in 1725 there were twenty-five. The early tapestries made by these Russians were either unsigned or identified simply: "Made by Russian apprentices."

The Russian tapestry had a very precarious existence and was often in financial difficulty owing to the great expense of its production; in fact production was almost abandoned at the death of Peter the Great. Revived in 1732, however, by order of Em-

press Anne, tapestry production was placed under court administration and given new, specially prepared quarters. Materials were imported, the number of apprentices increased, and by 1741 the shop had sixty employees. In 1741, too, a drawing school was established at the shop under the general artistic supervision of Caravaque. The period 1732–43 saw the production of a number of very artistic, high-quality tapestries in Russia.

From 1743, however, output declined and the number of apprentices dropped until finally only one experienced craftsman remained working. This decline

has been attributed in part to an allocation of funds for the first imperial china factory in Russia, which drew money away from tapestry production. Interest in the tapestry rose again in 1755, possibly because the shop had been commissioned to weave a tapestry depicting Elizabeth's accession; but this work, planned for the Winter Palace, was never carried out.

By order of Elizabeth, the tapestry shop was now placed under the supervision of the senate and subsidized by the government. Working conditions were improved, the old quarters were rebuilt and extended, the number of apprentices increased, and their pay was raised. A special decree of 1762 established an Imperial Office of Tapestry Manufacture, and two years later the factory was removed from senate supervision. The period 1764–1802 was the most productive in the history of the Russian tapestry; 150 people, almost exclusively Russians, were employed in the production of designs (many based on Hermitage paintings), hangings, and rugs. Only a few such articles were made for the court, however, the majority being for private individuals.

The making of tapestries was extremely difficult. It required great accuracy in weaving, and the craftsman had himself to be an artist to produce and reproduce an original design. Of the two methods of weaving tapestries—vertical (*haute lisse*) and horizontal (*basse lisse*)—the vertical was the more expensive but better method, as it ensured better design reproductions. In this method the work was placed upright with the weavers facing the back of the tapestry. A cartoon, or preliminary sketch the same size as the tapestry, was made of the design and placed next to the loom during the work. Work began after the design was applied to the warp by means of a special pencil. The complexity of the work came partly from the fact that the weaver had to manipulate a great number of spools of thread, using as many shades of color as there were colors in the section on which he was working. The weaver could look at the front of the work either by walking round the loom or by placing a mirror in such a way as to reflect the front.

In the other method the thread was stretched on the loom horizontally and the design placed directly under the warp. Because this tapestry, too, was woven from the back, the cartoon was reflected for the weaver's guidance in a mirror. The weakness of this method lay in the fact that the weaver worked, not from the original, but from a mirror reflection of

it, so that an exact reproduction of the design was difficult to achieve. Russian weavers used both methods, but those employing the vertical method were better paid because their reproductions were better.

Eighteenth-century Russian tapestries were made of wool or silk, sometimes both. Gold and silver threads were rarely used. Employed as a wall decoration, the tapestry was sometimes framed in wood, sometimes made with edges resembling a wooden frame, and sometimes fitted onto a lower wall panel. On occasion, tapestry was not woven but embroidered in wool and silk on canvas in imitation of expensive tapestry. Although color harmonies would later become more variegated and subtle, at the beginning of the eighteenth century they were intense, as the masters of the period were not afraid of boldness of color.

The subject matter of the eighteenth-century Russian tapestry was varied, ranging from historic subjects, such as the Battle of Poltava, to biblical and religious subjects, portraits, landscapes, and reproductions of paintings. The subject of one tapestry made for Peter the Great by one of the early arrivals from France is believed to have been copied from a seventeenth-century Dutch painting. A tapestry entitled *Versavia,* completed by a Russian student in 1727, copies a Rubens painting of 1635. A work entitled *Time Unchaining Faith* is also strongly reminiscent of a Rubens—although a Titian might also have been its prototype. Designs made by peasant artisans, however, depended for their subject matter on the purpose of the room or the customer's request. The more common peasant motifs included human, animal, and allegorical figures, flowers, military regalia, and family coats-of-arms.

The Russian tapestry reached its zenith in the second half of the eighteenth century and declined in the century that followed. During the 1830s the Office of Imperial Factories and Plants initiated a policy which placed such enterprises on a commercial footing so they might become self-supporting and realize a profit as well. In 1836 a shop was established at the tapestry factory for the production of simple carpets on English and Scottish models. Thus, what had begun as a royal aesthetic undertaking gradually became an industrial trade; it was made official as such by a regulation of 8 February 1837 issued in connection with the tapestry works.

A government inspection of 1838, however, found only two old weavers actually working on tapestries. On 1 July 1858 the factory was abolished by order

Velvet carpet. Kursk Province, end of the nineteenth
century.

of a minister of the court, and later that year, on
the completion of work in progress, it ceased to exist.
But the imperial manufactory had existed for almost
150 years and had influenced the numerous factories
and shops created on landlords' estates during the
nineteenth century. On estates in the provinces of Sar-
atov, Peutza, and Simbirsk, excellent carpets were
made on Aubusson patterns, and fine shawls were
done on French patterns. But the factories and shops
of the first quarter of the nineteenth century were,
like the imperial manufactory itself, very small enter-
prises producing carpets by hand, and their further
development was hampered by small output and lack
of profit.

CARPETS

Elsewhere in Russia, where the production of car-
pets owed its existence to the economic necessities of
life, carpetmaking took deeper root. Such enters in-
cluded the Tiumen area, where fifty-three villages
were once engaged in carpetmaking, the village of
Uryv in Voronezh Province, and Dubovka Posad in
Saratov Province. Carpet production was also estab-
lished in the provinces of Kursk, Poltava, Kherson, Po-
dolsk, and Bessarabia, where the craft arose both out
of local custom and out of the necessity for a source
of additional income.

Tiumen

Precise facts concerning when and under what con-
ditions carpetmaking began in the Tiumen area are
not known; local artisans believed that rugs had been
made there on old looms from time immemorial. Tiu-
men *okrug* (Tobolsk Province, Siberia) was originally
settled by Tatars; settlers from Bukhara (then Tur-
kestan) and Russians from various areas had come
later to make up a part of its multiracial population.
It is probable that carpetmaking was brought to Tiu-
men by the Bukharans and Tatars.

Bukhara (now in the Uzbek Soviet Socialist Repub-
lic) extends from the Aral Sea to the Pamir plateau
and was once a Central Asian religious, cultural, and
trade center through which caravans from China, In-
dia, and Persia brought carpets made by the tribes
of the whole region to Russian markets in Astrakhan,
Orenburg, and Nizhni Novgorod. It has been conjec-

tured that the Russian settlers of Tiumen learned from the Bukharans the technique of making rugs out of velvet materials of Bukharan and Persian origin, and from the Tatars the technique of making smooth rugs.

Tiumen rugs came in all sizes, were either smooth or shaggy, and included throw rugs as well as rugs for walls, tables, doors, and trunks, the two latter being the most popular articles in the city of Tiumen, where most of the area's carpets were sold. Carpets were made for the most part of sheep's wool and two-ply or three-ply linen yarn, some of the materials of local origin, some imported. Women dyed the wool, and in the old days the variety of color was limited. Dark and brown wool alone were dyed; white wool was used as it was. Although vegetable dyes predominated, aniline dyes were also used and were purchased by the weavers at local stores or from traveling merchants.

Throughout the villages and settlements of the area where carpetmaking provided a major source of income, the difficulty in obtaining good designs was a constant complaint. Although Tiumen weavers were proud of their ability to produce a carpet on any pattern given them, Tiumen patterns were unimaginative and often mediocre. Designs from Leipzig and Berlin might be brought to the area by a merchant who would buy the rug, but the weavers were also known to have been inspired by the pictures on bottle labels. Among weavers and buyers alike, the most popular designs were floral motifs and patterns involving human and animal figures.

Voronezh Province

Another rugmaking center under the influence of Eastern designs was the settlement of Uryv in the Province of Voronezh. Here, smooth-woven carpets called kilims were produced all on the same, typical Turkish pattern. Carpetmaking had been introduced to this settlement by Turkish prisoners of war temporarily interned in the Uryv area, and they were remembered with gratitude by the people whom they had taught to prepare and color wool and to weave carpets. These carpets, made on simple wooden looms somewhat larger than those ordinarily used for the weaving of linen, were sold by women at the railroad stations.

In 1912 approximately 600 households were em-

ployed in carpetmaking in Uryv; the village of Liski joined in the production later. A training shop for weavers named after Grand Duchess Olga Alexandrovna was established in the village of Staro-Zhivotino (also in Voronezh). Founded in 1911, it continued using old patterns produced by former students until World War I. In the town of Gorozhanka a needle-work and weaving shop owned by E. N. Chokolova produced knotted carpets.

Dubovka Posad

The carpets of Dubovka (Saratov Province) were made of local wool and characteristically exhibited large floral bouquets against a white background with a narrow garlanded border. Carpetmaking was probably brought to the settlers of this area from the Ukraine, but production was already on the wane here before World War I. In the early years, timber merchants from the areas along the Upper Volga were the major buyers. With the introduction of a railroad line to Tsaritsyn, the center of the timber trade shifted to that city, and in 1913 there were only four families still engaged in carpetmaking in Dubovka. A similar situation existed in many of the other centers already mentioned.

In areas where peasants were mainly occupied in agriculture, carpetmaking was pursued only during the time free from other work. The carpet was nevertheless an important article in the peasant household. During holidays, sledges were decorated with rugs, they were used as blankets during the cold winters, and they formed a portion of every bride's dowry. It is perhaps for this reason that few of them were sold; the majority were used at home.

Kursk

The story of carpetmaking in the Kursk area is fairly representative of the history of handicraft carpetmaking in Russia as a whole. Local traditions fostered the development of the craft in this area, where weaving and peasant-made fabrics used for clothing and home decoration had been important in the regional economy since the seventeenth century. A bride was blessed on a carpet, the wedding carriage or sledge was decorated with rugs, and rugs were inherited through the female line. Kursk rugs were generally made by women, who prepared the wool them-

selves as well as the dyes, which they made from herbs gathered in the spring. In the Kursk area, girls began to learn rug weaving at an early age, first at home with their mothers and grandmothers, and sometimes later from an expert female artisan to whom they were sent for further instruction. A girl would weave her own dowry carpet, and by its quality her own quality as an industrious wife would be judged.

Most popular among the Kursk peasants were a variety of smooth rugs made from coarse wool and known as *poponki, pokryshki,* and *postilki.* These were usually made on a linen or hemp warp and produced on simple horizontal looms. Shag carpets, also made on horizontal looms, required more skill, time, and materials and were therefore more expensive. Until 1860 both the peasant-made rugs and those produced in factories and shops on landlords' estates were all handmade.

The existence of carpet factories in the Kursk area was documented for the first time in a report of 1787 by S. Larionov, who had found them in the villages of Nikolsk and Kolapokovka—the former belonging

to Prince Izedinov, the latter to a nobleman named Lutovikov. At the same time a broadcloth and carpet factory had been organized by Prince N. B. Yusupov on his estate, Rakitnoe. The latter is interesting for the light it sheds on the manner in which these early enterprises were founded.

In 1798 Yusupov ordered that Russian craftsmen be brought to Rakitnoe from Poltava; these were the sons and grandsons of serfs who had earlier been brought there from Yusupov's estates in central Russia. Peasants were now gathered from the Yusupov holdings in Kursk, Voronezh, Kharkov, and Poltava provinces, along with some skilled artisans from the Yusupov textile enterprises in the Moscow area. When the Rakitnoe carpet factory was established in 1797, additional craftsmen were recruited from various areas, again including Moscow. The Yusupov archives indicate that by 1815 there were thirteen contracted workers at Rakitnoe, a number of serfs, a few children, and five "artists" (of whom only one—I. Kotliarov, age sixty—was listed as an artist, the others being regarded as apprentices). The "artists" were offi-

Woolen carpet. Orlov Province, nineteenth century.

Woolen carpet. Kursk Province, nineteenth century.

cially responsible for all art work connected with the enterprise, including all paint jobs on the estate.

By 1819 there were two carpet factories at Rakitnoe, one with twenty and one with seven female apprentices. The senior master was F. Gureev, an expert weaver, who was joined in 1819 by another expert weaver from Moscow, F. Trusova. In the interests of efficiency, Trusova was appointed supervisor of both factories, and she was also responsible for introducing the vertical loom at Rakitnoe. (Earlier carpets had been made on narrow horizontal looms, which involved joining several pieces together to make up a full-size rug.) From Rakitnoe, finished carpets were sent to Yusupov's central distributing center in Moscow, and it is known that some of these were sent to the court and even abroad. For all that, the Yusupov enterprise did not last long. In 1831 it was closed for lack of profit and converted into a linen-producing shop.

The principal design at Rakitnoe was based on a square enclosing a circle. If the main design was contained within the circle, the areas surrounding it might be filled with birds, flowers, lyres, and so forth.

Landscapes were also represented, as well as architectural motifs, people, animals, trees, floral baskets, and fairy tale subjects. The colors included all the popular Russian favorites of the early nineteenth century.

The period 1820–40 saw a blossoming of carpet production on the landed estates of Kursk Province, where there were approximately thirteen carpet enterprises in operation. In 1840, however, an increase in the price of bread and sugar beets in the Kursk area brought about a closing down of rug factories, as sheep pasturage was converted to the cultivation of sugar beets and grain. Later, with the abolition of serfdom in Russia, landlords lost a traditional supply of cheap labor, which further hampered the continuation of carpet production on their estates.

The Kursk carpets of the early nineteenth century were either smooth, shag, or knotted, or exhibited a combination of techniques. They were made of wool yarn on a hemp or linen warp and differ from later rugs by having been made on hand-operated horizontal looms only twenty-five to thirty inches wide. Colors were obtained from bark, onion peel, and herbs; in-

digo and sandalwood root were commercially prepared. The designs of the pre-1861 period included repetitive geometrical patterns without borders, designs enclosed in a clearly delineated central square both with and without borders, and sledge carpets in two or three parts, each having its own design and colors. Pre-1861 carpets used both geometrical and plant motifs, but human, animal, and bird figures might be introduced into any or all of them.

Certain decorative characteristics of the eighteenth century were better preserved in carpets than in other textile works of the first half of the nineteenth century. The design of floor rugs, for example, very often resembled that of ornamented ceilings and parquet floors, an architectural touch which better integrated the carpets into various interiors. In the case of those resembling ceilings, the carpet was not as a rule overcrowded with design. The center usually held a round or oval wreath, which was balanced at the corners by small floral bouquets. The center would be framed by a wide strip of floral garlands or stylized architectural ornament. Generally, the splendid large designs of these rugs were based on a sharp, colorful plant silhouette, with individual flowers, branches, and leaves lightly stressed and the design in soft harmony with its background. In the designs resembling early nineteenth-century floors, the main area would be decorated with geometrical shapes enclosing floral wreaths or bouquets. Fewer and more laconic colors were used than previously, with black and white generally predominating, and the stylized plant forms of architectural design were often combined with naturalistic floral forms.

The colors used would depend on the carpet's purpose. Those designed for holiday use exhibited predominantly light colors, and light designs were matched against a light background color with remarkable refinement. Designs were not crowded in this type of carpet, even though the free areas might be filled with floral garlands, bouquets, and branches. The contrast of light design against light background was achieved by means of dark outlines, and to strengthen contrast, the background was often made lighter in the center and darker at the edges.

In addition to light carpets, many carpets were made with a dark brown background of natural wool. Such carpets cost less and were more practical for everyday use. The dark brown ground invited the use of the brighter colors popular at the beginning of the

nineteenth century. A bright multicolored design on a black and white background was one of the most popular decorative effects of the nineteenth century and also found its way into Russian fabrics.

In addition to landlords' and merchants' factories, village peasants and monasteries also made carpets. Those made by the latter were aimed mostly at city markets and were for this reason often imitative of factory rugs. Peasant-made carpets were produced for various occasions, even for use as horse blankets during the freezing winters. Shag carpet motifs included human and animal figures, vased flower arrangements, and such household images as teapots, cups, and samovars. Such designs were typical of the nineteenth-century textile folk arts, many of them suggested by the *lubki* and other printed materials of the period.

After the abolition of serfdom in Russia in 1861, carpetmaking decreased on the landed estates but increased among the peasantry. The production of shag carpets dropped due to lack of demand by Moscow, and from the sixties to the nineties smooth carpets with large floral designs predominated for use by city dwellers and the peasant middle class. At the beginning of the nineteenth century, horizontal looms were mostly used by Kursk artisans to meet a demand for plain carpets with simple designs and average density. The majority of carpets of the second half of the century, however, were produced on vertical looms, because these made possible the production of better carpets of any width, and because the looms themselves occupied less room space.

The carpets of the second half of the nineteenth century were made of wool and handmade linen. The wool was of better quality than it had been previously, and from the 1880s it was colored with synthetic dyes. The peasant-made carpet featuring a large floral design against a black background was widespread in Russia during the second half of the century, when the tendency was away from stylizations and more toward floral representations realistic in both shape and color. Especially popular was a large, centered floral bouquet balanced by smaller bouquets and a narrow garlanded border, a design which survives to the present day.

At the beginning of the 1850s a number of art magazines, including *Buket, Vaza, Bazar,* and *Vestnik mody,* published supplements containing, as a help for handicraftsmen, printed decorative motifs made by artists. These designs were printed on square graphlike

paper, which greatly simplified the work. Such printed motifs were mostly used by the peasants working on landlords' estates and by the monasteries.

Russian carpetmaking reached its peak in the 1870s and 1880s, but the peasant-made article declined in quality during the eighties because of competition from factory-made carpets. The first attempt to mechanize Russian carpetmaking was made by a peasant named Andreev, who invented a mechanical loom and produced several carpets on it before his factory burned down in 1812. Because they were less expensive and offered a greater selection of designs, machine-made rugs soon became popular enough to compete with small-scale production. By the 1870s, of seventy-nine carpet enterprises in Russia, five were completely mechanized, and from the eighties onward, both folk and fine art rugmaking was influenced by the cheap factory article.

To satisfy merchants and other city buyers, carpets were increasingly based on designs available in popular journals. Russian design motifs were mixed with elements of baroque architectural ornamentation alien to folk art, and cheap carpet designs were to be found on the wrappers for soap and other toilet articles. Inexpensive synthetic dyes replaced the traditional means of achieving bright colors, and although many late nineteenth-century rugs exhibited combinations of halftones involving as many as fifty shades of color, there was finally too much color, design, and detail. Design became literal picture, and, at the turn of the century, with the historically decisive encroachment on the market of factory-made rugs, the Russian peasant rug lost its essential authenticity.

Ateliers and Shops

The Russian intelligentsia gradually became aware of the decline of carpetmaking as a folk art in the 1880s, and measures were undertaken in 1885 to revive production in Kursk Province. An article addressed to the problem, which appeared in an 1885 number of the *Ekonomicheskii zhurnal,* read in part:

> Carpetmaking could develop and prosper if favorable conditions were created. Now carpetmaking lacks organization; there is no organized sale of carpets. Due to these facts, carpetmaking and other handicrafts are slowly dying. . . . *Zemstvo* governments should come to the rescue of the carpet handicrafts and protect the local interests.

In 1885, a first handicrafts exhibition was organized in Kursk by the local *zemstvo* to initiate a study of local handicrafts.

In 1888 all matters pertaining to Russian handicrafts were transferred from the finance ministry to the ministry of state properties, and studies of rugmaking were undertaken in areas of the Caucasus, the Caspian Sea, Turkestan, and Bukhara. Studies carried out in 1888–92 in the provinces of Tobolsk, Saratov, Voronezh, Kursk, Poltava, Bessarabia, and Podolia revealed the various crafts' shortcomings in these areas and led the government in 1899 to open a department for the improvement of rugmaking at the Mariinskii School of Lacemaking in St. Petersburg. An expert on Persian, Tekin, and other rugs was invited to become the instructor in rugmaking, and the first apprentices were from Bessarabia, Tambov, and Kursk. Having completed their training, graduates were returned to their native areas as instructors.

In 1900 an atelier for female instructors of spinning and weaving was founded in the village of Sosnovtsy (Tver Province). In the northern provinces, and in Vitebsk especially, the work from the shop of Countess A. A. Moll was remarkable for the production of carpets of a modern style on drawings by Stabrovski.

Especially active in the development of artistic rugmaking in Tambov Province were A. N. Naryshkina and M. F. Yakunchikova. With the help of a graduate weaver of the Mariinskii school, in 1895 Naryshkina founded on her estate a weaving shop which produced rugs of high quality and fine artistic design. In 1909 Yakunchikova organized a weaving shop in the village of Solomenka, where sixty girls were trained under the supervision of weavers from the Mariinskii school.

To stimulate the handicrafts in the Sudzhansk District, three training shops were organized in Kursk Province: in the village of Kostora in 1900 and in the cities of Sudzh and Miropol in 1910. In 1897 F. Dolzhenkova was sent to the Mariinskii school, where for three years she studied carpetmaking, design, and composition. On her return to her native village of Kostora, with the help of the local *zemstvo,* she organized a two-year school for local rugmakers. This school trained girls from twelve to sixteen years of age on their parents' signed pledge that they would remain in school until their training was completed. Here twenty girls studied carpetmaking, design, and composition along with more general subjects. During the nine years of its existence, the Kostroma atelier

Woolen carpet, 1870s.

trained fifty persons, of whom twenty-two continued to work at the school shop, the rest working independently in various towns and villages.

Shops sponsored by a *zemstvo* were generally better equipped than peasant-run shops. Large vertical looms were common, and serious attention was given to the improvement of artistic quality. After graduation, a student might remain at the school shop or accept commissions from the shop for home work. A considerable influence was exercised on carpetmaking in Russia by these *zemstvo* schools and shops, where rugs were made on designs prepared by professional artists. Some of the best of these were included in the Second Russian National Handicrafts Exhibition of 1913, where they were in great demand. In general, however, such schools came too late to save the craft from decline.

At the beginning of the twentieth century, carpetmaking was increasingly influenced by contemporary, rather than folk, art trends, so that by 1908, of thirty-six carpets produced at the Sudzhansk shop, only four followed old patterns, the rest being modern in design. Still identified primarily with the Caucasus and Central Asia, handicraft rugmaking was relatively short-lived in European Russia.

GLOSSARY*

BOYAR	In Old Russia, member of a large landowning class belonging generally to the ruling elite of Moscow and identified with the Muscovite ruler; *boyarina* (f.)	KOSOVOROTKA	Long, belted, embroidered shirt for men
		KRASAVITSA	"Beauty"
BYLINA	Heroic tale of Old Russia	KUKHLIA	Ceramic table utensil shaped like a barrel
DRUZHINA	Princely retinue	KUMGAN	Tall ceramic pitcher with a trunk-like spout
ENDOVA	Ceramic spouted tureen	KUSTAR	Itinerant handicraftsman who traveled about the country practicing and selling his crafts
GUBERNIA	Province		
GUIPURE	Heavy decorative lace		
GUSLI	Ancient stringed instrument	KVASS	Traditional Russian beverage fermented from black bread and malt
ICONOGRAPHY	Formal symbolism and stylistics identified with Byzantine-Christian icon imagery	LAGUN	Large wooden pitcher
		LAPOT	Bast sandal; *lapti* (pl.)
ICONOPISETS	Icon painter	LUBOK	Woodcut or engraved broadside
IZBA	Russian peasant hut	MATRYOSHKA	Nested wooden doll
KAFTAN	Long outer garment for men	MUZHIK	Peasant
KOKOSHNIK	Ornamental headdress for women	NAGRUDNIK	Short jacketlike article of clothing for women
KOLT	Headdress ornament for women		
KORCHAGA	Primitive ceramic pitcher	NALICHNIK	Carved window or door frame
		OBLAST	Region
		OFENIA	In Old Russia, a salesman who

* Russian nouns are given in the singular.

182

wandered from village to village selling notions, books, icons, *lubki,* etc.; *ofeni* (pl.)

OKRUG — District or region

OLD BELIEVERS — Schismatic religious sect that separated itself from the Orthodox church during the seventeenth century, refusing to accept the church reforms of Patriarch Nikon

PANKA — Primitive wooden doll

PANYOVA — Tuniclike garment for women, mostly from the South

PELENA — Ecclesiastical embroidery, including icon covers and altar frontals

PEREDNIK — Woman's apron

PLASHCHANITSA — Embroidered funeral pall or winding sheet used on Good Friday to symbolize the rite of the Easter Sepulchre

POSAD — In Old Russia, the trade-industrial section of a city, usually outside the city walls

PROMYSHLENNIK — Entrepreneur

RAZNOCHINETS — Intelligentsia from all social classes; *raznochintsy* (pl.)

RUBAKHA — Woman's embroidered shirt

RUKOMOI — Ceramic pitcher shaped like a stylized ram

RUS — Name of Russia from the beginning of Russian history until approximately the end of the seventeenth century

SARAFAN — Tuniclike garment for women

SKOMOROKH — Itinerant minstrel-buffoon

SKOPKAR — Large pitcher

SLOBODA — Large settlement or city suburb which, before the emancipation of serfs, was composed of both serfs and free citizens

SVETETS — Holder for wooden tapers used to light a room

TARTARS — Mongols primarily from Central Asia; Tartar invasion and occupation of Rus, 1231–1480

UEZD — District

UKAS — Governmental decree having the force of law

VECHE — Common council of Old Novgorod

ZEMSTVO — In prerevolutionary Russia, a district assembly

BIBLIOGRAPHY

Adrianova-Perets, V. P., ed. *Russkii lubok: XVII–XIX vv.* Moscow, Leningrad: Gosudarstvennoe Izdatel'stvo Izobrazitel'nogo Iskusstva, 1962.

Akademiia Arkhitektury UkSSR. *Ukrainske narodne dekoratyvne mystetstvo i dekoratyvni tkanyny.* Kiev: Instytut Khudozhnoi Promyslovosti, 1956.

Aleksandrova, V. A., et al. *Russkie: istoriko-etnograficheskii atlas.* 2 vols. Moscow: Izdatel'stvo "Nauka," 1970.

Arbat, Iu. *Russkaia narodnaia rospis' po derevu.* Moscow: Izdatel'stvo "Izobrazitel'noe Iskusstvo," 1970.

Boguslavskaia, I. Ia. *Russkoe narodnoe iskusstvo.* Leningrad: Sovetskii Khudozhnik, 1968.

Bunt, Cyril G. E. *Russian Art: From Scyths to Soviets.* London and New York: The Studio, 1946.

Glavnoe Upravlenie Zemleustroistva i Zemledeliia. *Russkoe narodnoe iskusstvo, al'bom.* Petrograd, 1913.

Hansen, H. J., ed. *European Folk Art in Europe and the Americas.* New York and Toronto: McGraw-Hill, 1968.

Hare, Richard. *The Art and Artists of Russia.* Greenwich, Conn.: New York Graphic Society, 1965.

Iakovleva, E. G. *Kovry RSFSR.* Leningrad: Vsesoiuznoe Kooperativnoe Izdatel'stvo, 1959.

———. *Kurskie kovry.* Moscow: KOIZ, 1955.

Khokhlova, E. N. *Sovremennaia keramika i narodnoe goncharstvo.* Moscow: Izdatel'stvo "Legkaia Industriia," 1969.

Kriukova, I. A. *Russkaia skul'ptura malykh form.* Moscow: Izdatel'stvo "Nauka," 1969.

Kuznetsov, Z. D. *Russkie izraztsy.* Leningrad: Khudozhnik RSFSR, 1968.

Leonova, I., ed. *Russkoe dekorativnoe iskusstvo.* 3 vols. Moscow: Izdatel'stvo "Iskusstvo" SSSR, 1963–65.

Levin, L. M. *Kovry i kovrovye izdeliia.* Moscow: Gosudarstvennoe Izdatel'stvo Torgovoi Literatury, 1960.

Mozhaeva, E. I. *Matryoshka.* Moscow: Sovetskaia Rossiia, 1969.

Nosik, B. M. *Puteshestvie za Dymkovskoi igrushkoi.* Moscow: Izdatel'stvo "Znanie," 1966.

Otdel Selskoi Ekonomii i Sel'skokhoziaistvennoi Statistiki. *Kustarnaia promyshlennost' Rossii.* 4 vols. St. Petersburg, 1913.

Ovsiannikov, Iu. M. *Pero zhar ptitsy.* Moscow: Izdatel'stvo Sovetskaia Rossiia, 1963.

———. *The Lubok: Seventeenth–Eighteenth Century Russian Broadsides.* Moscow: "Sovetskii Khudozhnik," n.d.

Popova, O. S. *Khudozhestvennoe goncharstvo i farfor.* Moscow: KOIZ, 1959.

———. *Russkaia khudozhestvennaia bytovaia keramika.* Moscow: KOIZ, 1959.

Razina, T. M. *Russkoe narodnoe tvorchestvo.* Moscow: Izdatel'stvo Izobrazitelnoe Iskusstvo, 1970.

Rabotnova, I. P. *Russkaia narodnaia odezhda.* Moscow: Izdatel'stvo "Legkaia Industriia," 1964.

Saltykov, A. B. *Russkaia narodnaia keramika.* Moscow: Sovetskii Khudozhnik, 1960.

Skubenko, N. B. *Rez'ba po derevu.* Moscow: Izdatel'stvo "Legkaia Industriia," 1966.

Suslov, I. M. *Rostovskaia emal'.* Yaroslavl': Yaroslavskoe Knizhnoe Izdatel'stvo, 1959.

Taranovskaia, N. V. *Russkaia dereviannaia igrushka.* Leningrad: Khudozhnik RSFSR, 1968.

Utkin, P. I. *Russkie iuvelirnye ukrasheniia.* Moscow: Izdatel'stvo "Legkaia Industriia," 1970.

Voronov, V. S. *O Krest'ianskom iskusstve.* Moscow: Izdatel'stvo "Sovetskii Khudozhnik," 1972.

Zhegalova, S. K. *Sokrovishcha Russkogo narodnogo iskusstva.* Moscow: Izdatel'stvo "Iskusstvo," 1967.

Zotov, A. I. *Russkoe iskusstvo.* Moscow: Izdatel'stvo "Iskusstvo," 1971.

INDEX

Numbers in italics refer to illustrations.